Bakhtin and the Visual Arts is ⎯
Mikhail Bakhtin's ideas as they r
lished in the 1960s, Bakhtin's wri
and dialogue or dialogism, whic
diverse fields as literature and lite
ology, and psychology. In his four
1919 and 1926, and before he beg
categories, Bakhtin worked on a la
was never completed. Deborah Hay⎯
especially his theory of creativity, an⎯
rary art theory and criticism. With su
sideness, and unfinalizability, Bakhtin,
tual basis for interpreting the moral dir⎯

BAKHTIN AND THE VISUAL ARTS

CAMBRIDGE STUDIES IN NEW ART HISTORY AND CRITICISM

This series provides a forum for studies that represent new approaches to the study of the visual arts. The works cover a range of subjects, including artists, genres, periods, themes, styles, and movements. They are distinguished by their methods of inquiry, whether interdisciplinary or related to developments in literary theory, anthropology, or social history. The series also aims to publish translations of a selection of European material that has heretofore been unavailable to an English-speaking readership.

Bakhtin and the Visual Arts

DEBORAH J. HAYNES

Washington State University

CAMBRIDGE
UNIVERSITY PRESS

Published by the Press Syndicate of the University of Cambridge
The Pitt Building, Trumpington Street, Cambridge CB2 1RP
40 West 20th Street, New York, NY 10011-4211, USA
10 Stamford Road, Oakleigh, Melbourne 3166, Australia

© Cambridge University Press 1995

First published 1995

Printed in the United States of America

Library of Congress Cataloging-in-Publication Data

Haynes, Deborah J.
 Bakhtin and the visual arts / Deborah J. Haynes.
 p. cm. — (Cambridge studies in new art history and
 criticism)
 Includes bibliographical references and index.
 ISBN 0-521-47392-6 (hc)
 1. Bakhtin, M. M. (Mikhail Mikhaïlovich), 1895–1975—Aesthetics.
 2. Aestheticians—Russia. 3. Art—Philosophy—History—20th
 century. I. Title. II. Series.
 BH221.R94B354 1995
 111'.85—dc20
 95-10160
 CIP

A catalog record for this book is available from the British Library

 ISBN 0-521-47392-6 Hardback

CONTENTS

v

ABBREVIATIONS

AA Bakhtin, Mikhail M. "Art and Answerability." In *Art and Answerability: Early Philosophical Essays by M. M. Bakhtin*. Translated by Vadim Liapunov and Kenneth Brostrom. Edited with an introduction by Michael Holquist. Austin: University of Texas Press, 1990.

AH Bakhtin, Mikhail M. "Author and Hero in Aesthetic Activity." In *Art and Answerability: Early Philosophical Essays by M. M. Bakhtin*. Translated by Vadim Liapunov and Kenneth Brostrom. Edited with an introduction by Michael Holquist. Austin: University of Texas Press, 1990.

AiG Bakhtin, Mikhail M. "Avtor i geroi v esteticheskoi deiatel'nosti" ["Author and hero in aesthetic activity"]. In *Estetika slovesnogo tvorchestva*. Edited by S. G. Bocharov. Moscow: Iskusstvo, 1979.

CMF Bakhtin, Mikhail M. "The Problem of Content, Material and Form in Verbal Artistic Creation." In *Art and Answerability: Early Philosophical Essays by M. M. Bakhtin*. Translated by Vadim Liapunov and Kenneth Brostrom. Edited with an introduction by Michael Holquist. Austin: University of Texas Press, 1990.

DI Bakhtin, Mikhail M. *The Dialogic Imagination: Four Essays by M. M. Bakhtin*. Edited by Michael Holquist. Translated by Caryl Emerson and Michael Holquist. Austin: University of Texas Press, 1981.

IiO Bakhtin, Mikhail M. "Iskusstvo i otvetstvennost'" ["Art and Answerability"]. In *Literaturno-kriticheskie stat'i*. Edited by S. G. Bocharov and V. V. Kozhinov. Moscow: Khudozhestvennaia literatura, 1986.

KFP Bakhtin, Mikhail M. "K filosofii postupka" ["Toward a Philosophy of the Act"]. In *Filosofiia i sotsiologiia nauki i tekhniki*. Moscow: Nauka, 1986.

BiK Bakhtin, Mikhail M. "Pis'ma M. M. Baxtina M. I. Kaganu." *Pamiat': Istoricheskii sbornik* 4 (Paris: YMCA Press, 1981): 249–81.

M: FM Medvedev. P. M. *The Formal Method in Literary Scholarship*. Translated by Albert J. Wehrle. Cambridge, MA: Harvard University Press, 1985.

PDP Bakhtin, Mikhail M. *Problems of Dostoevsky's Poetics*. Edited and translated by Caryl Emerson. Minneapolis: University of Minnesota Press, 1984.

PS Bakhtin, Mikhail M. "Problema soderzhaniia, materiala i formy v slovesnom khudozhestvennom tvorchestve" ["The Problem of Content, Material and Form in Verbal Artistic Creation"]. In *Literaturno-kriticheskie stat'i*. Edited by S. G. Bocharov and V. V. Kozhinov. Moscow: Khudozhestvennaia literatura, 1986.

RAHW Bakhtin, Mikhail M. *Rabelais and His World*. Translated by Helene Iswolsky. Bloomington: Indiana University Press, 1984.

SG Bakhtin, Mikhail M. *Speech Genres and Other Late Essays*. Translated by Vern W. McGee. Edited by Caryl Emerson and Michael Holquist. Austin: University of Texas Press, 1986.

V: F Voloshinov, V. N. *Freudianism, A Critical Sketch*. Translated by I. R. Titunik. Edited in collaboration with Neal H. Bruss. Bloomington: Indiana University Press, 1987.

V: MPL Voloshinov, V. N. *Marxism and the Philosophy of Language*. Translated by L. Matejka and I. R. Titunik. Cambridge, MA: Harvard University Press, 1986.

ILLUSTRATIONS

PREFACE

Mikhail Bakhtin's ideas first captivated me when I read "Iskusstvo i otvetstvennost'," later translated as "Art and Answerability." I had been interested in the religious and moral overtones of the nineteenth-century debate about "art-for-art's sake" versus "art-for-life's-sake." In his essay, written at the young age of 24, Bakhtin clearly located himself in the "art-for-life's sake" camp, and I recognized him immediately as a kindred spirit. But it has been a long journey from that intimation to a full understanding of Bakhtin's early aesthetic essays.

In that essay of 1919, Bakhtin described a tension that would occupy his attention intermittently until he died in 1975. Art and life, he said, should answer for each other. Without recognition of life, art would be mere artifice; without the energy of art, life would be impoverished. And one of the most significant points of connection between art and life is the human act or deed, *delo* or *postupok*. The deed is like a two-faced Janus, Bakhtin wrote in another early essay, a Janus gazing simultaneously into the cultural sphere and into lived life.

Originally the numina or spirit inhabiting the doorway of a dwelling, the Roman god Janus, like Vesta (with whom he was often associated), was without gender or anthropomorphic form. As a kind of doorkeeper, Janus looked in – to the hearth and home – and he looked out – toward the larger world. Janus' name preceded all others in rituals of Roman religious life, and calling on him (or Vesta) was synonymous with praying. As the Romans developed more abstract concepts for their deities, Janus became known in cosmic terms as the god of beginnings, the source of all things, the generator of life, the original chaos out of which all things come.

A doorway, a portal. Beginnings. Bakhtin invoked Janus at the

beginning of "Toward a Philosophy of the Act." He looked in two directions, toward art and toward life, trying to make connections between the two. Gazing in these same two directions, I, too, invoke Janus. As the spirit of the doorway, Janus might be thought of as the great *and*: art *and* life, theory *and* practice, historical roots *and* contemporary application. The image of Janus is a key to the structure of this book.

I hope that *The Gift of Form* not only will illuminate Bakhtin's aesthetics and their relevance to the visual arts, but also that it will elucidate the larger philosophical and religious meaning of his early essays. This latter will be secondary to my discussion of his aesthetic categories and the visual arts, but the interested reader will find considerable reflection about the meaning of life and the inevitability of death.

Born south of Moscow in 1895, Mikhail Bakhtin grew up in Vilnius, a Lithuanian town called "the Jerusalem of the North" because of its rich Jewish intellectual heritage. He studied philology and classics at Petrograd University from 1914 to 1918, later living in small Russian cities – Nevel, Vitebsk (at the same time as Marc Chagall and Kasimir Malevich), Kustanai, Saransk, Savelovo – as well as Leningrad and Moscow, where he was active in both literary and philosophical circles. In the mid-1920s, he contracted osteomyelitis and was throughout the rest of his life subject to periods of acute pain and infirmity. His wife Elena Aleksandrovna took care of him until she died in 1971. His illness was possibly the reason he escaped death during Stalin's purges. During the harshest periods of repression, Bakhtin and his wife were exiled from Moscow; he alternately taught high school and worked as a bookkeeper. When he died in 1975, Bakhtin was eighty years old.

Mikhail Bakhtin's writings consistently began to appear in print in the 1960s; since then his name has been associated with concepts such as *carnival* (see *Rabelais and His World*, published in 1965, in English in 1968), and *dialogue* or *dialogism* (*Questions of Literature and Aesthetics*, 1975, in English as *The Dialogical Imagination* in 1981). But these are not the only significant ideas in his work; concentration on the carnivalesque or the dialogic alone has tended to skew both the reading and adaptation of Bakhtin's work by scholars in other fields. The recent publication of his early essays in both Russian and English significantly affects how his entire oeuvre is and will be interpreted.

Several additional obstacles have prevented the development of

a coherent and nuanced picture of his work. Many of his books and essays have been unavailable or difficult to obtain; translations have varied greatly in their quality and vocabulary; and the vexing question of who wrote the Marxist, Freudian, semiotic, and formalist texts that have been attributed to Bakhtin has continued to generate confusion and controversy. The writings of Bakhtin and his circle include texts in linguistics, psychoanalysis, social theory, historical poetics, literary criticism, axiology, and the philosophy of the self. The attribution of these books and essays remains a controversial issue, with differing positions taken by scholars.

On the one hand, Katerina Clark, Michael Holquist, and Tzvetan Todorov are among those who argue for Bakhtin's authorship of the disputed texts. On the other hand, Caryl Emerson, Gary Saul Morson, and I. R. Titunik argue that the evidence is not substantial enough to warrant this conclusion. I share the views of the latter group. Using the phrase "Bakhtin and his circle" is crucial, because many texts earlier attributed to Bakhtin are now identified as the work of independent scholars with whom Bakhtin was in dialogue. Because this book focuses on the early aesthetic essays, which are not among the contested texts, this is an issue that I will not address further.

But the fact that the authorship of these essays is settled does not mean that they are easily comprehensible. In the course of carrying out my research on Mikhail Bakhtin, I had occasion to read some of Wilhelm von Humboldt's letters and essays. Humboldt's ideas exerted considerable influence on Bakhtin, as they did on the ideas of others such as Alexander Potebnia and Ernst Cassirer. But what impressed me immediately was a curious similarity in the writing styles of Humboldt and Bakhtin. Ideas were explored repetitiously, using dense complex sentences that spill out over many pages. The process of writing seemed to be one through which both authors mused and meandered and ultimately, hopefully, found out what they thought. Each had a propensity to take on profound questions and to explore them through a writing process that resulted in prose difficult to translate and difficult to comprehend fully. I hope that my efforts to understand Mikhail Bakhtin's early aesthetic essays here will be of assistance to others in the future.

Many people deserve my thanks. Oleg Grabar and Wlad Godzich introduced me to Mikhail Bakhtin's work, and Caryl Emerson pushed me to interpret it responsibly. In particular, Caryl's generosity and personal commitment to dialogical practice, even when

ideas diverge from hers, are rare. For invaluable bibliographic references, I am indebted to Vadim Liapunov. Margaret R. Miles has and continues to provide a unique combination of scholarly and personal inspiration. Among those who offered critical and constructive comments at various stages of this project, I must also mention William Mills Todd III, Karen Elene Baker-Fletcher, Garth Anthony Baker-Fletcher, Gordon D. Kaufman, David Mitten, Anna C. Chave, Gary Saul Morson, Michael Holquist, Gary Vikan, Valerie Jenness, Shelli Fowler, and David Thorndike. Connie Broughton and Aniko Stettner assisted in my research. Finally, a Washington State University Research Grant-in-Aid supported me during the last stages of writing the book. I gratefully thank all the friends and readers, near and far, who have responded with criticism and love. At Cambridge University Press, Norman Bryson's initial enthusiasm for the book presaged the excellent support of others associated with the Press, especially Beatrice Rehl, Ernest Haim, and Peter Zurita.

BAKHTIN AND THE VISUAL ARTS

CONTEXT

Part One

INTRODUCTION

This book is about the aesthetics, particularly the theory of creativity, articulated in Mikhail Bakhtin's early essays. Not intended as an exhaustive study of the aesthetics of his entire oeuvre, *Bakhtin and the Visual Arts* has the more modest aim of investigating thoroughly the structure, meaning, and concepts of Bakhtin's four aesthetic essays of the 1920s.

Bakhtin conceived three of his early essays – "K filosofii postupka" [Toward a Philosophy of the Act], "Avtor i geroi v esteticheskoi deiatel'nosti" [Author and Hero in Aesthetic Activity], and "Problema soderzhaniia, materiala i formy v slovesnom khudozhestvennom tvorchestve" [The Problem of Content, Material, and Form in Verbal Art] – as part of a larger moral philosophy, a philosophy of creativity.[1] Unfortunately, he did not complete this project. But these essays remain as evidence of his attempts to analyze the moral dimension of authorship and creative activity. It should be noted, however, that Bakhtin never prepared these texts for publication. They exist only in rough drafts, having been edited in the former Soviet Union by his executors.[2] The fourth short essay, "Art and Answerability," was the first piece Bakhtin published, and it contains the seed of ideas that he would write about until he died in 1975.

AESTHETICS, THEORETISM, AND THEORY

Although there is no clearly defined and universally understood definition of aesthetics in the twentieth century, Bakhtin was an inheritor of modern aesthetic theories. He actively tried to refute formalist Kantian aesthetics; he vehemently challenged the expressivist theories of German NeoKantians such as Theodor Lipps. Un-

like both Kantians and NeoKantians, however, Bakhtin shunned orderly systematic thought, preferring instead to muse, to work out ideas by following the circuitous and often fragmentary meanderings of imagination. Most aesthetic theories are concerned with the category of beauty, which is visible both in nature and art, yet invisible in moral and intellectual activity. Some give priority to the aesthetic object or work of art. Others privilege the perceiving subject, the viewer who looks and experiences. I will argue here that Bakhtin brings us back to the aesthetics of the creative process itself, back to the activity of the artist or author who creates.

Since the 1730s, when Alexander Baumgarten had coined the term, "aesthetics" has remained ambiguous. For Baumgarten and for Kant after him, aesthetics had to do with sensory knowledge or sensory cognition, which included but was not limited to the problem of beauty. In a broad sense, Bakhtin's understanding of aesthetics fits into such a general definition. He was concerned with how humans give form to their experience: how they perceive an object, text, or another person, and how they shape that perception into a synthesized whole. But rather than focusing on beauty, he developed an unusual vocabulary for describing the process by which we literally "author" one another, as well as artifacts such as texts and works of art. As we shall see, concepts such as answerability, outsideness, and unfinalizability were central to Bakhtin's aesthetics.

Yet, Bakhtin never explicitly defined aesthetics. Like Kant, Bakhtin treated the aesthetic as a sphere in which the cognitive-theoretical and ethical-practical spheres may be brought together. But he pressed further than Kant in defining their activity. According to Bakhtin, each of these spheres approaches reality differently. By assuming primacy, cognition tends to separate itself from ethical evaluation and the aesthetic organization of reality. Cognition assumes a unitary world of knowledge that is always open, though separated from the world. In trying to establish its own purity and uniqueness, cognition reflects valuative judgments and aesthetic visions. Yet paradoxically, in the world of cognition, there are no separate acts and separate works (PS, 47).

The realm of ethical action differs from the cognitive, because here one meets with conflict over moral duty or obligation. "The split between obligation and being has significance only within the realm of obligation; that is, this split exists only for an ethically

4

acting consciousness" (PS, 48). As a result, neither cognition nor action alone can provide a foundation for philosophy.

Turning to artistic creation and the aesthetic sphere, Bakhtin stated that this sphere is fundamentally different from the other two, precisely because here reality and life interpenetrate with art.

Aesthetic activity does not create a completely new reality . . . art celebrates, adorns, and recollects this preveniently encountered reality of cognition and action (nature and social humanity). It enriches and completes them, and above all else it creates the concrete intuitive unity of these two worlds. It places the person in nature, understood as the aesthetic environment; it humanizes nature and naturalizes man. (PS, 49)

This statement is a key to why Bakhtin focused on the aesthetic dimension of life. By establishing a unity of nature and humanity (and of cognition and action) in society, aesthetics could become the basis for a new approach to philosophy.[3]

Bakhtin understood aesthetics as a "subfunction" or subcategory of the broader category of architectonics, as Michael Holquist has observed. Like aesthetics, architectonics is not a strict formal cognitive structure, but it is an activity that describes how relationships between self and other, self and object, self and world are structured.[4] The uniqueness of Bakhtin's approach to aesthetics is that it is based not on categories such as the aesthetic (the aesthetic attitude or aesthetic object) or aesthetic values (truth, goodness, or beauty), but on the phenomenology of self-other relations, relations that are embodied – in actual bodies – in space and in time.

Certainly, Bakhtin did treat traditional aesthetic categories such as detachment, empathy, isolation, and the aesthetic object, as well as theories of art and the relationship of art and morality. But his discussions of all of these categories and topics were grounded in the unique human being, located spatially and temporally and thus having a particular relationship to all other persons, objects, and events in the world. Especially in his early essays, Bakhtin was interested in, indeed compelled to understand, the nature of that relationship.

As humans struggle to express and to shape perception and experience, they engage in aesthetic activity. Bakhtin called such activity "authoring," another name for creative activity. He did not limit his interpretation of authorship to literary texts, but he saw this as a process involving other persons, nature, and even on oc-

casion, works of art. To author, in Bakhtin's vocabulary, is to create.

But just as he avoided clear definitions of aesthetics and creativity, Bakhtin never produced a systematic *theory* of the creative process. In fact, his early essays are both an implicit and explicit critique of unified and ordered systems. In "Toward a Philosophy of the Act," Bakhtin used the term theoretism to describe his aversion to unified and orderly structures or systems. What did Bakhtin mean by theoretism?

Like his writing on other topics, Bakhtin's critique of theoretism was neither sustained nor systematic. A few examples in his words will give a sense of his resistance to it.

> No practical orientation of my life in the theoretical world is possible. It is not possible to live, or to act responsibly in it. In it I am not necessary; I essentially am not. The theoretical world is obtained in essential abstraction from the fact of my individual being. . . . (KFP, 88)

> All attempts from within the theoretical world to make one's way into the real being-event are hopeless; it is not possible to open the theoretical cognitive world from within itself to the actual singular world. But from the act itself, and not from its theoretical transcription, there is an exit into its meaningful content. (KFP, 91)

> Although [philosophy's] position has some meaning, it is not capable of defining the deed of that world in which the deed really and responsibly completes itself. (KFP, 96)

In these short statements, Bakhtin made two interrelated assertions. On the one hand, theory cannot provide the basis for responsible action in the world. Immersion in the theoretical too often takes place at the expense of the everyday, the practical. Theory does not directly translate into everyday life and experience. On the other hand, a specific act or deed (*delo* or *postupok*) *does* provide a basis for assessing what is most meaningful, and for creating an adequate orientation in life. Where the theoretical alone does not provide a standpoint for assessing what content and action are most meaningful, specific acts do.

Theoretism, as the name for all kinds of theories isolated from action, was Bakhtin's enemy. Nevertheless, his resistance to all forms of theoretism did not preclude writing theoretical texts, such as the essays of the 1920s. In these essays, Bakhtin avoided systematic and practical analyses of individual texts and authors, but he articulated the basis of his aesthetics and his notion of creativity.

A few further words on the importance of theory are called for at this point, because *this* book is expressly theoretical. One of my primary objectives here is to show why Bakhtin's understanding of the creative process is significant for artists, art historians, and art theorists. Neither artists nor historians typically use philosophical aesthetics as the starting point for the production or interpretation of works of art. Theory, as I use it throughout the book, does not mean contemplation or abstract speculation, as the Greek *theoria* would suggest. Rather, I use the term to mean a "scheme of ideas which explains practice."[5] Theories, whether psychoanalytic, deconstructive, historical, and so on, can be used to understand systems (including the philosophical constructs) that affect our lives. In this sense, theory is not a totalizing, but a partial and fragmentary process.[6] Theory is an especially useful ally in political struggles, because of its empowering effects. Theory and practice are inextricable: Practice can be seen as a set of relays from one theoretical point to another. Theories encounter walls that practice helps us move through. Neither expressions nor translations of practice, theories are also forms of practice.

Theory, then, may be likened to a box of tools from which we take what we need. On the broadest practical level, I am searching for a way to persuade artists, historians, and theorists that we need to attend to the creative activity of the artist – yes, to continue our focus on the object and the viewer, but not to forget that artists have a significant moral and religious role in the culture. To accomplish this kind of metanoia, I seek to develop a persuasive theory and show how that theory translates into practice. Bakhtin's early essays constitute the box of tools from which I will forge my theory. His antitheoretical bias does not preclude such an approach, but rather, it opens the way.

BAKHTIN'S EARLY ESSAYS

Why, the astute reader may ask, focus primarily on Bakhtin's four early essays in a book that bears the title *Bakhtin and the Visual Arts*? There are two interconnected reasons for this focus: The first related to the way most scholars have previously dealt with Bakhtin's work; the second internally related to Bakhtin's ideas about the act and the word.

But before discussing these reasons in more detail, it may be

helpful to place these early essays in the context of his intellectual development. As Gary Saul Morson and Caryl Emerson have suggested, four main periods in Bakhtin's intellectual life can be discerned.[7] From 1919–24, in the four early essays I analyze in this book, Bakhtin addressed questions of aesthetics, including the nature of the embodied act and radical particularity. From 1924–30, he turned to a new definition of language as dialogue in his work on Dostoevsky. From about 1930 to the early 1950s in a series of essays that have been published as *The Dialogic Imagination,* and in his book on Rabelais, Bakhtin extended his thinking about language in ideas such as polyphony, heteroglossia, chronotope, and carnival. Finally, from the early 1950s until his death in 1975, he recapitulated earlier themes, while developing other ideas about genre, time, and creative understanding.

As mentioned earlier, the majority of books and articles written about Bakhtin's ideas have dealt with dialogue and carnival. These ideas, developed in the late 1920s and 1930s, but not published until the 1960s and 1970s, have proven to be immensely fruitful sources of insight for the analysis of cultural artifacts, especially literature. Both concepts are based in Bakhtin's own growing interest in verbal language – the word – and the possibilities and limitations of the word.

My point in this book is to show that the ideas Bakhtin articulated *prior to* his focus on verbal language are of special relevance to art historians, theorists, and artists. As will be clear in what follows, Bakhtin was not a thinker who set forth ideas systematically and then carried out his further research and reflection in a straightforward linear process. Consequently, the reader of Bakhtin's early essays cannot assume that the ideas of those essays – answerability, outsideness, and unfinalizability, as well as corollary ideas such as theoretism, live-entering, and surplus – all received fuller treatment in his subsequent writing. For example, many scholars have interpreted answerability as an early articulation of the concept of dialogue; but, in fact, the valence of the former is quite different from the latter. Answerability is more concrete, more embodied in time and space, and less logocentric than dialogue.

If, in the early texts, Bakhtin was "seeking [and not finding] his critical voice,"[8] does this mean one should therefore discount some of his ideas or look further for the truer or more developed voice? No. To do so would be counter to Bakhtin's larger commitment

to the open-ended quality of ideas and to his idea of internally persuasive discourse.

In an essay written late in his life, Bakhtin wrote, "Language and the word are almost everything in human life" (SG, 118). Perhaps one could read Bakhtin's intellectual development as a process of finding his critical voice *at the expense of* the body and the particular. From this perspective, we might then read his work as a process whereby the category of the act or deed, which means the engagement of a fully embodied human being at a given time and place and which was so central to his early thought, was displaced by logocentric values. When the word became the primary category of Bakhtin's analysis, the first and foremost creative material, then he fell prey to the pervasive logocentrism that characterizes much Western European philosophical thought. Although visual artists may use verbal language in their work, and much contemporary art certainly gains power through this practice, visual art relies on spatial and temporal categories, embodiment and action, differently than verbal discourse. Thus, to focus on his early essays in this book is to use material especially pertinent to the visual arts.

In "Toward a Philosophy of the Act," Bakhtin turned his attention to the nature and goals of moral philosophy. Moral philosophy, in his interpretation, is concerned with how the deed is oriented in the world, with the architectonics of the deed, which is composed of three emotional-volitional "moments": the I-for-myself, another-for-me, and I-for-another (KFP, 122). I will explore each of these in further detail later.

He set forth a plan for research, but unfortunately that plan was never carried out. The first part of his moral philosophy was to be about the architectonics of the real world as it is experienced; second, he would consider the aesthetic act from the vantage point of the author by focusing on the ethics of artistic creativity; third, he would write about the ethics of politics; and fourth, he would consider religion. "Toward a Philosophy of the Act" remains a fragmented meditation on architectonics in everyday life and in art. In that essay, he combined the first two parts of the larger task he had outlined.

In "Author and Hero," Bakhtin set out to scrutinize the aesthetics of verbal creation; but he acknowledged that there has been considerable fear of such analysis. (The same might be said about examining the creative process in general, as many artists are afraid this will diminish their ability to work and produce art.) Such scru-

tiny, according to Bakhtin, must be distinguished from source-criticism (as used in the historical sciences and literary history), general philosophical aesthetics, and special aesthetics. Each of these has its own way of dealing with the specifically aesthetic structure of a work of art (AH, 10–11).

Source criticism uses the historical and cultural context to derive the structure and meaning of an object or process under study. In general philosophical aesthetics, Bakhtin identified two useful ideas that could aid in developing his "aesthetics of verbal creation," though he insisted that they should not be fully or uncritically accepted. Empathy (from Theodor Lipps) and aesthetic love (from Hermann Cohen and from Jean-Marie Guyau, where it is articulated as social sympathy) were essential to a proper understanding of aesthetics. The concept of empathy would receive considerable attention, whereas Bakhtin would simply affirm the importance of love. "Only love can be aesthetically productive, only in correlation with the beloved is the fullness of multiplicity possible" (KFP, 130). Love, which Bakhtin described as objective aesthetic love, unselfish love, or lovingly interested attention, is necessary to accomplish the aesthetic task.

Special aesthetics focuses on the distinctive materials that are used in given works of art. From this perspective, the aesthetics of poetry and prose would differ from that of painting and sculpture. But even given these differences, Bakhtin insisted that there is just one organizing power for all aesthetic forms: the category of the other and the relationship to the other. "To contemplate aesthetically means to bring the object into the axiological plane of the other" (KFP, 138). This is an active process, given and set as a task to be accomplished.

Bakhtin further defined the tasks of "Toward a Philosophy of the Act" and "Author and Hero" in his slightly later essay "Content, Material, and Form." There, in a strong polemic directed at formalist linguistics, he insisted that the main task of aesthetics is to study and define the aesthetic object clearly by demonstrating the interrelationship of material, content, and form. In his view, the aesthetic object is not a thing. It is a "shaped content" that one enters as a participant and constituent, a personal interaction of the creator and the content of a work (CMF, 317).

In verbal creation, the aesthetic object has the character of a dramatic event into which one enters as a whole person – a body, soul, and spirit. Bakhtin suggested, however, that in some of the

other arts, form becomes more materialized in the content, and therefore is harder to describe separately. One of the main differences is the nature of the material. The use of "alien bodies," "technical intermediaries" like chisels, means that the activity of the artist "becomes specialized, one-sided, and therefore less separable from the content to which it has given a form" (CMF, 318). In general, artistic form gives form to the whole human being, and through the human being, to the world. Art should not be concerned with grammar, syntax, literary or artistic devices, or technique, but with values, with the valorizing activity of human beings.[9] Therefore, one of the most important tasks of aesthetics is "to create a theory of intuitive philosophy on the basis of the theory of art" (CMF, 281).

In all of these early texts, Bakhtin not only battled against what he saw as inadequate concepts of aesthetics, he also contended with classical and romantic theories of creation.[10] In classical poetics (and here Bakhtin included the writing of formalists of his own time such as Victor Shklovsky), creation is analogous to discovery. It is not an attempt to produce anything new, but rather to locate what is already present, but concealed. Shklovsky, for example, held a deliberately mechanistic view of poetry and emphasized the importance of craft and techniques such as "defamiliarization."[11] He avoided focusing on the content of an art work, preferring instead to experience its artfulness as an object. Bakhtin found this kind of technical and materialist perspective inadequate for analysis of complex artistic productions.

Somewhat differently, romantic theory held that newness is possible, but only as a result of inspiration. Creativity is exceptional in this model; it is the product of a Kantian creator-genius. Bakhtin had studied Kant's *Critique of Judgment* carefully: He and friends read it together during fourteen six-hour sessions in 1921.[12] Bakhtin argued vehemently against Kant's position that activities within the aesthetic, cognitive, and practical moral sphere were autonomous. In this model, history and life proceed mechanically until they are interrupted by a force from outside, specifically by the artist who endows the art work with values.

Romanticism and its idea of integral or "total" creation and of "total" man. One strives to act and create directly in the unitary event of being as its sole participant; one is unable to humble oneself to the status of a toiler, unable to determine one's own place in the event of being through others, to place oneself on a par with others. (AH, 203)

Bakhtin stated here that under a romantic aesthetic, art as part of the aesthetic sphere is assumed to be autonomous within culture. Within this model, the artist is presumed to be solely responsible for the creative act.

But both the classical and romantic theories are "monologic": "they presuppose a preexisting plan that need only be executed,"[13] and they do not account for the other consciousness that was so central to Bakhtin's view of the creative process.

Monologism, at the extreme, denies the existence outside itself of another consciousness with equal rights, and equal responsibilities, another "I" with equal rights (thou). With a monologic approach . . . the other remains entirely and only an object of consciousness. . . . The monologue is finalized and deaf to the other's response, does not expect it and does not acknowledge in it any decisive force. Monologue manages without the other; and therefore to some extent materializes all reality. Monologue pretends to be the ultimate word. (PDP, 292–3)

Rather than such a narrow monologism, Bakhtin wanted a more "polyphonic" or multivoiced theory that allows for the resonance, even cacophony, of many distinct voices.

In contrast to both the classical and romantic models, Bakhtin saw creativity as a living, active, ongoing event, which happens everyday and everywhere. "Creation, both divine and literary, produces not a finished world but a range of possibilities, of potentials for interesting and unpredictable histories."[14] The openness of this polyphonic creative process and the possibility of surprise are essential. Finally, this brings us to the question of how best to interpret Bakhtin's early essays.

INTERPRETATION

In his 1970 "Response to a Question from the *Novyi Mir* Editorial Staff," Bakhtin gave three ways of interpreting writings by an historical author. These are pertinent to my approach to Bakhtin. First, an interpreter might choose to "enclose the work within [its own] epoch," thereby limiting the reader's creativity to engage with it. Second, one might "modernize and distort" the text by reading it solely in relation to interests contemporary with the interpreter. This obviously would limit the author's creativity. Third, one might interpret the work in order to develop and exploit the

potentials present within it, thereby leading to a new kind of creative understanding of the author, the text, and the interpreter's world and world-view (SG, 1–9).

These three ways of interpreting texts have been rephrased by Michael Holquist in his introduction to *Art and Answerability*. As scholars have become familiar with Bakhtin's oeuvre, several discrete tasks have been initiated: (1) understanding his work in relation to thinkers with whom he was in dialogue (for example, Hermann Cohen, Theodor Lipps, Pavel Medvedev, and Valentin Voloshinov); (2) placing him in relation to current work on topics he explored (for example, literary criticism on Rabelais, Dostoevsky, or Tolstoy); and (3) extending his ideas in new directions.[15] Although I attend to some aspects of the first task, the primary focus of this book is this third direction of scholarship on Bakhtin.[16] (I leave the second task to scholars in literature and literary criticism.)

Holquist argues that the most important directions for future work on Bakhtin involve variations on the first task: for example, specifying Bakhtin's role in the Bakhtin Circle, especially because this continues to be a much disputed question; and understanding his work in relation to other thinkers of the past, both his sources and references, and those against whom he polemicized.[17] Each of these approaches is justifiable on the basis of what Bakhtin himself has said. For instance, Bakhtin wrote that "an understanding of the dialogue of languages as it exists in a given era" is needed (DiN, 417). This means not only that linguistic or stylistic analysis is called for, but also that analysis of the socioideological meaning of the multiplicity of voices in a given historical period is crucial. Thus, as mentioned earlier, the effort to untangle the web of intrigue concerning Bakhtin's role in the various Circles that included Medvedev, Voloshinov, and others has occupied numerous scholars.

In her excellent article on Bakhtin and Buber, Nina Perlina took a first step toward understanding Bakhtin's work in relation to his sources and references by simply identifying many of the sources of his work. These include interpreters of Russian Orthodox Christianity such as Tadeusz Zielinski and Vasily Rozanov; Patristic writers such as Augustine; medieval Christians such as Johannes Duns Scotus, Bernard of Clairvaux, and Peter Abelard; and European philosophers such as Kant, Fichte, Schelling, Saint-Simon, Hegel, Schopenhauer, Comte, Kierkegaard, Harnack, Bergson, and Cassirer.[18] Bakhtin's writing might be interpreted as a lifelong dialogue

with friends and with other writers and thinkers, some of whom he named, others who remained unnamed. Perlina has given us an excellent bibliography for future work. In the following pages, I discuss some of Bakhtin's sources, especially where they are pertinent to his aesthetics. But as mentioned earlier, this book is centered on the task of extending his ideas in new directions. Bakhtin himself offered persuasive suggestions that this is a justifiable use of his work.

In his essay "Discourse in the Novel" (1934–5), Bakhtin distinguished between the "authoritative" and the "internally persuasive" word (*slovo*). The authoritative word or discourse, which is the word of the fathers, the hierarchically higher, distanced word of the past, is "given . . . in lofty spheres, not those of familiar contact. Its language is a special (as it were, hieratic) language. It can be profaned. It is akin to taboo, i.e., a name that must not be taken in vain." This authoritative word "is indissolubly fused with its authority – with political power, an institution, a person – and it stands and falls together with that authority" (DiN, 342–3). The epitome of such an authoritative word would be the Bible.

In contrast, he posited the "internally persuasive word." This word or discourse is semantically open; it is unfinished and intimates "the inexhaustibility of our further dialogic interaction with it" (DiN, 346).

Such an exposition [of internally persuasive discourse] is always a free stylistic variation on another's discourse; it expounds another's thought in the style of that thought even while applying it to new material, to another way of posing the problem; it conducts experiments and gets solutions in the language of another's discourse. (DiN, 347)

This approach, however, is not mere imitation or reproduction of the other's language (by which Bakhtin meant, along with theorists such as Iurii Lotman, "any communication system employing signs that are ordered in a particular manner").[19] Rather, it means further creative development of another's ideas in a new context. Such activity is not frivolous: "the importance of struggling with another's discourse, its influence in the history of an individual's coming to ideological consciousness, is enormous" (DiN, 348). Why? Because in so doing we literally create and consummate one another. By putting another's discourse in a new situation we expose its weaknesses, we "get a feel for its boundaries, [we] experience it physically as an object" (DiN, 348).

This is precisely my approach to Bakhtin's writing. By entering into a dialogue with his ideas, by putting them in a new situation, by "getting a feel for their boundaries," specifically by examining his aesthetics and theory of creativity, I attempt to do what Bakhtin has suggested. I take his discourse not as authoritative, but as internally persuasive, as inviting development, extension, and application toward the goal of creative understanding.

Expanding on earlier remarks, Bakhtin wrote: "works break through the boundaries of their own time, they live in centuries, that is, in great time and frequently (with great works, always) their lives there are more intense and fuller than are their lives within their own time" (SG, 4). Though my intention in this book is not to assert or promote the relative greatness of Bakhtin's early work, it is obvious by the reception of his writing in the late twentieth century that his ideas will indeed live more fully outside of their own time, and possibly outside of their own cultural context as well.

Another justification for using ideas that Bakhtin derived primarily from verbal discourse to analyze the visual arts is given in Bakhtin's idea of "re-accentuation."[20] Because ideas live for both their creator and perceiver, they can never be limited to an author's intentions. "Every age re-accentuates in its own way the works of its most immediate past, [thus] their semantic content literally continues to grow, to further create out of itself" (DiN, 421). Bakhtin intimated in a few scattered references that his ideas might be applicable to the visual arts. I explore this possibility by "reaccenting" them. In his last published writings from 1974, Bakhtin reaffirmed this idea.

There is neither a first nor a last word and there are no limits to the dialogic context (it extends into the boundless past and the boundless future). Even past meanings, that is, those born in the dialogue of past centuries, can never be stable (finalized, ended once and for all) – they will always change (be renewed) in the process of subsequent, future development of the dialogue. . . . Nothing is absolutely dead; every meaning will have its homecoming festival. (SG, 170)

Caryl Emerson and Gary Saul Morson have also usefully paraphrased Bakhtin's concept:

Thinking . . . is a process of holding imagined dialogues with others, whose voices and values have been heard before and then internalized. . . . Just as real dialogue produces surprising results, so, too, does individual

thought – because it is not really individual thought at all. . . . The un-predictable processes of language and society take place within the self . . . [but] Dialogue has the last word, or, rather, the penultimate one, because it never ends.[21]

This radical view of the ongoing openness of creative work is in-trinsic to my approach to Bakhtin's early texts. Especially, I want to avoid the kind of "mechanical" application of his ideas that Iurii Lotman and Boris Uspensky criticized when they wrote: "Bakh-tin's complex and controversial ideas have been oversimplified and made into a handy decoration of scholarship."[22] Finally, it is par-ticularly appropriate to deal with Bakhtin's ideas and the visual arts in relation to the early essays, because he wrote them before de-veloping a sophisticated understanding of dialogue as a function of language and the word.[23] I hope that my work further opens the dialogic context of his writing by changing and renewing the many possible levels of meaning.

My guiding questions include the following: What can Bakhtin teach us about the creative process? What issues does he highlight? To what qualities or characteristics in the creative process does he direct our attention? By answering these questions, I attempt to untangle, understand, and interpret Bakhtin's difficult early essays. But I will also press further, in order to consider another range of questions. In what ways is his perspective gendered? How is it shaped by historical and cultural biases? What are the problems and limitations of his formulations?

My intention to analyze *and* criticize Bakhtin's work highlights the tension between what Margaret R. Miles has called a "her-meneutics of generosity" and a "hermeneutics of suspicion."[24] In-terpretation and subsequent understanding occur in a circular proc-ess. The nature of this hermeneutical circle has been described in various terms by Friedrich Schleiermacher, Martin Heidegger, Ru-dolf Bultmann, Hans Georg Gadamer, Paul Ricoeur, and others. In general, understanding evolves through a back-and-forth move-ment between reader and text, between parts of a text and the whole text, between the past and present. It involves awareness of the presuppositions of the text, its author, and the presuppositions of the reader and critic. It may take into account the historicity of both text and reader.

In interpreting a text, a hermeneutics of generosity would lead to trying to understand critically the meaning of ideas presented in a text; it might well try "to avoid misunderstanding," and "to un-

derstand the author better than the author understood himself" as Schleiermacher put it. Or it might urge Gadamer's "fusion of horizons" of text and interpreter. In analyzing Bakhtin's aesthetics and his model of creativity in Part Two, I show that Bakhtin's work offers a convincing model for how moral and religious values are inscribed in both the creative process and the artwork. In this sense, I practice a hermeneutics of generosity.

But such an interpretive perspective proceeds without particular attention to the author's political or institutional commitments or to the way gender influences language and metaphors. A hermeneutics of generosity does not attempt to articulate the complex relationship of language use to both implicit and explicit power structures, nor would it address issues of racism, sexism, or gender asymmetry expressed in the text.[25] A hermeneutics of suspicion directly examines such issues.

The interpretive attitude that Paul Ricoeur originally called a hermeneutics of suspicion developed in relation to the ideas of Marx, Nietzsche, and Freud. Ricoeur called these three the "masters of suspicion," who looked at the contents of consciousness as false and who each evolved ways to transcend what they perceived as false consciousness through new kinds of interpretation and critique.[26] Marxist critique of ideology, the Nietzschean will to power, and Freudian psychoanalysis thus led to new interpretive means – to hermeneutical suspicion. Although the word suspicion seems tainted, perhaps even implying some sort of subtle malevolence, here I use it much as Gadamer described Ricoeur's approach: "to reveal the meaningfulness of statements in a completely unexpected sense and against the meaning of the author."[27]

Bakhtin's ideas deserve critical analysis. His model of creativity does not include a clear articulation of how structures of power and authority delimit the ability of a person to author or create. Nor does he discuss how such structures delimit the ability of a person to be a fully self-conscious self, capable of living and acting in an answerable or dialogical relationship with any other. Therefore, I practice a hermeneutics of suspicion. An adequate interpretation of Bakhtin's ideas must incorporate both a hermeneutics of generosity and a hermeneutics of suspicion.

OUTLINE OF THE BOOK

Bakhtin and the Visual Arts has three main objectives related to the three major parts of the book. First, it will help scholars interested

in Bakhtin's work develop a more complete picture of the range of questions he addressed. Although the book as a whole addresses this objective, Part One focuses on how his early essays contribute to his philosophical and literary projects. Here I set the context for consideration of Bakhtin's aesthetics and theory of creativity in two ways. In the present chapter, I discuss Bakhtin's understanding of aesthetics and theory, as well as my approach to his work. In Chapter 2, I examine his historical and intellectual milieu in terms of events of the period, his own description (that is, as a time of crises of the deed, authorship, and philosophy), and in terms of the influence on his aesthetics of philosophers such as Hermann Cohen and Theodor Lipps.

My second objective is to lay out the premises of his theory of creativity. Much of the large and still growing scholarship on Bakhtin in the west deals with ideas he developed after 1929.[28] Consequently, scholars have continued to give primary attention to concepts such as carnival and dialogue.[29] Bakhtin's philosophy of creativity, which he developed in early essays of the 1920s, contains a number of other key concepts that need to be thoroughly explored. Chapters 3–5 in Part Two address this second objective. The basis of Bakhtin's philosophy of creativity is found in three ideas from his writing of the 1920s: answerability, outsideness, and the degree of finalizability or unfinalizability of a creative act.

Chapter 3 explores his understanding of answerability (*otvetstvennost'*). Bakhtin emphasized that we are not obligated by theoretical norms or values (what he calls theoretism), but by real people in real historical situations. A genuine life, and genuine art, can only be realized in concrete responsibility or answerability. Although Bakhtin did not develop this idea in a consistent or systematic fashion, it dominates his earliest essay of 1919, "Art and Answerability," and is a theme to which he returned many times until his death in 1975.

In developing my interpretation of this concept, I also deal with ideas such as the aesthetic event, and Bakhtin's fascinating account of soul and spirit. In his writing, the architectonics of the deed has three moments or aspects: I-for-myself (*dukh*, spirit), another-for-me, and I-for-another (*dusha*, the soul). An event, perceived by a person as a living, concrete, graphically unified whole, may be oriented toward one of these moments, which do not necessarily occur in order. For Bakhtin, spirit and soul are simultaneously tech-

nical terms for arranging people in space, and ways of describing how one's inner and outer selves are expressed in artistic creativity.

Chapter 4 focuses on Bakhtin's idea of outsideness (*vnenakhodimost'*). With this concept, Bakhtin criticized and tried to balance the notion of aesthetic empathy and identification, understood from a NeoKantian perspective. For Bakhtin, aesthetic and moral activity only begin *after* empathy. Only with the return into the self do we begin to form and consummate the experience derived from projecting the self into another's position.

Creativity itself is only possible on and because of boundaries among persons, events, and objects. In Bakhtin's words, "A cultural sphere has no inner territory. It is situated entirely on boundaries; boundaries go through it everywhere. . . . Every cultural act lives on boundaries: in this is its seriousness and significance" (PS, 44). The meaning of a creative act evolves in relation to the boundaries – the inside and outside – of the cognitive, ethical, and aesthetic spheres of culture. Indeed, creative activity must be understood in relation to the unity of culture and to life itself. As Bakhtin repeated many times in subsequent writings, text and context are inseparable.

Chapter 5 takes up Bakhtin's notion of unfinalizability (*nezavershennost'*). This is a core concept in all of his writing, as Gary Saul Morson and Caryl Emerson have shown, and it has been neglected by most scholars. Unfinalizability results because we are finite human beings and have finite knowledge. What we apprehend are constructions, and inevitably conflicts arise over these constructions. Therefore, no one person or group can contain the truth. We simply cannot see the whole – everything that is. Ultimately, the unrepeatability and openendedness of a creative act make transformation possible.

It should be noted, however, that in his early texts, Bakhtin was somewhat ambiguous about the degree of finalization that is necessary. On the one hand, he differentiated between the problematic and even immoral attempt to finalize another person, except in death. To do this would deny the other the possibility of full becoming as a soul, an "I-for-another." On the other hand, he emphasized the multifarious ways in which we need the other to create and finalize ourselves. In artistic creativity, as he articulated it in these early essays, aesthetic finalization is essential.

Together, these three ideas are a meditation on the crucial links between creativity and religious and moral issues. They form the core of his extended, if fragmentary, theory of creativity. I conclude

each of the chapters of Part Two with a critical assessment of Bakhtin's ideas and suggestions for how they might be useful for contemporary art theorists and historians. These assessments and suggestions are in no way a "last word," but I hope they will help other scholars wrestle with the significance of his ideas for the visual arts.

Parts One and Two of *Bakhtin and the Visual Arts*, then, may be read as an introduction to Bakhtin's philosophical and moral aesthetics. These largely abstract theoretical sections of the book stand on their own, and some readers may wish to focus their attention here.

My third objective is to show why Bakhtin's theory is significant for artists, art historians, and art theorists. Bakhtin's linkage of creativity with ethics has profound implications for how we analyze and understand historically significant works of art, as well as creative activity in the present. Throughout the book, I offer illustrations of how his ideas apply to works of art. But in Part Three, Chapters 6 and 7, I specifically address this third objective. I want to acknowledge here that a distance exists between this section of the book and the first two parts. *Bakhtin and the Visual Arts* is not an attempt to interpret the entirety of Bakhtin's oeuvre, nor to set forth a basis for new art historical theory, nor to demonstrate a passion for visual art that lurks beneath the surface of Bakhtin's prose. Can the ideas set forth in Parts One and Two be applied to art historical examples and to contemporary theory? My answer is yes.

Chapter 6 relates Bakhtin's key aesthetic concepts to two works of art: one of the oldest extant Russian icons, the *Spas nerukotvornyi* [Savior Not Made by Human Hands], and Kasimir Malevich's *Black Square* of 1915. Although Bakhtin seldom mentioned visual artworks, his ideas offer a fresh perspective for interpreting these important Russian images. I address art historical questions, such as the role of the personal, social, and political context in both the creation and interpretation of the images, as well as how their formal elements focus perception. I also examine how Bakhtin's concepts of answerability, outsideness, and unfinalizability specifically aid us in understanding such difficult and complex images.

In Chapter 7, I argue that Bakhtin's aesthetic theory, which links creative activity and ethics, redresses a critical imbalance in contemporary art theory. Within postmodern discourse, attention has shifted from interest in the artist's activity to concern with either

the *object* or the *viewer*. Bakhtin's work provides a unique perspective from which to criticize object- and viewer-centered theories and to develop a renewed appreciation of the religious and moral significance of the artist's creative activity. Simultaneously, in this chapter, I use postmodern and feminist cultural criticism to demonstrate the limitations of some of his concepts.

I end *Bakhtin and the Visual Arts* with an Afterword. What can a modernist like Mikhail Bakhtin offer in a tangled postmodern field? He can remind us that human creativity has profound religious and moral implications, and that answerability and creativity must be understood in a dynamic relationship where self and other, work and world are intimately connected.

BAKHTIN'S HISTORICAL AND INTELLECTUAL MILIEU

Any attempt to interpret Bakhtin's early aesthetic essays adequately must take into account his historical and intellectual milieu. Although he was remarkably silent about actual social, political, and economic life, events of this period are relevant as one context for Bakhtin's understanding of the multiple crises of his time. They provide the historical background not only for the foreground intellectual crisis of philosophy and the deed, but also for the crisis of authorship.

In the early texts, and as part of an early formalist aesthetic, Bakhtin denied that understanding the author in a particular historical time, milieu, or class should be a necessary part of analyzing a work. He preferred to focus on the author as the active principle of seeing *within* a work. To look at the author as a human being in history would render the author passive. Later, in dialogue with Marxists such as Voloshinov, Bakhtin modified this position. I agree that historical context is a valid and necessary complement to Bakhtin's early point of view.

Although I cannot be comprehensive in describing political events, literary history, developments in the visual arts, as well as the philosophical background for Bakhtin's thinking and writing, I can provide a multifaceted portrait that gives a sense of the complexity of his historical and intellectual context. The reader might therefore approach this chapter as a kind of cubist portrait based on multiple perspectives, with no single focal point and many centers of interest. Under the general category "historical background," I offer the following: a sketch of political, social, and economic events and effects; a metaphoric description of the time in terms of promethean longing, sensualism, and apocalyptic or eschatological attitudes, all of which are apparent in Bakhtin's early essays; a more detailed description of events in literary and artistic circles; and a

short discussion of his ideas in relation to the form/content debates in Russian Symbolism, Futurism, and Formalism (a debate that also engaged Kandinsky). Later in the chapter, I discuss the ways in which Bakhtin himself conceptualized the crises of his time; and finally, I consider the contribution of NeoKantian philosophy to his thinking.

HISTORICAL BACKGROUND

Following the October Revolution, November 1917 marked the reorganization of the Soviet government. From the summer of 1918, civil war raged between the Whites and Reds. (The term civil war here is used to describe the complex of military events between mid-1918 and March 1920.) During this period, the Russian Communists successfully eliminated internal opponents and extended the country's boundaries.[1] Though the White movement had been defeated by the end of 1920, war was not completely over until 1922. Simultaneously, other conflicts were underway. The Soviet-Polish war lasted from April until the Peace of Riga, March 1921. From 1917 to 1926, other national independence movements were active. These conflicts, along with severe droughts and famine during 1920–2, brought the number of people who had died to 20 million. The only indication of Bakhtin's personal situation during this time comes from a letter he and his wife wrote to Matvei Kagan, in which they both alluded to his having been sick for over a month.[2] Bakhtin's silence is remarkable, given the events of the period.

Lenin's New Economic Policy, begun in spring 1921, led to a revival of the economy. The NEP meant the end of forced, confiscatory grain collections, and the restoration of a limited free-market economy in food and consumer goods. Handicraft and cottage industries were revived, whereas heavy industry and finance remained under governmental ownership and control. Increasing expenditures were made for social services. Progressive schools opened, and private publishing houses operated. The Union of Soviet Socialist Republics was consolidated under a new constitution on January 31, 1924. Thus, the early 1920s was a period of economic recovery from revolution and war, and of political consolidation within the international community. It was a time of contingency on many fronts.

As Nicholas Berdyaev wrote in his autobiography, the time was one

> of awakening in Russia of independent philosophical thought, the flowering of poetry and the heightening of aesthetic sensibility, of religious disquiet and searching, of interest in mysticism and occultism . . . feelings of sunset and death combined with the feeling of sunrise and with hope for a transfiguration of life.[3]

Berdiaev was not alone in his assessment. Another more metaphorical interpretation of this time was given by James Billington. Borrowing from Vladimir Soloviev, Billington identified three attitudes that dominated the first quarter of the twentieth century: prometheanism, sensualism, and apocalypticism,[4] each of which can be located in Bakhtin's writings of the early 1920s.

Prometheanism means the belief that human beings, when aware of their creative powers, are able to transform the world. The reference is to Prometheus, the Greek God who created humans and was later chained to a mountain by Zeus because he gave us fire and the arts. It is just this promethean power that Bakhtin identified as the special province of the artist. As we shall see, by creating a new vision of the world, Bakhtin asserted that the artist gives birth to new ways of thinking and to "a new human being" (AH, 191).

Examples of this promethean impulse can also be found throughout the many essays of Kasimir Malevich, whose *Black Square* is analyzed in Chapter 6:

> I am happy to have broken out of that inquisition torture chamber, academism. I have arrived at the surface and can arrive at the dimension of the living body. . . . I say to all: Abandon love, abandon aestheticism, abandon the baggage of wisdom, for in the new culture, your wisdom is ridiculous and insignificant. I have untied the knots of wisdom and liberated the consciousness of color! . . . I have overcome the impossible and made gulfs with my breath. . . .[5]

Sensualism not only referred to the preoccupation with sex that is exemplified in Soloviev's *The Meaning of Love* and Alexandra Kollontai's writings on free love between 1919 and 1925, but may also be seen in primitivism in the arts – what many call Neo-Primitivism in painting – with its explicit inspiration from old Russian folk culture. The ribald, even pornographic, paintings of Larionov in 1912; the eroticism of Stravinsky's "Rite of Spring"; and the 1912 manifesto *A Slap in the Face of Public Taste* by Kruchenykh,

Mayakovsky, Khlebnikov, and the artist David Burliuk: all express this sensualism. In Bakhtin's early texts, this sensualism is apparent in his emphasis on the body in time and space, and on the importance of embodiment as a literal necessity for the deed to be accomplished. Unlike other Russian writers such as Tolstoy, Bakhtin's focus was on incarnation rather than resurrection.

The apocalyptic attitude was more dominant in Russia during the reign of Nicholas II (1894–1917) than anywhere else in Europe. Apocalypticism seems to have had political, social, and religious roots. This period was one of tremendous political upheaval, as already noted. Of the social and religious turmoil of the period, Sergei Diaghilev had written in 1905:

We are witnesses of the greatest moment of summing-up in history, in the name of a new and unknown culture, which will be created by us, and which will also sweep us away. . . . The only wish that I, an incorrigible sensualist, can express, is that the forthcoming struggle should not damage the amenities of life, and that the death should be as beautiful and as illuminating as the resurrection.[6]

Vladimir Soloviev was even more explicit about the sense of apocalyptic expectation: "The approaching end of the world is wafted to me as a kind of clear, though elusive breath – just as a wayfarer feels the sea air before the sea itself comes into sight."[7]

In this apocalyptic mood, artists were identified as having a special function. As Mikhail Matiushin, quoting P. D. Ouspensky and others, wrote, "Artists have always been knights, poets, and prophets of space in all eras, sacrificing to everyone, perishing, they opened eyes and taught the crowd to see the great beauty of the world which was hidden from it."[8] Ouspensky had called the artist a clairvoyant, able to see what others cannot, and a magician, possessing the power to make others see what "he" does.[9] Examples of apocalypticism in the arts can also be found in Kandinsky's repeated use of themes of the Deluge and Last Judgment, as in *Small Pleasures* (Figure 1), in Zamyatin's novel *We*, and in the mystery plays of Scriabin and Mayakovsky. Even Bakhtin's interpretation of the crises of his time may be understood in these apocalyptic terms. Radical new thinking was called for, and Bakhtin attempted to provide it.

But the kind of prometheanism, sensualism, and apocalypticism that dominated the first quarter of the twentieth century in Russia, and the series of artistic styles that expressed these attitudes, were

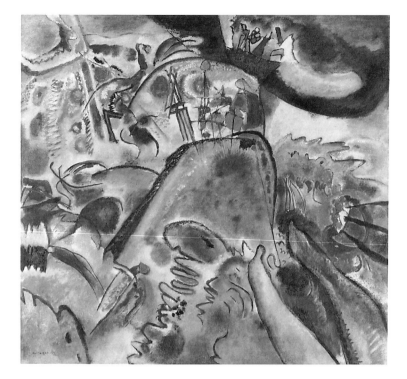

Figure 1 Wassily Kandinsky, *Small Pleasures,* 1913, oil on canvas, Solomon R. Guggenheim Museum, New York, photograph by David Heald.

short-lived.[10] Such attitudes and styles varied in their emphasis on the spiritual, philosophical, and formal aspects of art and the artist's role in the culture. Initially, artists revised the aesthetic theory of "art for art's sake," seeking, as Bakhtin might have put it, an art that is answerable to life, an "art for life's sake."

Artistically, the early years of the twentieth century were an incredibly vital and dynamic time, and even a brief chronology of literary and artistic development between 1919 and the mid-1920s will demonstrate this. In January 1919, simultaneously Kandinsky and Malevich published articles in a new journal *Visual Art,* and the first issue of the last Symbolist journal, *Dreamers' Notes,* was edited by Andrey Bely. A posthumous exhibition of Olga Rozanova's work opened in Moscow following her untimely death. Alexander Blok delivered his lecture titled "The Collapse of Humanism"; and Vladimir Tatlin designed his *Monument to the Third International,* which was displayed in both Petrograd and Moscow in late 1920. Malevich replaced Chagall as the director of the Vitebsk Popular Art Institute, and there he and his students formed Unovis (Affirmers of the New Art). Their art and spectacles dominated the town during the same years that Bakhtin lived there.

Gabo and Pevsner published their *Realist Manifesto*. In early 1921, writers such as Blok, Mayakovsky, and Zamyatin were actively reading and publishing their work, and The First Working Group of Constructivists was organized by Alexander Rodchenko, Varvara Stepanova, and A. Gan.

By late 1921, some artists had begun to leave the country because of the widespread difficulties. Anton Pevsner had gone to France. His brother Naum Gabo went to England and then America. Wassily Kandinsky moved to the Bauhaus. El Lissitsky also left Russia and became its unofficial representative in Europe. Gorky moved first to Germany, then to Italy. Mikhail Bulgakov left Moscow for the Caucasus. The Brotherhood of Saint Seraphim was founded.

Numerous publications appeared and exhibitions occurred during the following few years. Publications included works by Mayakovsky, Anna Akhmatova, Osip Mandelshtam, and in 1924, Zamyatin's *We* was published in English. Zamyatin himself had been arrested, and later was denied his request for deportation. Exhibitions included the *Mir Iskusstva* [World of Art], the "Exhibition of Paintings by Artists of the Realist Tendency in Aid of the Starving," the "Association of New Trends in Art"; and finally, international shows were held in Berlin (1922), in New York (1924), and at the Fourteenth Venice Biennale (1924) that introduced new audiences to the art of members of the Russian avant-garde. In late 1924, the State Institute of Painterly Culture, Ginkhuk, was founded in Leningrad and Malevich worked there until 1926.

Lenin's four strokes, which culminated in his death in January 1924, led to intense struggles for power between different factions of the Soviet government. By 1928, Stalin had consolidated his dictatorship, which lasted until 1953. The purges of the 1930s were especially sweeping; but Bakhtin had already been exiled during the 1928–30 assault on the Church that included persecutions of intellectuals. Churches and monasteries were closed down during these years, and unofficial religious organizations with which Bakhtin was affiliated, such as the Brotherhood of Saint Seraphim, Voskresenie, and the Josephite schism, were banned.[11] In this context, the alliance of artists and the Church obviously was destroyed, and artists were faced with the breakdown of traditions in which they had previously participated.

Among artists who stayed in Russia past the late 1920s, the artistic experimentation of the first two decades of the twentieth century was replaced by conservative and mandatory practices that

matched Stalinist ideologies in the 1930s and 1940s. Even Malevich stepped back from his radical abstract images toward figurative representation once again (Figure 2).

Such political and cultural events asides, Bakhtin's writing may also be seen in relation to the larger discussions and debates about the relationship of form and content that characterized Russian Symbolism, Futurism, and Formalism. For the earlier positivists, against whom the symbolists revolted, form was simply the outer expression of content, a "purely external embellishment with which one could dispense without any appreciable damage to communication."[12] The symbolists wanted to eliminate this kind of mechanistic dichotomy.

Russian Symbolism began with a series of lectures about the decline of Russian literature delivered in 1892 by Dmitry Merezhkovsky. "Our time must be defined by two opposing features – it is a time of extreme *materialism* and, at the same time, of the most passionate *idealistic* outbursts of spirit." He called for three new elements in art: "mystical contents, symbols, and a broadening of artistic sensibility."[13] For the Symbolist, art then became a form of higher knowledge, capable of revealing ultimate truth and the unknown. Alexander Blok put this starkly in his claim that "a Symbolist from the very beginning is a theurgist, that is, a possessor of secret knowledge, behind which secret action stands."[14] Thus, for Symbolist writers and artists such as Mikhail Vrubel, metaphors were extremely important vehicles for revealing those truths and secret knowledges. Further, far from being an external embellishment of content, form was seen as integral. In fact, as another Symbolist, Vyacheslav Ivanov, put it, "form becomes content, content becomes form."[15] These values led the Symbolists to a concentration on the problems of poetic language and form. But by the 1917 revolution, most writers and artists recognized that Symbolism would no longer predominate, nor would it ever regain the earlier stature it had had during the first decade of the twentieth century.

Although the relationship of Symbolists to Futurists and later Formalists is complex, one can say simply that these latter two groups took a radically if not diametrically opposed view of form and content. Disdaining the symbolist exhaltation of symbol and content, artists like Olga Rozanova and writers like A. Kruchenykh, to whom Rozanova was married, considered that form *determines* content. In her important statement of 1913, "The Bases of the New Creation and the Reasons Why it is Misunderstood,"

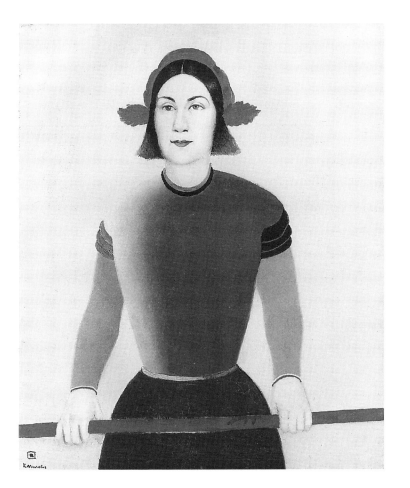

Figure 2 Kasimir Malevich, *Girl with a Red Staff*, 1932–3, oil on canvas, State Tretyakov Gallery, Moscow.

Rozanova put this quite specifically. After declaring that modern art no longer needs to copy objects or nature, she urged instead "the full and serious importance of such principles as pictorial dynamism, volume and equilibrium, weight and weightlessness, linear and plane displacement, rhythm as a legitimate division of space, design, planar and surface dimension, texture, color correlation, and others."[16] All of these are formal qualities of work, and her own abstract collages and drawings for Kruchenykh's poetry would illustrate these qualities.

Russian Formalism originated with the formation of the Moscow Linguistic Circle in 1915 and the Society for the Study of Poetic Language in 1916 in St. Petersburg. If, as suggested earlier, the Symbolists had helped to create an interest in poetics linked to philosophical and metaphysical thought, then the Formalists followed the Futurists in subjugating content to form. Victor Shklov-

sky, often considered a leading Formalist, put this baldly in 1923: "The most amazing thing about . . . the Formalist method is that it does not negate the ideological content of art, but considers the so-called content as one of the aspects of form."[17] Later, because of the inherent difficulties of the form/content dichotomy (not the least of which was the problem of defining form clearly), many Formalists dropped the category "content" in favor of "material." They then reinterpreted form not as an outer shell or external embellishment, but as a principle of integration and control.[18] Another response to these problems was to drop both terms in favor of the pair, material and the device.

Although I develop at some length Bakhtin's objections to formalist and materialist aesthetics in Chapter 5, here I might add a few words about why Bakhtin criticized the formalist perspective. He understood that by aligning themselves with linguistics, formalists were trying to find ways of accounting for general aesthetic principles, as well as the nature and material of artistic creation. But, he thought this perspective problematic. On the surface, the formalist focus on material creates a kinship with empirical science, thus seeming to render the conclusions of such scholarship objectively scientific. But this seeming advantage was actually an illusion. Bakhtin, too, wanted to understand the linguistic qualities of the word, especially in poetry, but he then would examine its significance vis-à-vis art, science, religion, and philosophy. In keeping with its goals, formalist linguistics would stop at the first task; whereas for Bakhtin, an utterance only comes alive and acquires meaning in cultural and personal contexts. Linguistics sees an utterance only as a phenomenon of language, which "masters" its object while being indifferent to extralinguistic values of language (CMF, 292–3). In Bakhtin's view, this partial and therefore flawed way of understanding the complex interrelationships of content, form, *and* material was the result of formalist ideas.

Bakhtin was certainly not alone in such criticisms of the materialist aesthetics of the Formalists. In his essays on form between 1910 and 1913, Kandinsky had developed his own point of view, which was strongly aligned with Symbolist aesthetic ideals. For instance, in "Content and Form," he stated that "The work of art is the inseparable, indispensable, unavoidable combination of the internal and external element, i.e., of content and form." But ultimately form was determined by content; and "only that form is correct which expresses, materializes its corresponding content."[19]

Later, in "On the Question of Form" (1911–12) and "Painting as Pure Art" (1912–13), he continued this meditation on the relationship of content and form:

Form is always temporal, i.e., relative, since it is nothing more than the means . . . by which the revelation of today sounds forth, manifests itself. This sound [*or, we might say, content*] is thus the soul of form, form that can have life only by virtue of this sound and that produces its effect upon the external world from within. Form is the external expression of inner content.[20]

For Kandinsky during the 1910s, a work of art must express this inevitable and inseparable joining of content, the inner element, with form, the outer element.

Later, in letters and essays written between 1916 and 1922, his writing reflected a growing distance from his contemporaries, particularly those at the newly formed Inkhuk in Moscow. Younger artists like Alexandra Exter, Varvara Stepanova, Alexander Rodchencko, Liubov Popova, Alexander Vesnin, and others were committed to a more utilitarian interpretation of the goals of art, an interpretation that depended upon formalist values regarding the relationships of form, content, and material. As implied earlier, this rift was related to Kandinsky's decision to leave Russia for Germany in December 1921.

Bakhtin's aesthetics and his interpretation of creativity evolved in relation to this historical situation. But interpretations of such historical processes and events are not the only part of his context. His early essays are filled with both tacit and overt philosophical references, many of which are obscure for the late twentieth-century reader. Many statements remain incomprehensible unless interpreted in relation to Bakhtin's intellectual conversation partners. He wrote of contemporary cultural crises as involving *philosophy and the deed*, and *authorship*; these two interrelated categories, as well as a section on the contributions of NeoKantian philosophy, will serve to focus the remaining discussion of his intellectual milieu.

CRISIS OF PHILOSOPHY AND THE DEED

In analyzing the *crisis of philosophy,* Bakhtin identified the main problem as a pervasive *theoretism,* a brief definition of which I outlined earlier.[21] In his view, the belief that the world is a theoretically

31

cognizable whole is a peculiarity of the nineteenth and twentieth centuries. He thought that real, unique, historical existence is impossible to define using the theoretical categories of philosophy, psychology, aesthetics, or ethics.

Bakhtin had two objections to material ethics, and one major objection to formal ethics. The first problem with material ethics was that it attempts to find (or create) general moral norms rather than particular ones. But "oughtness" (*dolzhestvovanie*) and obligation always arise in specific situations, and therefore the attempt to find such general norms will always fail. Material ethics has no way of understanding the moral orientation of consciousness, because that consciousness is grounded in the deed. Within material ethics, obligation is evaluated in terms of authority and legislation: "if you want or need this and that . . . you must act so-and-so" (KFP, 100). In such a situation, action is not based on individual volition, but on outer authority, which is not a sound basis for an ethical system.

The second problem was that material ethics (like formal ethics) understands "oughtness" as a generality. If norms are based on a concept of truth or on commandments, the generality of norms is inevitable. For Bakhtin, this was unacceptable.

The fundamental deficiency in formal ethics was based on a correct assumption, that oughtness is a category of consciousness. But formal ethics further conceives oughtness in terms of theoretical consciousness, and consequently loses the individual deed. Bakhtin thought that even Kant's categorical imperative is justified theoretically, based on sociological, economic, aesthetic, legal, or scientific principles, rather than on the real unique person in a particular moment.

Thus, the fatal flaw of most ethical philosophy was, in Bakhtin's view, its theoretism. "Only from within the real deed − singular, whole, and unified in its answerability − is there an approach to unified and singular existence in its concrete reality. Only toward it [the deed] can a first philosophy be oriented" (KFP, 102). Or, in another formulation: "The contemporary crisis is a crisis of the deed, theory has been cut off from the deed and has developed by its inner immanent law" (KFP, 123). In short, as exemplified in both formal and material ethics, the crisis of contemporary philosophy was that there was no clear connection between theoretical thinking and the deed.

The roots of this crisis lay in the tendency to split the act into

its meaning or content, on the one side, and the subjective process of carrying it out, on the other. This division of a unified and unique act into its abstract meaning or relation to a system of rules and its specificity in a given instance is misleading. To try to separate the essence of the act from its "eventness" (*sobytiinost'*) fails to account adequately for the power of particularity and unrepeatability.[22] In actual fact, according to Bakhtin, these two "worlds" (of philosophy and of the deed) do not and cannot communicate. "Although the position of philosophy has some significance, it is not capable of defining the deed in the world in which the deed is actually and responsibly completed" (KFP, 96).

Bakhtin also referred to the "pathos [literally, the enthusiasm or spirit] of Tolstoyism" and to cultural nihilism that "sucks all moments of the ideal out of existence." The possibilities for the transformative power of the deed are impoverished when and if "all the wealth of culture is returned to the service of the biological act" (KFP, 123). Though he did not directly confront Tolstoy's polemic "What is Art?" in these early texts, Bakhtin was writing in its shadow. He translated Tolstoy's questions, "What shall we do and how shall we live?" into the question: How can we act effectively in a world of contingency?[23] Cultural nihilism was one possible response to this situation that Bakhtin especially wanted to avoid.

In the deed, the subjective and psychological, the objective and logical are united. This is why no single approach can be adequate for understanding the deed in its fullness. Some fear that the deed is somehow irrational. But Bakhtin asserted that "the deed in its wholeness is more than rational – it is responsible. Rationality is only a moment of answerability, [words are missing from the original text] a light, 'like the reflection of a lamp in front of the sun' " (KFP, 103). Answerability is like the light of the sun; rationality but a lamp, a poor substitute for the real thing.

All contemporary philosophy originates in and is saturated by the prejudices of rationalism, and this is part of its problem. Philosophy tends to oppose objective rationalism to the subjective as irrational and arbitrary, and therefore it cuts itself off from "a unified and singular center of answerable consciousness" (KFP, 104). Bakhtin acknowledged that it is impossible for this answerable consciousness to be totally and utterly opened, but when we think, our rationality "shines by the borrowed light of our answerability." In other words, rationality is dependent on answerability. From within the deed, one is oriented by the light of answerability.

33

According to Bakhtin, we are not obligated by theoretical norms or values, but by real people in real and unique historical situations. "No practical orientation of my life in the theoretical world is possible," he wrote, "it is not possible to live in it, or responsibly to act. In it I am not necessary, in it I essentially am not. The theoretical world is obtained in essential abstraction from the fact of my singular existence" (KFP, 88). Bakhtin asserted that theory provides an inadequate basis for living and acting. A genuine life, for Bakhtin, could only be realized in concrete responsibility. A philosophy of life therefore must be a moral philosophy, and for him the crisis of nineteenth- and early twentieth-century philosophy was its failure to see this.

In these remarks concerning the crisis of the deed, it is unclear whether Bakhtin was referring strictly to philosophy or to Russian life in the early 1920s. On the one hand, a main object of Bakhtin's criticism was the kind of social-philosophical apologetic of alienation exemplified by Spengler's *Decline of the West*. On the other hand, he despaired that money could become the motive for action, and that writers would construct a system such as economic materialism with money as the primary category for understanding history and culture.[24]

Another major crisis in philosophy in Bakhtin's interpretation was the attempt to create rational and unified philosophical systems. Philosophers of rationalism such as Hegel strove to think the whole of life and thought as a unity that coalesces out of generalized and repeatable moments. Such thinking minimizes the singularity and unrepeatability of an act or event. Bakhtin called this idea the "sad legacy of rationalism." In the philosophy of his own time, Bakhtin thought that there was an inclination to understand the unity of consciousness and being as a unity of value. But such a unified value could only be theoretical, having nothing to do with real acts and real, responsible obligation. Wilhelm Windelband's *Lehrbuch der Geschichte der Philosophie*, originally published in German in 1892 and in English in 1893, exemplifies this view. "Philosophy," Windelband wrote, "can only live as the science of values which are universally valid. . . . Philosophy has its own field and its own problem in those values of universal validity which are the organizing principle for all the functions of culture and civilization and for all the particular values of life."[25]

Unlike Windelband, Bakhtin was emphatically not seeking to create a unifying or unified *system*. He was, as Gary Saul Morson

and Caryl Emerson have shown, a "prosaic" thinker, interested in the everyday, in newness, surprise, and unpredictability. In an even stronger statement, David Carroll has argued that servitude to any political, historical, aesthetic, or rhetorical metanarrative, to any master-theorist or master-theory, was Bakhtin's enemy. Bakhtin wanted to resist all "dialectical syntheses of diversity by showing the serious repressive consequences of not being able to answer, counter, dispute, reverse, parody, undermine or transform the metanarratives in which such resolutions are rooted."[26] Carroll's argument is actually more appropriate to Bakhtin's later work than to the texts of the early 1920s, because any sense of the political, or of the need to subvert metanarratives, including repressive ideologies, is missing from these early writings. Nevertheless, Carroll's perspective identifies the direction Bakhtin's thought would take.

CRISIS OF AUTHORSHIP

Although most of his attention centered on the crisis of philosophy and the deed, Bakhtin also turned his attention briefly to what he called "the crisis of authorship." As I described earlier, it was a time of energetic experimentation and new ideas in Russia; this was the period of the avant-garde, variously defined as 1863–1922 or 1890–1930.[27] But as an avid reader of philosophy and aesthetics, Bakhtin perception was also shaped by broad intellectual currents. In his view, the very place of art in culture was being reevaluated.

In "Author and Hero," this sense of crisis and change in relation to authorship and creativity is reflected in two ways. First, Bakhtin said, it had become impossible to be an artist as something determinate. No longer did one try to surpass others in art, but rather to surpass art itself. How this occurred will also become more apparent when I discuss Malevich's *Black Square*, but it may also be useful to consider briefly the nineteenth-century debate about art for art's sake versus art for life's sake.[28]

Philosophically based in the writings of Kant, Schiller, Goethe, Schelling, and Friedrich Schlegel, the idea of art for art's sake had adherents in France, England, and Germany. Among its primary tenets are the following interrelated ideas. First, art has its own distinctive sphere in which the artist is sovereign. Second, freedom for the artist is essential; the artist is committed only to personal vision and not to a school or given formal structure. Third, the

true artist is concerned only with aesthetic perfection, and not with the personal or social effects of the work of art. In other words, aesthetic creation is the highest goal of life, rather than other goals such as moral perfection. Fourth, aesthetic perfection is achieved through the expression of form. Here "expression" is understood as expressing inner vision rather than outer appearance; form means essence. Fifth, creative imagination, or sensuous intuition, predominates over cognitive or affective processes of thought and reflection.

These ideas were expressed in literature and the visual arts in a variety of ways, but for Bakhtin, "art for art's sake" constituted a fundamental crisis, an attempt by artists simply to try to surpass art. Bakhtin, as we shall see in Part Two, followed nineteenth-century aestheticians such as Jean Marie Guyau who were convinced that art must be deeply connected to life.[29]

Bakhtin's second point in articulating the crisis of authorship concerned the author's outsideness, *vnenakhodimost'*. Bakhtin claimed that the author's or artist's outsideness was questioned, and no longer deemed essential. Because I examine Bakhtin's understanding of outsideness in Chapter 4, suffice it to say that Bakhtin identified aesthetic culture as a culture of boundaries, presupposing a warm atmosphere of trust. In this atmosphere, one could abide and act without constraint. But when tradition breaks down, as it was during the period Bakhtin was writing the early texts, "life breaks up all forms from within"; the meaninglessness of various traditions is exposed.

Life tends to recoil and hide deep inside itself, tends to withdraw into its own inner infinitude, is afraid of boundaries, strives to dissolve them, for it has no faith in the essentialness and kindness of the power that gives form from outside; any viewpoint from outside is refused . . . the culture of boundaries (the necessary condition for a confident and deep style) becomes impossible . . . all creative energies withdraw from the boundaries, leaving them to the mercy of fate. Aesthetic culture is a culture of boundaries and hence presupposes that life is enveloped by a warm atmosphere of deepest trust. (AH, 203)

Bakhtin may have been referring not only to changes in the activity of artists, but also to the process of secularization in postrevolutionary Russia; such comments seem to presage events in Russia a few years later.

The development of Bakhtin's aesthetics did not rest only on his interpretation of the multiple crises of his time. His interpretation of aesthetics was indebted to several general contributions of both Kantian and NeoKantian philosophy.

First, Kant's assertion that time and space are fundamental categories of human thought found expression in Bakhtin's use of spatial and temporal categories throughout "Philosophy of the Act" and "Author and Hero." As will be evident later, Bakhtin rejected Kant's transcendental claims about time and space, preferring to identify them as forms of perceptible reality. Second, Bakhtin translated Kant's skepticism regarding the limits of reason and rationalism into a general contempt for theoretism. Third, the expressed need among the NeoKantians to make a philosophy of life into what Windelband had called a "science of values" became for Bakhtin an urgent call for a new moral philosophy.

More specifically, the Jewish strand of NeoKantianism was significant for Bakhtin and other members of the Circle.[30] In 1918, Matvei Kagan had just returned from nine years in Germany, where he was allied with the Marburg NeoKantians. Hermann Cohen (1842–1918) was the leader of this group, which focused on logical, epistemological, and methodological themes. Though often charged with being formalistic and abstract, the Marburg school was the only NeoKantian school that tried to have a "critical reformatory impact on the redirection of society."[31] Cohen had visited Russia in 1914, but it was through Kagan that Bakhtin came into contact with Cohen's ideas and assimilated them into his thinking.

There were three stages in Cohen's work.[32] First, as one of Kant's famous exegetes, Cohen wrote long commentaries on Kant. Second, he set forth his own philosophy. Finally, after 1912, he began blending Talmudic metaphysics and Kantian ideas in order to develop a new philosophy of religion, which was posthumously published as the *Religion of Reason Out of the Sources in Judaism* in 1918. Three ideas in Cohen's writing were particularly significant for Bakhtin: the difference between what is given and what is conceived or posited, the centrality of ethics, and ideas about God and creativity.

Cohen's principle that "The world is not given, but conceived" (*Die Welt ist nicht gegeben, aber aufgegeben*) became the rallying cry

for both the Marburg school and the early Bakhtin Circle. "It was so often invoked by the young Bakhtin and his friends Pumpiansky, Iudina, Tubiansky and others, that Konstantin Vaginov, in his *roman à clef* about the circle, *The Satyr's Song*, uses the phrase as their iconic attribute."[33] In his last work, Cohen repeatedly asserted the primacy of human work, human action, and human virtues as crucial to the world's being and becoming.[34] Artistic creativity especially was, for Cohen, the supreme instance of how humans create the world.

In Bakhtin's early texts, this principle is expressed many times in the tension between *dannost'*, what is given, and *zadannost'*, what is set as a task to be accomplished. For example, in "Author and Hero" he wrote: "[The] body is not something self-sufficient: it needs the other, needs his recognition and form-giving activity. Only the inner body . . . is *given* to a human being; the other's outer body is not given but is *set as a task*: I must actively produce it" (AH, 51).[35] Even the human body is not given, according to Bakhtin; it is produced through interaction with others. This is one of Bakhtin's first statements of what a dialogical relationship might be, though it is not so named. Here he did not talk about language as primary, but about the body in space and time. Further, in a creative act, the artist's individuality is not given, but rather is set as a task to be accomplished in and through the object. How does this self that is produced through creative activity relate to another person?

In order to answer this question, Bakhtin followed Cohen and other NeoKantians in asserting the primacy of ethics. All of these philosophers believed that ethics and a doctrine of the human being should form the center of an adequate philosophical system.[36] This branch of NeoKantianism identified the two primary aspects of reality as the self and the other, "but they did not stand in a dichotomy, for each pole was interrelated with the other."[37] In his *Ethik des reinen Willens*, Cohen had developed his view of the self and the other, the I and Thou. "The other person is not an other; rather he stands in exact correlation, in a relation of continuity to the I. The other, the alter ego, is the source of the I. . . . The I cannot be defined, cannot be created, unless it is dependent on the pure creation of the other, and has emerged from him."[38]

For Cohen, the existence of the self, and even self-consciousness, is dependent on the existence and consciousness of the other per-

son. Bakhtin developed Cohen's assertion in relation to the mother as the first other.

[M]y outer body has been as it were sculpted for me by the manifold acts of other people in relation to me, acts performed intermittently throughout my life: acts of concern for me, acts of love, acts that recognize my value. In fact, as soon as a human being begins to experience himself from within, he at once meets with acts of recognition and love that come to him from outside – from his mother, from others who are close to him. The child receives all initial determinations of himself and of his body from his mother's lips and from the lips of those who are close to him. (AH, 49)

In addition, Cohen claimed that the self and the other form a unity, a unified whole. This focus on unity parallels his emphasis elsewhere on the unity of God and the human being in Christianity; on the unity of the soul and spirit in the person; on the essential unity of all the arts.[39] Bakhtin rejected Cohen's pervasive emphasis on unity, preferring to understand the relationships of persons and objects as more open-ended and unfinished.

Cohen, following Kant, asserted that religion is necessary as a supplement to ethics, because ethics (especially in the traditional Kantian schema) deals with a person's relationship to the totality of humankind, whereas religion deals with a person's relationship to other individuals.[40] The need to overcome the split between knowledge and reason on the one hand, and faith and belief on the other, was for Cohen a struggle between "a defense of God as an intellectual concept and the unspoken desire for direct experience of God."[41] But there is in his work no resolution of this polarity of God as idea versus God as experience. For Cohen there could be no personal encounter with God. Intellectually, Maimonides had destroyed this possibility, as well as the analogy that one might love God like one loves a beloved. "Rather than being present as a concrete fact, God is known to us through the process of construction, a process that looks to the Bible, its commentaries, the philosophic tradition, and everything else which informs our religious experience."[42] God in this sense is an archetype, rather than a personal being, because God "exists" at or past the limits of human experience, perception, and knowledge. We encounter God, according to Cohen, not in any direct way, but through our moral agency:

The idea of God is the idea of the holy God, the idea of the holy spirit

as the spirit of holiness, that is to say, the spirit of morality. Morality, however, is only a realm of actuality insofar as it is the realm of action. . . . Action establishes the realm of morality. In this realm there are no other actualities than goals, which are ever new actualities. The ideas are archetypes for actions. And the archetypes have no worth of their own unless they are models for the actions of reasonable beings.[43]

Even though Cohen's statement about God as the spirit of morality is striking, he used traditional language when he maintained that "creativity is God's primary attribute."[44] Creativity is not just the consequence of God's uniqueness, but identical with it. But Cohen did not have in mind here an understanding of God as creating once-and-for-all, or out of nothing. "Therefore, 'creation in the beginning' does not seem to have been considered the last word on the problem."[45] Rather, creation and God's creativity mean continuous renewal of the world: "The renewal therefore is not the renewal out of chaos or out of nothing – if it were so, one could rest satisfied with the idea of creation. Renewal, rather, emphasizes each point in becoming as a new beginning."[46] Bakhtin took over Cohen's emphasis on process, especially on creation as an ongoing and unending process of renewal, in developing the concept of unfinalizability.

By the time of his later work, Cohen had appropriated the Judaic religious tradition in his metaphysics; Bakhtin in turn appropriated several of Cohen's techniques for translating religious discourse into philosophical language in order to pursue his own task of creating a new ground for aesthetics. This represents a secularization of ideas that had an obviously religious aspect in Cohen.[47]

But it is not just to Kant and Cohen that Bakhtin turned in developing his ideas about aesthetics. Bakhtin was a student of nineteenth-century attempts by Theodor Lipps and Johannes Volkelt to develop a new basis for aesthetics. He was especially critical of their "expressivist" mode and the concept of empathy. Although it is difficult to speak of an expressivist tradition, since the eighteenth century, a stream of thought has existed that emphasized art as expression of feelings and the inner self.

In his essay on the origin of language (c. 1749), Rousseau identified the arts, especially music, as forms of emotional expression. Where a gestural language is sufficient for expressing basic human needs, according to Rousseau, the passions require languages, both artistic (for example, color, sound) and verbal. Sound and color are more direct emotional expressions than are possible ·with words.

To this idea of expression in Enlightenment aesthetics, Kant added the notion of the exalted artist as a person both bound and free, a genius. Innate genius provides the material for artistic expression; training then gives it form. Only the original and exemplary artist-genius through "his" expression of imagination, understanding, spirit, and taste could produce "fine art." Both Rousseau's and Kant's understandings of expression, indeed the entire notion of art as expression of emotion, thought, or nature, derive from the Enlightenment formulation of the individual self characterized by reason. Only such a free and reasonable self would be capable of personal expression.

Theodor Lipps' theory of empathy is a prime example of this type of expressivism. Certainly, descriptions of the process that came to be labeled empathy exist in many earlier writings, such as those of Plato, Aristotle, the Gospel of John, Plotinus, St. Augustine, Aquinas, and Spinoza. In Plato's seventh letter, for instance, he used the phrase "kinship of insight" to name what he saw as the highest level of knowledge. But the word empathy (feeling-in) was coined more recently by Edward Titchener to translate the German *Einfühlung*, the basis of which lies in Kantian philosophy.[48]

In his *Critique of Judgment*, Kant had asserted that pure beauty is the beauty of form, and that the judgment of beauty is not intrinsic to the object, but is a projection of the subject. Unlike the Hegelians, who would later see form as a bearer of the Idea, those developing a theory of empathy saw form as a vehicle for feeling and emotion. The new aestheticians thus followed Kant in turning away from the classical theories of art based on imitation of the Idea, and toward the human subject who perceives and judges. In the NeoKantian view, the main problem of aesthetics became one of expression of feelings and emotions. But how does expression take place?

The idea of empathy had German predecessors in Herder's notion that "the beauty of a line is movement, and the beauty of movement expression," and in Herman Lotze, who wrote about how the mind projects itself into nature.[49] Even Hermann Cohen had written briefly about *Einfühlung*, saying that pure feeling of a subject toward an object does not constitute empathy.[50] Among nineteenth-century NeoKantians, Robert Vischer was the first to use this word. He proposed that there must be an unconscious process at work, whereby the perceiver involuntarily endows an object or objects with meaningful content. In his 1872 psycholog-

ical theory of art, Vischer suggested that the dynamics of artistic form in an object elicit muscular and emotional attitudes in the viewer or subject. The subject in turn experiences these as properties of the object. This process he called *Einfühlung*.[51]

However, in the work of these philosophers, the theory of empathy is mostly undeveloped. Theodor Lipps wrote extensively about it in several works from 1893–1913: in his *Raumaesthetik*, 1893–7, the two-volume *Aesthetik*, 1903–6, in various sections of *Archiv für die gesamte Psychologie*, 1903–5, and in *Zur Einfühlung*, 1913. Bakhtin took over Lipps' description of the aesthetic object, but polemicized against his concept of empathy.

In Lipps' formulation, the aesthetic object consists of both sensuous appearance (the external object) and the image of the object as it is remodeled in the imagination and invested with meaning. The mind "enlivens" the object by projecting the mind's own striving, willing, and its sense of freedom and power. Thus, there are two factors in the aesthetic object: the inner activity of the perceiver, and the bare physical object. By 1924, Bakhtin had directly appropriated this idea in "Problem of Content," when he claimed that "material aesthetics cannot establish the essential distinction between the aesthetic object and the external work" (CMF, 266). The aesthetic object evolves from the artist's and spectator's inner contemplation of the artwork, whereas the external work is a result of techniques used to complete it.

Empathy means the disappearance of the twofold consciousness of the self and the object. It is "the fact that the antithesis between myself and the object disappears, or rather, does not yet exist."[52] The perceiver might bodily mimic the object, but this would not be true empathy. Lipps thereby differentiated between perception of another's movement and aesthetic imitation, where "I become progressively less aware of muscular tensions or of sense-feelings. . . . All such preoccupations disappear entirely from my consciousness. I am completely and wholly carried away from this sphere of experience."[53] According to Lipps' theory, we forget the body completely. "Empathy means, not a sensation in one's body, but feeling something, namely, oneself, into the esthetic object . . . sensations of my own bodily state are entirely absent in aesthetic contemplation . . . or enjoyment."[54] This idea of *Hineinleben*, of "living oneself into an object through self-abandonment and [a] corresponding imaginative expansion of one's own personality," was crucial to Lipps' understanding of aesthetic experience.[55] Later, it

would also influence Bakhtin's notion of *vzhivanie*, also translated as "living into."

In elucidating how this interaction between the perceiver and the perceived occurs, Lipps used the example of how sound produces emotion:

I reexperience this emotion, not as an associated idea, but directly in the sound. This seems at first sight merely immediate sympathetic imagination. It is actually more. I don't merely have the idea that the emotion is the cause of the sound, but rather I experience it. I reproduce it inwardly and do so the more reliably and completely the more I am inwardly wholly absorbed in the sound. I am impelled to celebrate with the rejoicer, to harmonize inwardly with his exultation. And I actually do so if nothing prevents my total self-abandonment to what I hear. This situation, this rejoicing with the joyful expression one hears, may be termed . . . empathy.[56]

Lipps claimed that there are three levels of empathy, roughly corresponding to inanimate objects, animate objects or processes in nature, and other persons. First, there is a general apperceptive empathy, when an object presents itself to be perceived. Second is natural empathy, as when natural objects become "humanized." Third is the empathy we feel when responding to a human being. Each of these three levels is experienced when looking at a work of art, except that experiencing empathy vis-à-vis an artwork is different from experiencing a similar object or condition in the natural world. Lipps' example is a raging storm, where we would obviously have a different empathetic response to an actual storm than to a painting of a storm. A source of Lipps' notion – and hence of Bakhtin's – was probably Giambattista Vico, who had asserted that "man knows only what he makes, his history, his art, his languages, his customs."[57] Particularly, Vico had said, we understand the poetry, customs, and culture of a people of the past by reconstructing their circumstances, by *empathizing* with those people of the past.

As we shall see, with the idea of outsideness, Bakhtin argued against Lipps' idea that we can or should merge empathetically with the person or object of our contemplation. In his early work, he also gave special emphasis to the embodied and incarnate nature of human experience, as noted earlier. Both Cohen's and Lipps' ideas are thus important in understanding Bakhtin's concept of creativity.

Before turning directly to the primary categories of Bakhtin's aesthetics, a few words about the relevance for art historians, critics,

and theorists of his criticism of monologic theoretism. All scholars, whatever their disciplinary background, would do well to heed Bakhtin's warning that when theory is cut off from the deed, and from practice generally, it loses its meaning. Theory can only be of the narrowest academic significance when it is not related to life or when it does not acknowledge how the polyphonous nature of experience impacts theory.

Earlier, I described my own approach to theory with the image of a wall, borrowed from Gilles Deleuze. Theory alone can lead to a wall, a cul de sac from which the only exit is practice, a practice that involves climbing over, digging under, chipping through, or piercing that wall. I have sought throughout to be wary that my own love of theory – in this case an aesthetics grounded in Bakhtin's moral philosophy – does not devolve into theoretism.

BAKHTIN'S THEORY
OF CREATIVITY

Part Two

ANSWERABILITY

In his earliest published essay, "Art and Answerability," Bakhtin made an attempt to articulate the importance of *otvetstvennost'*, responsibility or answerability.[1] Following a Kantian framework, he stressed that the three domains of human culture (science, art, and life) are united, or at least can be united, in an individual, but that this unity can be either external and mechanical or internal and organic. Like any other person, the artist can make an external connection between the self, art, and the world, thus creating a falsely self-confident art that does not and cannot answer for life.

But to make an inner connection between art and life necessitates answerability: "to answer with my own life for what I have experienced and understood in art, so that everything I have experienced and understood would not remain ineffectual in my life" (AA, 1). From this perspective, experience and understanding must be linked to activity in a life. It is easier to create if one does not attend to the situation in life ("without answering for life") and vice versa: It is easier to live if one does not think much about art (AA, 2). His goal in this essay was to point out that through a process of consistent response- or answer-ability, art and life can be unifed by and in the person.

Bakhtin's talk about "life" was very general. In this short essay, he began a pattern that he would follow for years to come: a pattern of not addressing the specifics of a given situation, its politics, economics, class, and so on, while simultaneously urging that the uniqueness and particularity of each person was of prime importance. One might read "Art and Answerability" as Bakhtin's first attempt to articulate ideas that he would spend much of his life elaborating. By the late 1920s, the general notion of answerability or responsibility would be replaced by dialogue and the dialogic, both of which have stronger linguistic valences. Because Bakhtin

posited an interrelatedness and coresponsibility for life and art, his aesthetics was ultimately also a philosophy of life, a moral philosophy. It remains for us to investigate how he developed the moral dimension of his interpretation of aesthetic activity.

ARCHITECTONICS OF THE REAL WORLD AND THE EVENT

As we saw in the last chapter, Bakhtin was convinced that in his time there was a pervasive crisis of philosophy and the deed, and of authorship. He claimed that both art and life could only be fully realized in concrete answerability, and he also insisted that a philosophy of life could only be a moral philosophy: "Dropping away from answerability, life cannot have philosophy: it is essentially arbitrary and ungrounded" (KFP, 124). His response to this contention was to set forth his agenda for a four-part moral philosophy. Such a moral philosophy would be concerned with how the deed is oriented in the world, and more specifically, with the architectonics of the deed. Originally titled "The Subject of Morality and the Subject of Law," the text we know as "Toward a Philosophy of the Act" was Bakhtin's beginning.[2] Unfortunately, he did not complete this project.

Bakhtin used the word "architectonics" in a special sense: not to suggest a strict formal cognitive structure as Kant did, but rather to describe how the relationships between the self and the other are structured. Just as he had insisted on the distinction between life and art in answerability, so he made the same distinction in talking about the architectonics of the real world (especially the deed) and the architectonics of aesthetic activity.

His written definition is vague: Architectonics is the intuitively indispensable, nonarbitrary distribution and linkage of concrete, unique parts and aspects into a consummated whole, and this is possible only around a given human being (KFP, 139). In other words, architectonics is the ordering of meaning, the integration of parts to form a whole, around a distinct person. As he would repeat many times, the human being is the organizing center in the actual world – in the event of being – *and* in aesthetic or artistic vision.

The unity of the world of aesthetic vision is not a systematic unity of meaning, but a concretely architectonic unity; it is distributed around a concrete value center [the person] who is thought, seen and loved. . . .

All possible existence and all possible meaning are structured around a given human being as the center of unique value. Everything – and here aesthetic vision knows no boundaries – must be correlated with the person, must become humanized. (KFP, 128)

Most of Bakhtin's essays are predicated on the presupposition that the human being is the axiological or value-laden center around which action in the real world and artistic vision are organized. The "I" and the "other" are the fundamental categories of value that make all action and aesthetic vision possible: "to live means to take an axiological stand in every moment of one's life" (AH, 187–8).

But Bakhtin's goal was not to create an axiological system, to systematize a list of values into a hierarchy of dominant and subordinate values. An architectonics of the real world could not, in his view, be based on such a hierarchical system built upon an analytical foundation. Rather, it must be built around a real concrete human center, the human being who is oriented by and within spatial, temporal, and axiological categories. Bakhtin was careful especially to stipulate that the relationships established between persons and the world are not necessarily based on a traditional hierarchy. "It is impossible to substitute axiological architectonics with a system of logical relations (subordination) of values" (KFP, 129).

The unit that builds the architectonic structure of the actual world is the event. The event of being as an architectonic structure is given in a concrete, individual person. In Bakhtin's work, the event implied a deep "universal understanding of dialogue as the decisive event of human relations."[3] But just what did Bakhtin mean by this word?

In his *Introduction to Philosophy*, NeoKantian Wilhelm Windelband had described the event as a philosophical category. Though Bakhtin did not explicitly note Windelband's work (he seldom noted his sources at all), this text offers a clear description of the event that is relevant to an understanding of Bakhtin's work.

"The event," wrote Windelband, "absolutely implies this element of time, that one [moment or aspect of experience] is real after the other and that the series is not interchangeable."[4] The nature of an event changes, depending upon whether it occurs in the external world or in one's inner world. In the external world, every event in space implies movement and spatial change of the

position of bodies; whereas in the inner world and in the psychic event, there is no such continuity.

> The successive acts of consciousness, of which the individual experience consists, are discrete or discontinuous elements. . . . As we pass from image to image, thought to thought, motive to motive, in our inner experience, these various elements are definitely separated from each other.[5]

Time perception is also discontinuous. Hearing noises, seeing moving images, the alternation of hearing and seeing, seeing and touching take place without discernible time intervals. Thus, for Windelband, the succession of time alone cannot define an event. To account for how seemingly disconnected aspects of experience can come together and constitute a single event (his example is a train whistle that sounds simultaneously with a word spoken in the house), Windelband distinguished between an immanent and trans-gredient event. An immanent event may be psychic or in the body, and is characterized by the fact that "one presentation or emotion follows another in definite succession" within *one* subject.[6] A trans-gredient event may also be psychological or physical, but takes place between two bodies, two persons. In sum, an event implies the necessity of a clear and invariable succession of both spatial and temporal conditions.

In Bakhtin's writing, both life and art have the character of an event as Windelband has described it. Bakhtin, however, differentiated between the "event of being" and the "aesthetic event." In life, "the event of being is a phenomenological concept, for being presents itself to living consciousness as an event, and a living consciousness actively orients itself and lives in it as an event" (AH, 188). This does not mean that there is just one singular unified event. Rather, there are as many different worlds of the event as there are individual, uniquely responsible subjects. Bakhtin's use of the concept emphasizes the transitional and transitory "eventness" of life.

> The very moment of transition, of movement from the past and the present into the future, constitutes a moment in me that has the character purely of an event, where I, from within myself, participate in the unitary and unique event of being. It is in this moment that the issue of the event, the "either/or" of the event, is perilously and absolutely unpredetermined. . . . It is a moment of fundamental and essential dissonance, inasmuch as what-is and what-ought-to-be, what-is-given and what-is-im-

posed-as-a-task, are incapable of being rhythmically bound within me myself from within myself. (AH, 118)

Within life only death consummates or brings to an end the on-going event of life. This sense of the event *of* life is to be contrasted with the idea of events *in* life.

ARCHITECTONICS OF AESTHETIC VISION

In art, the author is the individual who performs aesthetic acts and finalizes, or tries to finalize, what is incomplete. But, like Windel-band's transgredient event, every aesthetic event requires two consciousnesses, two unified and unique participants:

Sobytie (event) and its adjective *sobytiinyi* (full of event potential) are crucial terms in Bakhtin. At their root lies the Russian word for "existence" or "being" (*bytie*), and – although the etymology here can be disputed – *so-bytie* can be read both in its ordinary meaning of "event," and in a more literal rendering as "co-existing, co-being, shared existence or being with another." An event can occur only among interacting consciousnesses; there can be no isolated or solipsistic events.[7]

For Bakhtin, this pair of participants might be God and a person, the self and an other, or the author and hero in a given work of art. If the two coincide, or if they are antagonists, the aesthetic event ends and an ethical event begins. This is the case in genres such as the polemical tract, invective, confession, and manifesto. When there is no hero, then the event is purely cognitive, for example, in treatises, articles, or lectures. And when the other consciousness is that of God, we have a religious event, for example, prayer, worship, or ritual. Although he never explicitly announced such a list, Bakhtin effectively distinguished four types of events: aesthetic, ethical, cognitive, and religious.[8]

Aesthetic value and the architectonics of the aesthetic object, like architectonics *in* the world, are constituted and organized around a given human being. The human being is the most important category of aesthetic analysis. Certainly there are other criteria for examining, formulating, and evaluating aesthetic vision, but these are subordinated to the "supreme axiological center of contemplation – the person" (KFP, 130).

A work of art, like the world in which it takes place, has the character of an event. The aesthetic event encompasses elements of

all the others because the aesthetic is the most fundamental and embracing of all the spheres of human experience. Bakhtin asserted repeatedly that outsideness is what gives meaning to an aesthetic event, for it is only from the outside that the event can be completed, consummated, finalized. But whereas an aesthetic event may be finalized, life cannot be finalized except in death. As we shall see, perhaps this is why he ultimately settled on unfinalizability as a fundamental idea in his writing.

Aesthetic vision is dependent upon the presence of a given human being. But, of course, a person can be viewed from a variety of perspectives other than the aesthetic, such as the biological, ethical, or historical. The same is true of any object. But if it is viewed from the standpoint of "human givenness," then this is aesthetic vision. Thus, we can have aesthetic contemplation of nature, or contemplation of a work of art without a hero, such as music, ornament, landscape painting, nature morte, architecture, and so on (AH, 227–8). Isaac Levitan's *The Birch Grove* (Figure 3) is a good example of a landscape painting without a particular hero, but one that implies and elicits aesthetic vision. Birch trees, such a potent symbol of Russia, seem to be brought to life by the play of light and dark. As the writer Anton Chekhov put it, Levitan seemed to capture "nature's smile."[9]

Figure 3 Isaac Levitan, *The Birch Grove*, 1885–9, oil on paper on canvas, State Tretyakov Gallery, Moscow.

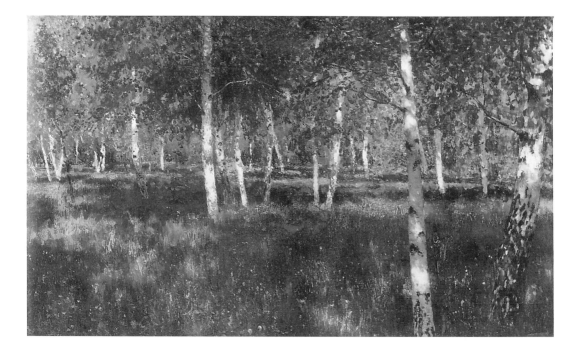

Every act of aesthetic seeing, which includes aesthetic creation, *must* include at least the potentiality of a hero. The hero was Bakhtin's name for the other consciousness that pervades a work of art. "In every aesthetic perception there slumbers, as it were, a determinate image of a human being, as in a block of marble for the sculptor" (AH, 228). There must be at least the sense of another consciousness, and in order to identify the author's axiological position, one must identify that other consciousness inherent in the object of vision.

Bakhtin was critical of attempts by other philosophers such as Bergson to separate aesthetic contemplation from thinking in and through experience.[10] "The world of aesthetic vision, received in abstraction from the real subject of visualizing, is not the real world . . ." (KFP, 92). For Bakhtin, it was not possible to enter into life from within purely aesthetic vision. The unique event of being, of living in the world moment to moment, cannot be understood from this perspective.

Aesthetic vision usually involves two steps. They are not necessarily chronological, but interpenetrate each other. There is a moment of "living-into" (*vzhivanie*) that which is being experienced (projecting oneself, experiencing empathy); then a moment of objectification (separating from what one felt, returning to oneself). As we shall see, Bakhtin's criticism of expressive aesthetics, with the concept of *Einfühlung,* empathy, was based on the fact that pure "living-into" or "live entering" is impossible, for this would mean that instead of two participants in the event of being, there would be only one.

Aesthetic vision cannot pretend to give a picture of a concrete, unified, and singular life in its eventness, but it can give knowledge of the "externally positioned subject of existence" (KFP, 95). Although such vision is closer to the real world than theoretism, it still does not show the fullness and richness of life, of life experienced as an event.

In life, we are seldom interested in or compelled by the whole person; usually, we react to some part. By contrast, an aesthetic reaction is always a reaction to the whole (a person, a hero); and this reaction to the whole person "consummates" that person as a "concrete, intuitable whole, but also a whole of meaning" (AH, 5).[11] In this way, an artist gives concrete shape and meaning to, and provides the architectonics of, the aesthetic event.

But compared to the architectonics of the real world, Bakhtin

thought aesthetic action to be more limited: "Aesthetic activity is special, objectivized participation. From within aesthetic architectonics there is no exit into the world of acting" (KFP, 136). Both the real architectonics of the experienced world of life, "the world of participating – acting consciousness," and the architectonics of aesthetic vision are structured by and around the singularity of every person, each self. Fundamentally, consciousness exists in an opposition: the opposition of the I and the other. And this opposition is the "highest architectonic principle of the real world of the deed" (KFP, 137).

THE DEED

Ultimately, however, neither aesthetic activity nor aesthetic intuition can "master" the open event of being, which is constituted by the act or deed. The world of culture (the already completed world of cultural artifacts) and the world of life (the world in which we create, in the present) are like a two-faced Janus: They each gaze in a different direction. One face looks into the "objective unity of the cultural sphere," whereas the other looks to the "unrepeatable unity of experienced life" (KFP, 83). There is no single plane where they can face each other and see each other. But this lack of confluence between culture and life is overcome in the act or deed, carried out with a kind of two-sided answerability.

Exactly what did Bakhtin mean by "deed"? Vadim Liapunov has provided excellent notes on both the etymology of the term and the valence of *postupok*, act or deed, and it is worth quoting his description of the term at some length:

Postupok (dictionaries usually define it as "an action intentionally performed by someone"): an action or act that I myself choose to perform, "my own individually answerable act or deed." This is Bakhtin's fundamental term throughout [his essay, "Toward a Philosophy of the Act"]; he uses the word in the singular, presumably in order to bring out the focus on its singularity or uniqueness, on its being *this* particular action and no other, performed (answerably or responsibly) by this particular individual at this particular time and in this particular place. Furthermore, focus is on the performing of the act or deed, or on the act or deed as it is being performed, in opposition to the consideration of the act *post factum* (the act that *has been* performed).

The word, as he further notes, etymologically denotes presentness

or eventness, because it means "a step taken" or "the taking of a step."

Bakhtin's own words express this quite eloquently: "For all my life in its entirety may be considered as some kind of complex deed," he wrote, "I am acting through all of my life, each separate act and experience is a moment of my life – a deed" (KFP, 83). Life itself is like a deed composed of many individual acts. Or, "I act through deed, word, thought, and feeling; I live, I come-to-be through my acts. . . . What is absent in a performed act is the feature of self-reflection on the part of the act-performing person" (AH, 138). The act-performing consciousness is instrumental; it does not ask existential questions such as "who am I? Rather, it asks evaluative questions such as "to what end?" "how?" "is it necessary or not?" (AH, 139).

In the creative act, we create ourselves. The artist's individuality is actualized in the created object; it is set as a task to be accomplished through the object. In this sense, a performed action, even a creative action, does not have a hero. "The performed act itself tell us nothing about the performer; it tells us only about the objective state of affairs in which it is performed" (AH, 140). And there is an ethical freedom in this act because its source and meaning lie in the future, in what does not yet exist. The consciousness that one has in performing an act, therefore, is object-directed, but it is not aesthetic.

Three qualities or pecularities of Bakhtin's concept may be noted.[12] First, in these early texts, the deed is always absolutely new, adding something unprecedented to a given person's world.[13] Second, the deed is by definition productive, because through our acts, human existence is created moment by moment. Third, every deed is inseparable from answerability and obligation. In other words, the morally responsible deed expresses the nonaccidental, nonarbitrary character of a given life.

Attempts can be made to abstract the act from the life in which we live and die, but these are alien to the truth of our historicity. My life and my individual, answerable, and historical acts are not part of the world of theoretical consciousness. As suggested in an earlier quotation, Bakhtin claimed that practical orientation within the theoretical world is impossible, because the self can neither live nor act in a theoretical universe. "The theoretical world is obtained in essential abstraction from the fact of my individual being . . ." (KFP, 88).

Neither the event of being nor the responsible deed can be described theoretically or abstractly. Language developed historically in the service of thought and the deed. According to Bakhtin, only in the nineteenth and twentieth centuries have philosophers and linguists tried to abstract it from the singular event of being in which the deed is performed. Consequently, we should not overestimate the power of language to describe the event of being and the act of participation in that event.

A phenomenological account could come closest to describing the deed and the being-event, but even this would give only a partial description. Every deed has the character of an event, and yet the fullness of an event is ineffable. We experience it in the moment of participating in it, but we cannot express it abstractly. "The answerable deed alone overcomes all hypotheticalness. Indeed, the answerable deed is the realization of a decision, already perpetual, irreparable, irrevocable. . . . In the deed is the only exit from possiblity into unity, once and for all" (KFP, 103). Nevertheless, we do try to use language to describe our experience.

A word designates an object, and as soon as it is uttered it takes on an intonation. That is, a word, like a deed, takes on an emotional-volitional tone. With this phrase, "emotional-volitional tone," Bakhtin meant "the moment of my activity in experience, the experience of experience as *mine*: *I* think, *I* act the thought" (KFP, 109). *Everything* is given in emotional-volitional tones, because each moment of an event is characterized by such tones. "To experience experience actively, to think thought, means not to be absolutely indifferent toward it [but] to assert its emotional-volitional form. Real acting-thinking is emotional-volitional thinking . . ." (KFP, 107). Bakhtin asserted here that thought, experience, and action all carry an emotional-volitional tone that is inseparable from both the content and the meaning of the event.

An emotional-volitional tone cannot be isolated outside of a particular context, for it expresses what is unique and unrepeatable in an event. Emotional-volitional tone is not a passive psychological reaction, but a morally responsible movement of consciousness. It permeates all experience, reflecting the unrepeatability of a given moment, and it is the root of answerability.

The world where the deed is performed is a sensory world, where objects and feelings are visible, audible, palpable, conceivable. This world is imbued with emotional-volitional tones that are value-laden, and they have axiological significance. This world is

given to me from my unique place as concrete and singular; that is, I perceive the world as situated around me, I am at the center. All my acts in the world issue forth from this place where I am situated. My place in the world, this center from which I act, is structured by space and time (spatial and temporal categories), and by value and meaning (axiological categories) (KFP, 124–5).

The ambiguity of language, which can transcribe everything into theoretical and general terms, allows us to describe a deed, and life, as a unity. But such a description presupposes a unity of apperception and cognition, which a living acting consciousness does not know. The unity of an experiencing, responsible consciousness, and the deed that a person with that consciousness performs, simply cannot be adequately described theoretically.

OBLIGATION AND "OUGHTNESS"

In describing the nature of the deed, Bakhtin introduced the category of obligation, or more literally, "oughtness" (*dolzhestvovanie*). Obligation can never be theoretical. It always arises as a response to a singular event, not from a theoretical definition of truth. This category of obligation or "oughtness" is neither contained by, nor is it to be deduced from, theoretical definitions or conditions. It arises in the unity of an individual answerable life. There can be no valid talk about fixed obligation, or about predetermined moral and ethical norms, because oughtness arises in the deed, the performed act. "Oughtness is the original category of the performed act . . . it is a kind of purpose of consciousness, a structure which will be revealed to us phenomenologically" (KFP, 85).

To understand an object or another person means to understand my obligation in relation to that other; and this presupposes my own responsible participation in the event of being. If I would try to live only in aesthetic vision, I would become my own double, like Golyadkin in Dostoevsky's *The Double*, forever talking to himself in the mirror (KFP, 95). Finally, the aesthetic world and aesthetic vision are but one moment in the event of being.

Bakhtin concluded that neither through theoretical cognition nor aesthetic intuition can one gain full comprehension of the event of being in all its richness and complexity. Even philosophy, which some people think capable of understanding the act in its wholeness, cannot define the answerable deed in the real world.

NeoKantianism in particular had obtained obvious heights, and was able to produce scientific methods such as positivism and pragmatism; but even this philosophy could not pretend to be able to teach about the singular event of being. To Bakhtin, the world of philosophy did not communicate with the world of the deed. Theory and theoreticized culture were separated from the singular event of life.

We see the concrete: real people and objects. Our relationships to them are not governed by abstract laws, but by real concrete obligation. My oughtness in relation to others arises as a function of my singular place in existence. "Not for one moment can I be apathetic in the perpetually-compelled singularity of life; I must have obligation" (KFP, 113). For, from this position I see, think about, know, and can forget, the other. Oughtness occurs where I recognize the fact of my unique individuality and accept responsibility for my existence. Of course, one can try to renounce one's singular place, thereby renouncing responsibility. But fully to exist in life, for Bakhtin, meant to act.

From this it should be clear that there are many individual centers of responsibility because there are many participating subjects in life, and there are many different "worlds of the event." My emotional-volitional picture of the world looks one way; for the other, it looks another way. "The point is that between the axiological pictures of the world of each participant there is not and must not be a contradiction . . ." (KFP, 116). The final truth of the event, for Bakhtin, lies in the fact that each participant occupies a singular position and from this position experiences and acts on his or her oughtness.

It is not an abstract obligation that obliges me, but my *signature* on an act, my signature that acts like a confession. I, as it were, sign my acts just as an artist signs a work of art. The source of the deed, and of obligation (oughtness) lies in that fact that *I am*, that I participate in being in my unique and unrepeatable form. "I occupy in singular existence a singular, unrepeatable, irreplacable and impermeable place [in relation to] the other" (KFP, 112). No other was or could be situated in my unique time and place. "That which can be accomplished by me, can be accomplished by no one else, ever" (KFP, 112). This singularity constitutes my "non-alibi in being." Recognition of my uniqueness and singularity, my non-alibi in being, is the real basis of my being and acting in the world.

Values such as truth, the good, or beauty are only possibilities until one acts. The world of such abstract values is

> infinite and self-sufficient; its power to signify makes me unnecessary, for in it my act is accidental. This is a realm of endless questions, where questions about who is my close friend are possible. Here it is impossible to start anything, every beginning will be arbitrary . . . [this world] does not have a center, it does not provide any principles for choice: everything that is could both be and not be, and could be differently. . . . (KFP, 114)

This is the world of nonincarnated thought, action, and arbitrary life, the world of empty possibility. This is the world of the *pretender*, of the person who tries to avoid the "non-alibi in being."

In trying to describe such a life, Bakhtin used the image of a sketch or a document without a signature. An existence where a person seeks to evade answerability is like a rough sketch or an unsigned document. "Only after answerable participation in the singular deed can one leave [these] endless rough variants and make a fair copy of one's life once and for all" (KFP, 115). This is certainly analogous to the process of a painter, who may make numerous variations of an image before committing her- or himself to one "fair copy."

Bakhtin also described the contrast between a "Nietzschean Dionysianism," which is skewed by its exhaltation of a one-sided participation in the event of being, and answerability. "We repeat," he said, "to live from oneself does not mean to live for oneself, but it means to be a responsible participant, to assert one's necessary non-alibi in being" (KFP, 119).

He also made a few comments about ritual, and a "moment of rituality" that can be introduced into the concretely real deed. I may participate in a political act or a religious rite, either in a way that renounces my personal responsibility, or if I act as a representative of some group, then in a way that empowers me. "The silent prerequisite of the ritualism of life appears not as humility, but as pride" (KFP, 121). If we attempt to understand the entirety of our lives as ritualistic, as representative acts that hide some real motives or meanings, then we become pretenders, that is, we give up the non-alibi in being that results from our singularity.

SPIRIT AND SOUL

Thus, Bakhtin set forth his basic rationale for I-other relationships, grounded in the answerable deed. But this relationship between

the self and any other does not take place in a vacuum. *Postupok*, the human act or deed, rather than the word, is the paradigmatic act of authoring the self and the other, and is an analogy to divine authoring.[14] The architectonics of the deed has three moments or aspects: I-for-myself, another-for-me, and I-for-another (KFP, 122). If I consider my singular place alone, I am an "I-for-myself." All others are "others-for-me." With the phrase "another-for-me," he indicated that we always see and know others only in relation to ourselves, never as that person would know her- or himself. Each person is an axiological center; there is no person in general, as homo sapiens. "There is no person in general, there is me; there is a definite concrete other: my close friend, my contemporary (social humanity), the past and future of real people (of real historical humanity)" (KFP, 117). If I consider myself in an answerable relation with another, I am "I-for-another." An event, as a living, concrete graphically unified whole perceived by a person, may be oriented toward one of these moments. They do not necessarily occur chronologically. The following discussion focuses on "I-for-myself" and "I-for-another," because these are the categories Bakhtin most clearly described.

Bakhtin gave special names to two of these three moments that constitute the deed. For describing the complex relationship of self and other, Bakhtin used the religious categories of *dukh*, the spirit or "I-for-myself," and *dusha,* the soul or "I-for-another." *Dukh* and *dusha* are simultaneously technical terms for arranging people in space, and ways of describing how one's inner and outer selves are expressed in artistic creativity.

I experience the inner life of another as his soul. Within myself I live in the spirit. The soul is an image of the totality of everything that has been actually experienced, of everything that is present on hand in the soul in the dimension of time. The spirit is the totality of everything that has the validity of meaning, a totality of all the forms of my life's directedness from within itself, of all my acts of proceeding from within myself. . . .[15]

The inner self is the artist's spirit; the outer self seen and described by others is the soul. We only know the spirit from within, that is, we can never know another's spirit.

Dukh, spirit or "I-for-myself," means the general compulsion to understand, or the drive to meaning shared by all human beings. Spirit is my inner life and inner self as I experience it, eternally unfinished and open to change. This inner self "always knows that

whatever it does is provisional; any act could, and should, have been better and different."[16] It is extra-aesthetic; "it is set as a task, it is yet-to-be" (AH, 111). Spirit cannot be the bearer of rhythm, by which Bakhtin meant that spirit alone cannot aesthetically embody inner life.

But acknowledging that each person is an "I-for-myself," living from a singular place in existence does not mean that one lives only *for* oneself. To live from oneself means to be a responsible participant in life, to assert one's compulsory non-alibi in being. In a strikingly unusual and unique military metaphor, Bakhtin called the "I-for-myself" the "center of emanation of the deed . . . an energetic headquarters of the commander-in-chief" of one's possibility and obligation in the event of being (KFP, 127).

This person from whom the singular deed emanates does not exist in an emotional and volitional void. Love is essential:

[O]nly love can consolidate this much diversity . . . only lovingly interested attention can develop strength to embrace the concrete diversity of existence without impoverishing and schematizing it . . . only love can be aesthetically productive; only in correlation with the beloved is the fullness of multiplicity possible. (KFP, 130)

But whereas Bakhtin's comments about the spirit were sparse, he gave considerable attention to the soul.

Dusha, soul, means the feature of each particular person that serves to situate him or her in a particular place in existence not occupied by anyone else (SG, 129). Soul, "I-for-another," is shaped in me and given final form by another, in love.[17] One can create an image of the opposition of the endless world and the small individual, but this opposition can only hold if I am abstracted from my singular place. The world (the outer body and thus the environment) is a gift bestowed on the hero by another consciousness (for example, the artist or viewer). This same relation pertains to the inner person, the soul, which emerges in time. Whereas the outer body emerges and exists in space, the inner body emerges and exists in time.

"The soul is the spirit the way it looks *from outside*, in the other" (AH, 100). The problem of the soul, therefore, is a problem in aesthetics, rather than in psychology, ethics, metaphysics, or religion, precisely because it involves self-other relations. "It concerns that individual and valuational whole of inner life proceeding in time which we experience in the other, and which is described and

imaged in art with words, colors, and sounds . . ." (AH, 100–1). But the soul is not a function of the self.

> From within myself, the soul does not exist for me as an axiological whole that is given or already present-on-hand in me. . . . The soul descends upon me – like grace upon the sinner, like a gift that is unmerited and unexpected. . . . the soul may be saved and preserved, but not through my own powers. (AH, 101)

Because this outer self is the only self others can see, it is to some extent closed, finalized, and identified through completed deeds.[18] The soul is given or bestowed by the aesthetic act of another person:

> The phrase "my soul" must therefore be seen as a sort of paradox or oxymoron, because soul results from a complex process in which others finalize me and I incorporate their finalization of me. That is why my soul is simultaneously "social" and "individual." My soul is a moment of my inner, open-ended, task-oriented self (my spirit) that some other consciousness has temporarily stabilized, embodied, enclosed in boundaries, and returned to me "as a gift" (dar).[19]

Yet both of these "I's" – the spirit and the soul – are socially constituted, because both evolve *in relation* to another consciousness.

Bakhtin's major concern with the soul was *how* this category of the soul is formed, ordered, and organized. For Bakhtin, the existence of the other person is what allows an individual spirit to become a soul in relation, perceived by the other as alive and beautiful.

> The soul is spirit-that-has-not-yet-actualized-itself as it is reflected in the loving consciousness of another, another human being, God. It is that which I myself can do nothing with, that in which I am passive or receptive. From within itself, the soul can only be ashamed of itself. From without it can be beautiful and naive. (AH, 111)

What then are the organizing principles for the soul in artistic vision? Just as the spatial form of a body is developed by the surplus of another's seeing (an idea that will be developed shortly), so the soul is formed through interaction with the other. Thus "the soul is actively produced and positively shaped and consummated only in the category of the other . . . the soul is a gift that my spirit bestows upon the other" (AH, 132).

"In art the world is not the *horizon* of an act-performing spirit, but the *environment* of a departed or departing soul" (AH, 132). The world is to the soul as the world's visual image is to the body: It encompasses, surrounds the soul. The actual world (in contrast to the yet-to-be future world) "is an already uttered, already pronounced meaning of the event of being." It is a word that has already been uttered, and sounds hopeless because it seems that "all of it is here, and there is nothing else" (AH, 133).

But such a vision of the world fails to take account of the ways in which the world is not yet achieved or fulfilled. There is a sense in which the world is in a state of always becoming, and as seen from within, this unfinished horizon forever draws one forward. Only when we look at the life (or soul) of another is there the possibility that the world can be completed, finalized, consummated. With reference to the other, the world becomes specific. It is a *particular* world, just as the other is determined in part by her *particular* history, his *particular* culture, her *particular* world view. "The world" does not have meaning as a generality; the unique other endows it with meaning and value. The soul, the world, and rhythm ("the aesthetic embodiment of inner life") cannot be forms of self-expression ("the expression of myself and what is mine"); they evolve only in relation to the other person and her or his self-expression (AH, 134).[20] What this means in relation to the visual arts will become clearer when I discuss the problems of representing the self in the next chapter.

Both the outer body and a person's inner life are subject to form. The soul, Bakhtin's name for the inner body, is given form both in self-consciousness and in the consciousness of the other; it may be shaped in my own inner life, or in the other's inner life. A person's outer form, the body, is expressed through spatial form, whereas the inner body, the soul, is expressed through temporal form. Both develop through the excess, the surplus of the other's perception, what is transgredient to my own perception and experience. Spatial and temporal boundaries, as we shall see, are important to this process, because life is defined by birth and death.

RHYTHM AND INTONATION

Bakhtin developed his definition of rhythm in trying to understand how the inner life could be shaped aesthetically to form a soul.

To be able to experience my own acts of experiencing, I have to make them into a special object of my own self-activity. . . . I have to detach myself from those objects, goals, and values to which my living experience was directed and which gave it meaning. . . . I must become another in relation to myself. (AH, 113)

But, my own experiencing is not and cannot be present for me without a "point of support" *outside* the context of my life. Bakhtin acknowledged that we can engage in moral reflection, in epistemological reflection, in psychological analysis; but none of these allows for the creation of an aesthetic whole, for understanding a life aesthetically. None of them provides a way to experience oneself directly.

Rhythm was Bakhtin's way of naming the way a particular lived experience or an inner situation could be ordered in time.

Rhythm is the axiological ordering of what is inwardly given or present-on-hand. Rhythm . . . does not express a lived experience . . . it is not an emotional-volitional reaction to an object and to meaning, but a reaction *to* that reaction. Rhythm is objectless in the sense that it has to do with the reaction to an object, with the experience of an object, and not directly with an object. (AH, 117)

Rhythm is the way an utterance or work of art is ordered. It is not object-related, but names any temporal ordering that returns the creator to that person's own "acting, generating unity" (CMF, 310).

An interesting comparison may be made between Bakhtin's interpretation of rhythm, which focused on the ordering of experience, and that of Alois Riegl. Riegl had adapted key ideas about rhythm from the Arts and Crafts movement, and probably from the Art Nouveau style that was especially vital in Austria during 1889–99. But he used the category as a means of describing flatness. "Rhythm . . . is necessarily bound to the plane. There is a rhythm of elements next to each other and above each other, but not behind each other. . . . Consequently, an art which wishes to present entities in rhythmic composition is forced to compose in the plane and avoid deep space."[21] He further differentiated between coloristic rhythm and linear rhythm, but what is significant here is that Bakhtin interpreted rhythm as an axiological category, whereas Riegl emphasized more formal qualities.

According to Bakhtin, the creative act itself, which consists of experience, striving, and action, takes place outside of rhythm. The

artist's free will and self-activity are not compatible with rhythm, whereas that which is created is unfree and passive, and thus definable in terms of rhythm. "Rhythm is possible as a form of relating to the other, but it is impossible as a form of relating to myself. . . . Rhythm is an embrace and a kiss bestowed upon the axiologically consolidated or 'bodied' time of another's mortal life" (AH, 120). Rhythm requires two souls (a soul and a spirit), two consciousnesses, one of whom shapes while the other is shaped.

However, it is possible – in communal life, an established order, an institution, a nation, or a state – to become alienated from the self, and to live in and for the other. Then one literally "submits" to the "sway of rhythm"; one participates in the rhythm of the group, just as in a chorus (AH, 121).

But whereas rhythm cannot be a reaction to an object, intonation is the reaction of the hero to an object within the created whole. An author "intonates" a hero by having that person pronounce, perform, sing, play, or recite with a particular intonation (AH, 4). Through intonation, a word – or in the visual arts an image – expresses the diversity of the speaker's or artist's attitudes toward the content of that word or image. Intonation is axiological insofar as it expresses values and feelings.

The emotional-volitional tone of a word or an utterance is carried by linguistic devices such as simile, metaphor, repetition, parallelisms, and the use of questions (CMF, 312). In the visual arts, it may be carried by color or line, as in the earlier example of Kandinsky's *Small Pleasures* (Figure 1). In *Concerning the Spiritual in Art*, first published in 1914, Kandinsky explored in considerable detail the way color and form produced their effects in his painting.

A yellow triangle, a blue circle, a green square, or a green triangle, a yellow circle, a blue square – all these are different and have different spiritual values. It is evident that many colors are hampered and even nullified in effect by many forms. . . . Since colors and forms are well-nigh innumerable, their combination and their influences are likewise unending. The material is inexhaustible.[22]

Kandinsky used the language of color and form to talk about what Bakhtin called emotional-volitional tone and rhythm. Both writers were interested in the relationship of outer aesthetic structures to inner spiritual meaning.

At the beginning of this chapter, I suggested that the intricate interconnectedness of art and life in Bakhtin's early essays moves his writing away from aesthetics or theories of poetics and toward moral philosophy. In particular, because of its narrow implications, its usual focus on epic, lyric, or tragedy in literary analysis, poetics is insufficient for describing his work. Caryl Emerson and Gary Saul Morson have suggested that the term "prosaics" is more appropriate than poetics to describe his approach to architectonics. Prosaics implies a way of thinking that: (a) focuses on the ordinary, messy, quotidian facts of daily life; and (b) stresses the novel and other forms of artistic prose.[23] The basic assumption underlying Bakhtin's work is that the natural state of the world is *mess*. Order is not given, it is posited; that is, it is set as a task to be accomplished through work and especially through creativity activity. This means that moral decisions are not made by following rules, although rules do have a pedagogic function. Rather, moral decisions are made through the hard work and choices that grow out of experiences in everyday life. In this sense, "ethics is a matter of prosaics, and great prose develops our ethical sense."[24]

Analogously, one could say that, insofar as it wrestles with ordinary, messy, quotidian facts of daily life, "great" visual art is "prosaic" and can help to develop our ethical sense. This, however, does not mean that in order to have an impact in the world (that is, to be great) art must always be prosaic in the sense that Emerson and Morson have defined it. Think, for instance, of Mark Rothko's abstract paintings (Figure 4). Having been ably interpreted by Anna C. Chave and others in relation to landscape and portrait traditions, as well as to the conventions of sacred art, his paintings still have an ineffable and mysterious quality that defies clear definition.[25] The relative greatness of Rothko's paintings may lie more in what is *not* clearly definable in prosaic terms, but rather in their ability to push the viewer toward contemplation of the great mysteries of life and death, birth and suffering. The value of Bakhtin's articulation of answerability or responsibility is his insistence on the link of art to life. Even abstract art such as Mark Rothko's color field paintings can move the viewer to see art in relation to lived experience.

Based in the idea that we do not exist alone, as an isolated con-

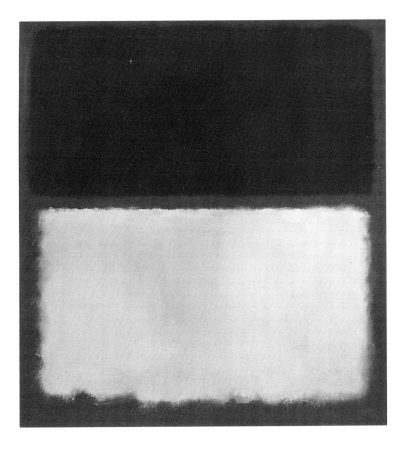

Figure 4 Mark Rothko, *Black, Orange on Maroon (#18)*, 1963, mixed media on canvas, Solomon R. Guggenheim Museum, New York, gift of the Mark Rothko Foundation, Inc., 1986, photograph by David Heald.

sciousness, Bakhtin argued for a concrete pragmatic ethic founded in specific everyday situations rather than in theoretical rules. His ethic emphasized the profound answerability and obligation we bear toward others. Although he did not state it clearly, Bakhtin implied that answerability and obligation toward others compel the artist to consider moral and ethical issues in the creative act. Yet, as I shall argue later, such a sense of individual answerability must be balanced by a commitment to communal and collective solidarity with those who are different from us.

What does the concept of answerability offer to art theorists and historians? It offers a way of articulating the profound moral obligation and responsibility that we bear toward others. As Bakhtin insisted, this was not just a general ethical rule, but rather an implicit and integral part of the creative process. Answerablity contains the moral imperative that artists engage with and in life, that the artist and the work of art answer life. Especially in the current critical climate where discussions are underway regarding social responsi-

bility, theorists and historians might use this term as a key to evaluating both historical and contemporary work.

But as this chapter demonstrates, Bakhtin also offered a complex vocabulary for interpreting answerability. The event, living into, the act or deed, non-alibi in being versus the pretender, spirit and soul, rhythm and intonation: All of these suggest questions for the analysis of cultural artifacts.

With the concept of the aesthetic event, Bakhtin introduced a potentially fruitful way of reconceptualizing the work of art. The "event" brings attention to the "eventness" of art, to the fact that any artifact exists in a clear and invariable succession of temporal and spatial conditions involving both the artist and viewer. Such a concept would challenge more static ways of conceiving the creator-object-viewer-context relationship. The nature of the aesthetic event and aesthetic vision is further elucidated with the idea of "living-into." When we encounter a work of art, we often project ourselves into the work. The concept of empathy that Bakhtin so roundly criticized names this process. We live ourselves into a work in order to feel its impact. Leon Golub's paintings of Central American mercenaries or Sue Coe's drawings depicting social injustices or Luis Cruz Azaceta's Aids series (Figure 27) are all examples of art that have tremendous impact at this level. But if our response, as viewers or critics, simply stops here in the experience of empathy, we are effectively disempowered, for the ability to act in the world depends upon separation and what Bakhtin called the "moment of separation," when we return to reexperience our own unique position. If visual art is ever to have social or political efficacy, the critic or viewer must practice this kind of living-into *and* separation.

Perhaps the most obviously applicable of Bakhtin's ideas listed before is the act or deed. The astute historian or critic might consider not only the ways in which the work of art functions as a deed in the world, but also how the practice of art history itself is a complex deed. Toward what is it oriented? To what or whom is it obligated and answerable? Do the artist and art historian fully claim his or her "non-alibi in being," that person's unique and singular basis of being and acting in the world? Is he or she guilty of being a "pretender," trying to create an alibi and thereby avoid the non-alibi in being? My own biography does not really have a place in this book on Bakhtin and the visual arts, but I simply note that I constantly experience my own non-alibi in being as I read

Bakhtin, reflect about his ideas, and write this book. My long love affair with Russian culture, especially its art and philosophy, has impelled me along this difficult, though not treacherous, way. My present involvement with contemporary Russian artists in Siberia gives the ideas developed here special poignance.

The spirit-soul distinction that Bakhtin developed, though it may not be readily accessible to secular scholars, represents an intriguing distinction. In what ways does a work express a relationship of the "I-for-myself" (spirit) and the "I-for-another" (soul)? Is a particular work oriented by and toward the self, or does it imply and invoke another consciousness? As we shall see, Bakhtin's critique of expressive aesthetics and, we might also infer, expressionist art, was based on the lack of that other consciousness. For scholars more comfortable with the religious overtones of the language of spirit and soul and who would therefore want to use them in analyzing works of art, the words indicate the difference between the consciousness of the creator or artist (spirit) and the self or image created *by* the artist (soul). But an artist cannot form or organize her or his own soul; this requires another person. Thus, the terms might be used for analyzing the way self-other relations are structured in a given work of art.

Although they function in different ways, the categories of rhythm and intonation further specify the aesthetic event. Typically, we speak of rhythm in analyzing visual images as an ancillary to pattern and repetition, as Riegl did. Bakhtin's use of the term adds another dimension, that of time; rhythm may be useful for describing the temporal ordering of a work of art. Rhythm itself is objectless, but it has to do with the *experience* of an object. The term intonation is related not only to music, but it also offers a way of describing the emotional-volitional tone of an image. When I first encountered the phrase "emotional-volitional" (a direct translation of the Russian *emotsional'no-volevoi*), it seemed an excessively abstract and vague notion. However, I have come to understand it as a nuanced way of expressing the way feelings and values are interrelated in a given work. One might well compare, for instance, the emotional-volitional tone in the landscapes of the Hudson River School, the Barbizon painters, and the Russian Wanderers (*Peredvizhniki*).

Although *Bakhtin and the Visual Arts* will take its place in libraries and on the bookshelves of scholars interested in Bakhtin, I hope its larger agenda will have a more dynamic life. I fervently believe that

art practice and art theory must be answerable to life. If it is not, a work of art remains a rough sketch, one of the endless rough variants that artists produce. To the extent that art historians and critics do not understand their own deeds in the world, their work, too, will suffer the same fate.

OUTSIDENESS

If answerability should be the fundamental goal of aesthetic activity, then outsideness, *vnenakhodimost'*, is what makes that goal possible. As I have already emphasized, the embodied nature of Bakhtin's aesthetics makes his formulations unique, and nowhere is his focus on the body and bodily experience more vivid than in his discussions of outsideness.

In order to achieve a proper understanding of this concept, we need to consider further his phenomenology of self-other relations, particularly the nature of authorship and author-hero relations, and the interrelationships of bodies in space. For, as he repeated many times, aesthetics should be grounded in the concrete relationship of the I and the other.

AUTHORSHIP

Authorship or creative activity is not the special province of a cultural elite. It is an everyday, prosaic activity: "we author others at each encounter with them, and are in turn 'authored' by those who interact with us."[1] We cannot author ourselves, because we cannot see the whole of ourselves. From within the self, there is always the possibility of and openness to change. This means that no stable or authoritative definition of the self is possible. For this we need the other, and the other needs us. Bakhtin held to this understanding of the centrality of the other as constitutive of the self throughout his life:

Everything that pertains to me enters my consciousness, beginning with my name, from the external world through the mouths of others (my mother and so forth). . . . I realize myself initially through others: from

them I receive words, forms, and tonalities for the formation of my initial idea of myself. . . . Just as the body is formed initially in the mother's womb (body), a person's consciousness awakens wrapped in another's consciousness. (SG, 138)

Creativity, in Bakhtin's thinking, is an everyday prosaic and ethical activity, but it is exemplified in the work of the author or artist. The artist's task is not to respond to other literary or artistic schools, languages, or to manipulate devices. Rather, the artist's or author's task is godlike, "to find a fundamental approach to life from without," to define others in ways they cannot do for themselves (AH, 191). In a creative act, the artist's individuality is not given, but rather is set as a task to be accomplished through the work.

Whereas in "Toward a Philosophy of the Act" Bakhtin used the categories of spirit and soul to describe self-other relations, in "Author and Hero" he introduced the names of author and hero. The case of an artist creating – what Bakhtin treated as the relation of the author to the heroes – is a special exemplary case of the more general relationship of self and other. He treated the relationship of author and hero as analogous to an "I" and any "other," including God.

Just what do the categories of author and hero mean? The author is the category of acting, the subject who acts. The author's consciousness is the consciousness of a created consciousness, that is, a consciousness that encompasses the world of the other, the hero. The author orients the hero in the open ethical event of life. The hero is that of which the author speaks, the living object of discourse.

How is the activity of the artist or author possible? Because the author has a unique position of outsideness to what has been created.[2] The artist never begins to create with only formal aesthetic elements. "The work of art is regulated by two systems of laws: the hero's and the author's, i.e., the laws of content and the laws of form" (AH, 198). In other words, the content of an artwork is determined by the nature of the hero portrayed. The form is determined by the author. For example, Bakhtin described the possible relationships between author(s) and hero(s) in literature and art by a set of abstract ideal forms.[3] These forms are bounded on one end by confessional self-accounting (including prayer), where there is no hero; on the other by lives of the saints, where there is effectively no author. In a given work, the relationship of author and hero will vary: The two may contend, approach, join, or dis-

sociate with each other. According to Bakhtin, the form of the artwork is decided by the author, but the actual content of the work is determined by the nature of hero.

An artist cannot just "think up" a hero; such a hero would be unconvincing. "We must be able to feel in a work the reality of being *qua* event . . ." (AH, 200). This gives artistic verisimilitude. We must feel another consciousness besides our own creative or cocreative consciousness, feel its forms, its salvific power, its axiological weight and beauty. In an artistic event, there are two participants: one passively real (the hero), the other active (the author/contemplator). In his early manuscripts, Bakhtin did not differentiate between the creator and contemplator of an artwork, because both are able to encompass the meaning of the whole work in temporal terms. "[F]or the author-contemplator always encompasses the whole temporally, that is, he is always *later,* and not just temporally later, but later *in meaning*" (AH, 118). Even in works such as music where there is no object, "we can feel the resistance, the persistent presence of a possible consciousness, a lived-life consciousness, a consciousness incapable of being consummated from within itself . . ." (AH, 201).

Finally, however, the creator is returned to the unity of her or his own subjectivity and creativity. This is the unity "of the embrace of the object and event. So, the beginning and end of the work, from the point of view of the unity of form, is the beginning and end of activity. I am beginning and I am ending" (PS, 82). Aesthetic activity creates subjects and subjectivity: "the acting soul and body of the acting, whole person." But this activity and this person are not self-sufficient; they turn outward, toward the other, in the activity of "loving, elevating, humiliating, celebrating, mourning" (PS, 83).

Obviously, Bakhtin was not alone in his interpretation of the self as a fully embodied self. His writing at points seems especially close to the way Ludwig Feuerbach described human experience.

The identity of subject and object, which in self-consciousness is only an abstract idea, is truth and reality only in man's sensuous perception of man. We feel not only stones and lumber, flesh and bones; we also feel feelings, in that we press the hand or lips of a feeling being; we hear through our ears not only the rustle of water and the whisper of leaves, but also the soulful voice of love and wisdom. . . .[4]

Thus, the boundary between life and art is very thin. The "I"

is a "threshold concept, a boundary phenomenon" in Bakhtin where the aesthetic and ethical realms meet.[5] Self and society interact in life as in art. They are separable and irreducible, but their reaction and interaction are mutually determinative. In Bakhtin's theory of art, "patterns of ethical-aesthetic interaction shape the inner form of the artwork itself."[6]

The artistic task is to organize the parts: the spatial world with the body as its axiological center; the temporal world with the soul as its center; and the world of meaning. All of these must be organized in their interpenetrating unity. It is, therefore, to Bakhtin's understanding of the body and embodiment that we now turn.

THE BODY

One's own body, according to Bakhtin, is always an inner body, whereas the other's body is always an outer body. The inner body corresponds to the spirit, the outer body, to the soul. "I cannot react to my own outward body in an unmediated way: All of the immediate emotional-volitional tones that are associated for me with my body relate to inner states and possibilities, such as suffering, pleasure, passion, gratification, and so forth" (AH, 47). And one cannot love another human being in this same way, because there is no access to inner states and inner feeling.

For the self, everything associated with the body is mediated by *inner* states: suffering, pleasure, passion, gratification, and so on. I cannot react to my outer body in any other way. But feelings about the other are profoundly different from feelings about the self.

My suffering, my fear for myself, my joy are profoundly different from my compassion or suffering with the other, rejoicing with the other and fearing for the other. Whence the difference in principle in the way these feelings are ethically qualified. The egoist acts as if he loved himself. But in reality he experiences nothing that resembles love or tenderness for himself. The point is precisely that he does not know these feelings at all. Self preservation is an emotional-volitional attitiude that is cold and cruel; it is utterly devoid of any loving and cherishing elements, any aesthetic elements whatsoever. (AH, 48)

Only love that comes from outside the person throughout life can "give body" and shape to the inner body. The outer body, in contrast, "is unified and shaped by cognitive, ethical, and aesthetic

categories, and by the sum total of external, visual, and tangible features that make up the plastic and pictorial values in it" (AH, 51). In particular, the recognition and form-giving activity of the mother is crucial.

The mother's actions, words, and lips bestow meaning and value, and these, of course, come from outside. The mother seems to be *the* formative power in Bakhtin's writing. The value of the outer body has been "sculpted" by others, first of all, by the mother. Identity itself is given from her lips, her voice, her touch. The child's personality is demarcated by and built upon the mother's love, and the child begins to identify its own body by the language and care of the mother. Clearly, the body of the self is not self-sufficient.

Through words of love and acts of genuine concern, one becomes aware of oneself as something other than "the dark chaos of my inner sensation of myself" (AH, 50). This absolute need for the (m)other, who quite literally gives form to a person axiologically, shatters any illusion of self-sufficiency that a person may have. Sexuality is also important, but secondary. In sexual experience, the outer body of the other and one's own inner body merge into an "inner flesh."

"Every aspect of this outer body (the body enclosing the inner body) performs . . . a double function: an 'expressive' function and an 'impressive' function" (AH, 61). The outer body *ex*presses the inner self, and it simultaneously *im*presses the other. In Bakhtin's view, this twofold attitude corresponds to the activity of the artist and viewer, where the artist is expressive and the viewer receives impressions.

SURPLUS OF SEEING

Bakhtin's phenomenology of self-other relations also includes considerable commentary on the nature of seeing, appearance, and representation that are especially relevant to the visual arts. When contemplating another, we see parts of the body, the environment, and so on, that the other cannot see.

This ever-present excess of my seeing, knowing and possessing in relation to any other human being is founded in the uniqueness and irreplaceability of my place in the world. For only I – the one-and-only I – can occupy

75

in a given set of circumstances this particular place at this particular time; all other human beings are situated outside me. (AH, 23)

Two persons looking at each other do not have the same horizon. Parts of the body (head, face, expression), the world behind the other's back, other objects and relations between objects are only accessible to me. The excess or surplus of seeing is a function of my uniqueness in space and time. Everyone and everything else is situated outside of the self. But this surplus also signals a deficiency, for the other person has the same ability to see more than I can of my own situation. Cognition can surmount this situation of surplus and deficiency – or so it would seem – by trying to construct a world in isolation from a particular individual or situation. But although this supposedly unitary world can be thought, it cannot actually be perceived. The *I-for-myself*, as my own lived experience and the *other-for-me*, as the lived experience of a particular other human being, thus interact. The surplus of seeing provides the foundation for all actions, inner and outer, that the self performs vis-à-vis the other person.

Given this situation, just how do we experience our own exterior? Although outward appearance is always transgredient to a person's consciousness, vision and inner body sensation (that is, perception) are important. "I am situated on the boundary . . . of the world I see" (AH, 28). In creative imagination, in erotic fantasies and dreams, we do not really see ourselves at all. We experience the self from within the self. An artist's first task is to give the "leading actor" (the consciousness in the artwork) an outward appearance or bodiliness. Or, in another similar articulation, an artist must seek to represent the self as "a hero among other heroes," as one person among others.

Both self-perception and artistic representation are possible because of the excess or surplus of seeing that is a function of the different horizons so crucial to Bakhtin's formulation of outsideness. He described this surplus of seeing with a metaphor: that it is a bud, which enfolds form. The form of a work of art unfolds from the surplus of seeing like a blossom from a bud.

REPRESENTING THE SELF

One of the most obvious ways to represent the self is through thinking, for it involves abstraction – abstracting oneself from one's

unique place in time and space – and placing oneself on the same plane with others. But ethical and aesthetic objectification are much more difficult.

One always experiences the self as fundamentally different from the way one experiences others in life and in imagination. We lack any approach to ourselves from outside the self. Although it is possible to attain some sense of the self this way, it always remains hollow. One can represent the self, but it requires a special effort; and an uncomfortable "doubling" may occur, a peculiar "emptiness," "ghostliness," or "solitariness" that indicates a self encountered in isolation from the world, inner feeling, and will (AH, 27).

In trying to resolve the question of self-representation, Bakhtin set up a hierarchy based on the relative adequacy of each of the following: self-perception in a mirror, representation in a self-portrait, a photograph by another, and a portrait painted by another. The first three, according to Bakhtin, fail to represent the self as a consummated whole. Let us see how he came to that conclusion.

Before a mirror, we see a reflection of our exterior, not ourselves. There are three aspects of relating to the mirror: A face can reflect (a) one's present attitude of feeling, desire, and will; (b) the evaluation of a possible other person; and (c) the reaction to this evaluation by another person, experienced as my pleasure or displeasure, my satisfaction or dissatisfaction. And there is a possible fourth reaction as well: attitudinizing. Posing, making faces that we think others will desire, "we evaluate our exterior not for ourselves, but for others through others" (AH, 33). All of these demonstrate that one is never really alone when looking in a mirror. A second person is always implicated; "a fictitious other" is present in self-contemplation.

An artist working on a self-portrait must therefore immediately begin with this process of imagining another; the expression of the reflected face must be purified. But in actuality, this is very difficult, and Bakhtin thought that one could almost always distinguish a self-portrait from a portrait by another. In a self-portrait, he said, there is a ghostly character in the face, because it can never encompass all of the person (AH, 34).

If, indeed, we can never see the entirety of ourselves, then Bakhtin is right: A self-portrait cannot be complete in the same way that a portrait by another can be. Although his point is theoretically clear, in actuality it is not so easy to discern differences between these two kinds of portraiture. Although he did not elaborate on

his remarks, Bakhtin briefly mentioned self-portraits by Rembrandt van Rijn (Figures 5 and 6) and Mikhail Vrubel (Figures 7 and 8). Rembrandt's many self-portraits are well-known, and hence I will not discuss them here.[7] But Vrubel presents a fascinating case for testing Bakhtin's statement.

In two portraits, done in 1885 and 1905, Vrubel has depicted himself in vividly different ways.[8] The early portrait is perhaps the most dramatic, showing a special intensity around the eyes. The planes or facets of this early sketch are typical of Vrubel's drawings: With them he shows both the expressive and architectonic structure of the face. The obvious lines become a way of indicating psychological intensity, and this is heightened by the strong light and dark contrasts.

The later portrait from 1905 was done during a period when Vrubel was quite ill, probably with syphilis. Here his upright posture, neat suit, high stiff collar, and unruffled hair all contribute to his careful disguise. A sense of vulnerability is suggested by his mouth, covered in both portraits by his heavy moustache. Where is Vrubel in his images? Are we to believe that either of these has adequately captured his experience, or even his momentary expression?

A photograph, Bakhtin also thought, offers a reflection without an author. Bakhtin considered a photograph to be more pure than

Figure 5 (bottom left) Rembrandt van Rijn, *Self-Portrait*, 1629, oil on panel, Isabella Stewart Gardner Museum, Boston, courtesy of Isabella Stewart Gardner Museum/ Art Resource, NY.

Figure 6 (bottom right) Rembrandt van Rijn, *Self-Portrait as an Old Man*, 1669, oil on canvas, National Gallery, London, Great Britain, courtesy Alinari/Art Resource, NY.

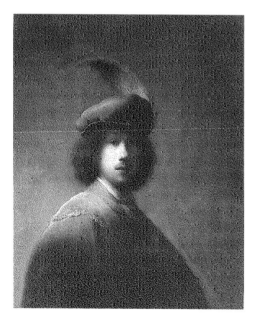

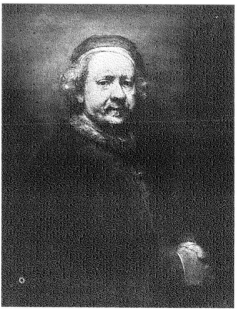

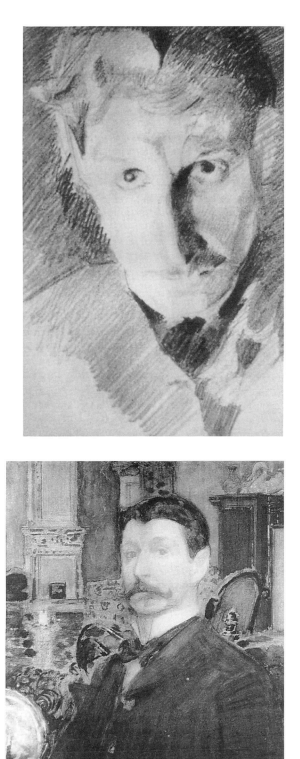

Figure 7 Mikhail Vrubel, *Self-Portrait*, 1885, pencil on paper, Museum of Russian Art, Kiev.

Figure 8 Mikhail Vrubel, *Self-Portrait*, 1905, charcoal and watercolor on paper, State Tretyakov Gallery, Moscow.

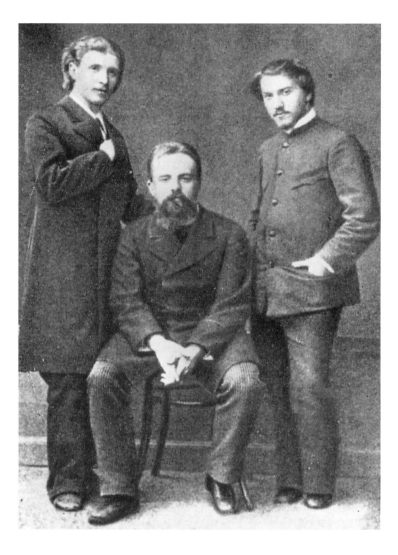

Figure 9 Photograph of Mik-
hail Vrubel, V. D. Derviz, V.
A. Serov, n.d., from Igor
Grabar, *Valentin Aleksandrovich
Serov, Zhizn' i tvorchestvo,
1865–1911*, p. 21.

a reflection in a mirror, but still not able to express "one's essential
emotional and volitional stance in the ongoing event of being"
(AH, 34). A photograph, then, is a form of raw material. Especially
in this context, it is interesting to compare Vrubel's self-portraits
to his photographic portrait with two friends (Figure 9). As the
figure on the left, Vrubel stands with one hand in his coat, in a
gesture that echoes Jacques Louis David's famous portrait of Na-
poleon in his study. Unlike his two friends who look directly at
the camera, Vrubel looks into the distance, as if in a reverie. It is
indeed difficult to imagine that this is the same man who has
painted the two self-portraits. Although the camera might be con-
sidered a more objective eye than the artist's own, the photograph

also contains a degree of attitudinizing that is similar to looking at one's own image in a mirror.

But if one's portrait is painted by an artist, Bakhtin thought that a different relationship could be established. For here, he said, is the other who can finalize me, who has a "window into a world in which I never live." The artist offers a form of "seeing as divination," a seeing that can shape and even predetermine the self (AH, 34). Only a portrait created by another can represent a consummated or finalized self. But even such a portrait has the distinct limitation that it cannot depict change – change in deportment, gait, vocal timbre, changing facial and body expression, changes in one's life over time, and in one's appearance. This is true of the visual arts in general, because they are not linear or sequential, but immediate. (The one obvious exception to this is film.) Bakhtin wrote that although a plastic/pictorial portrait is better than the mirror, self-portrait, or photograph at showing and offering the other's finalizing perspective, still, it is limited because it cannot demonstrate change through time as a verbal portrait given in a verbal text can (AH, 35).

Although he acknowledged the possibility of posing or attitudinizing, a lacuna in Bakhtin's consideration of various forms of portraiture, whether executed by the self or by another, is the idea that there is inevitably in any portrait an element of deception. Richard Brilliant has articulated this well:

On the whole, portrait artists eschew the representation of strong expressions of feeling because traditionally they are thought to reflect transitory states of being and are therefore an obstacle to the artist who seeks to capture the essential stability of the self, existing beneath the flux of emotions. In their own self-interest, portraitists also tend to avoid "unpleasant" expressions because of their negative connotations. . . . This sanitizing of facial expression . . . allows the successful portraitist to encase his subjects within the masks of convention.[9]

In this sense, every form of portraiture is actually a kind of mask making, creating a public image that may or may not be true to the person in everyday life.

We can see this process at work in Vrubel's portraits or in Alfred Stieglitz' many portrait photographs of Georgia O'Keeffe (Figures 10 and 11). Between 1918 and his death in 1946, Stieglitz made more than three hundred posed portraits of O'Keeffe, and he took over two hundred informal snapshots. From one perspective, these

might be seen as his attempt to finalize her, to fix her in a final form. But such attempts must always fail, because O'Keeffe, like any person, always exceeded the possibility of being represented in a final form. From another perspective, however, Stieglitz's portraits demonstrate very clearly the fact that identity itself is slippery and ambiguous. Personal identity, the body and appearance, the mind, even reputation: None of these can actually be fixed and finalized.[10]

Nevertheless, making portraits — whether self-portraits, photographs, or portraits made by another — is an attempt to challenge the transient nature of human life and to express the wish to endure, to be somehow immortal. As portraitists try to answer questions such as, "What do I (you, he, she, we, or they) look like?" "What am I like?" "Who am I?," they work with issues that are complex, contentious, and fragile.[11]

Yes, we then might say with Bakhtin, the self has an "absolute need for the other, for the other's seeing, remembering, gathering, and unifying self-activity — the only activity capable of producing his outwardly finished personality" (AH, 35–6). The outward personality is given shape by the other. Aesthetic memory — and aesthetic activity in general — is productive, because it gives birth to the outward human being. The complexity of this process is exemplified in the images by Vrubel and Stieglitz discussed earlier.

BOUNDARIES OF THE BODY, HORIZON, AND ENVIRONMENT

In delineating various approaches to the body in space, Bakhtin began to focus on boundaries. The boundary is, first of all, a line: a line that delineates the other's body against a background. And this line is imperceptible to oneself: I cannot see the line that delineates my body in space. "I am situated on the frontier of the horizon of my seeing; the visible world is disposed before me" (AH, 36). But I never can see the line that separates me from and within the world. Certainly, I can try to create this in a mental representation, but it will always be incomplete. In other words, I can see my horizon, but not my environment.

Horizon and environment are terms Bakhtin used for describing how we see the world. The horizon is the world as it appears from inside a person's consciousness. It is the sphere of one's "active,

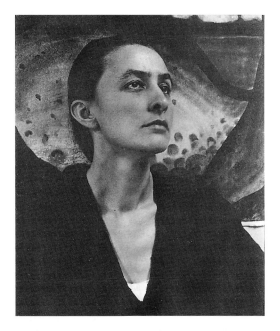

Figure 10 (top) Alfred Stieg-litz, *A Portrait: Georgia O'Keeffe,* 1918, photograph, Metropolitan Museum of Art, New York, gift of David A. Schulte, 1928.

Figure 11 (bottom) Alfred Steglitz, *A Portrait: Georgia O'Keeffe,* 1922, photograph, Metropolitan Museum of Art, New York, gift of David A. Schulte, 1928.

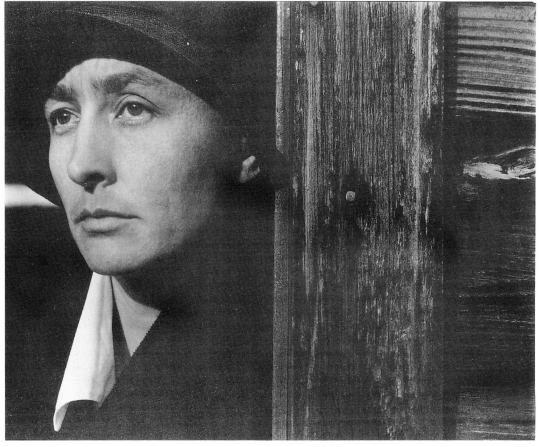

act-performing consciousness" (AH, 97). From within my own horizon, the world appears as the object of my action: my thinking, feeling, speaking, doing. Relationships are never consummated; life proceeds as an open event where everything always changes. "I cannot tarry and come to rest" (AH, 98). Objects do not surround me, for this would imply that I could see all around me; they stand over-against me as objects.

The environment is the world as seen by another from outside the self. I can see my horizon, but not my world; for this, I need the other person. The environment is also the term Bakhtin used for describing the "object-world within a work of art" (AH, 99). It is expressed in formal elements such as the harmony of colors and lines, symmetry, and other features that are transgredient (that is, inaccessible) to the hero or other consciousness in the work.

I experience another's "I" as an other, which is completely different from how I experience myself. This difference makes *all* the difference in both ethics and aesthetics. In Christian ethics, for instance, love for the other and altruism are touted over love for the self. Bakhtin emphasized that Christian ethics differentiates between the I and the other, placing a higher good on doing and acting on behalf of the other (AH, 38).

The situation in aesthetics is similar in that the self-other relationship is important, but different in relation to how it is important. From an aesthetic perspective, the other human being exists only as an object, while the I, the self, can never fully become an object in this way. I may try to make myself into an object by trying to perceive myself though my senses, but the object I am able to see never corresponds fully with myself, the I-for-myself. "I" always exceed any object. Bakhtin was concerned here not with the cognitive dimension of self-perception, but with the "concrete lived experience of our subjectivity and the impossibility of its – of our – being exhaustively present in an object . . ." (AH, 38–9).

In relation to the boundaries of the body, the other is "gathered and fitted" into an outward image that functions as a whole. "I" encompass and embrace the world, rather than being fitted into it. So, in order to experience my boundaries, I need the other.

The line, therefore, is an adequate image to use when we speak of finalizing the other, but it is totally inadequate for describing the experience of the self. I extend myself beyond all such lines and boundaries. The other is connatural (of the same nature) with the world, but I am not, because my subjectivity always distinguishes

me. My subjectivity can never be contained or encompassed by the outer world. Therefore, I always have a loophole through which to escape.[12] The other is associated with the world. I am associated with my "world-exceeding self-activity" (AH, 40). The other is always in space. I am oriented by my nonspatial inner center.

Clearly, the outer body of a human being is given at birth, its boundaries and its world are set within certain parameters. Through the activity of the artist, these boundaries of the body and the person's world are recreated, shaped, and justified. Aesthetic activity then proceeds at the intersection of various boundaries: where the reality of what is given meets the possible boundaries of the body and soul (AH, 206).

Thus, the artist works with the spatial givenness of a human being in the world. Because the artist works at the boundaries – of the body, where two consciousnesses meet – an aesthetic event is possible, "the artistic gift of form is bestowed" (AH, 97). The work of the artist also proceeds on the boundaries of inner life, "at the point where the soul is inwardly turned (adverted) to the outside of itself. By using an oxymoron, we could speak here of the other's inward outsideness and over-againstness" (AH, 101).

Bakhtin acknowledged the analogy between the significance of spatial boundaries and temporal limits. Both spatial and temporal boundaries of my own life have a different significance in my consciousness of myself and my consciousness of another. Where the other is totally in time, I am extratemporal. I never experience the whole of myself in time: I always exceed those limits, slipping through a loophole out of time. "I do not arrange and do not organize my own life, my own thoughts and acts, in time . . . time is instrumental for me, just as space is (I master the instruments of time and space)" (AH, 109–10).

But this should not be taken to mean that I organize the *other's* life in chronological time. Rather, I organize the other's life in "the emotionally and axiological ponderable time of lived life that is capable of becoming a musical-rhythmic time" (AH, 110). While I experience the unity of my own life as a unity of meaning, I experience the unity of another's life as a unity of space and time. Nevertheless, that unity is still experienced on and through boundaries.

An aesthetic approach to the world begins when we realize that

our personal stories are made up of other people, just as the world is composed and constructed of the consummated lives of other people. "It is about the other that all the stories have been composed, all the books have been written, all the tears have been shed; it is to him [and her] that all the monuments have been erected" (AH, 111). And, I would add, it is about and to the other that all art has been created.

ACTION AND AESTHETIC VALUE

Bakhtin's phenomenology of self-other relationships also included attention to the perception of action and space, as experienced both by the performer and the viewer. Where, he wanted to know, is aesthetic value?

When we perform a physical action, we are unlikely to be conscious of it; for this self-consciousness could endanger us. Inner sensation of the self is important during intense physical action, but focusing on one's outer body may destroy the action or even be fatal. One "contracts" consciousness, pulling it into a "pure inner unity," reducing one's awareness of external stimuli (AH, 43). Although Bakhtin did not emphasize it here, this contraction of attention is true of creative activity in general.

Another person, experiencing my action, is able to form it artistically (that is, to evaluate it and place it in context) and to finalize it. The viewer or spectator has a fundamentally different perspective from the actor. That person makes value judgments and understands the purpose and meaning of a work from a different horizon than the actor or artist. With such comments, Bakhtin anticipated discussions on the significance of the viewer in both literary and art criticism since the 1960s.

Although Bakhtin did not say or imply that therefore the viewer, spectator, or reader replaces the artist, author, or actor, he did assert that both are necessary to understand fully an aesthetic act. The horizon of the artist complements the horizon of the viewer. "For in the fateful time of my ongoing life, no action ever presents itself to me in terms of its artistic aspect. . . . All features of the plastic-pictorial consummation of an action are transgredient in principle to the world of purposes and meaning . . ." (AH, 46). This was Bakhtin's way of saying that aesthetic value is always given or attributed by an other consciousness that is both outside the creator's

own life and outside the purpose and meaning the creator may ascribe to an action.

Finally, Bakhtin's interpretation of outsideness, based on such ideas as the surplus of seeing and the boundaries of the body, serves as a necessary correction to expressive aesthetics, with its emphasis on empathy and identification.

EXPRESSIVE AESTHETICS AND EMPATHY

Before discussing Bakhtin's criticism of expressive aesthetics in more detail, let us briefly consider his dismissal of impressive aesthetic theories, such as those of Konrad Fiedler, Adolf Hildebrand, Eduard Hanslick, and Alois Riegl, where attention shifts to focus on "the formally productive self-activity of the artist" (AH, 91–2). For "impressive" theorists, the artist's creative act is one-sided: The artist does not confront another consciousness, but only a material or an object to be shaped. Form, therefore, does not have any depth, because it does not express genuine relationship; it is derived solely from the material of the work of art. Bakhtin accused impressive aesthetics of centering too heavily on the creating consciousness and the artist's interaction with the material at the expense of the "hero," the other independent consciousness that, by its outsideness and answerability, makes an artistic event possible.

By focusing on the contribution of Alois Riegl, an Austrian art historian whose influence helped shape the modern discipline of art history, we may gain further insight into both the insights and problems with Bakhtin's contention. That Bakhtin would have included Riegl here is understandable, especially given Riegl's articulation of the importance of *Kunstwollen*, which has been variously translated as artistic intention, formative will, or stylistic intent.[13]

In *Die spätrömische Kunstindustrie,* Riegl developed his idea that ornament and representation more generally "symbolize a world, not the material that composes them, and they do so not in the spirit of disinterested inquiry [the Kantian paradigm], but inspired with their makers' desire to implement values."[14] As for Bakhtin, this world is not only understood, but *mastered*, and the vocabulary of struggle and strife is marked in Riegl's formulation. The desire to implement values through form is what Riegl called *Kunstwollen.* This concept was Riegl's attempt to counter empiricist and materialist tendencies in art history and theory. By emphasizing the in-

tention or will of the artist, Riegl sought to give the agency of the artist a new basis.[15] For him, the future belonged to the individual *Kunstwollen* of the great creative artist, and consequently, art history should concern itself with "him."[16] Although he shared the vision of the significance of a value-related domain in the arts, his major focus remained an analysis focused on formal principles such as coloristic and linear rhythm and related elements such as symmetry, proportion, and interval; overall composition; unity; and ground/space relationships.[17] Riegl, like Bakhtin, was reluctant to separate form from content, even though he relied on a definition of art that featured formal values such as those listed before or, as he wrote elsewhere, "outline and color in the plane and in space."[18]

With *Kunstwollen,* Riegl was searching for an adequate way to describe the continuous development of visual form by focusing on the way styles are transformed from culture to culture and from one historical period to the next. For instance, he identified three distinct periods of development in ancient art that corresponded with the *Weltanschauung* and with the other major expressions of human will at a given time. In the first phase, individual shapes were determined by arbitrary forces. In the second period, thinkers and artists developed a clearer conception of the "binding and logical relationships among individual phenomena," seeing them in a "chain-like connection."[19] In the third phase, a different kind of connection between individual shapes and forms was sought through magic, which was expressed in Neoplatonism, syncretic cults, and early Christianity.

But Riegl's articulation of this teleological model contained significant differences from its Hegelian point of origin. In contrast to Hegel, Riegl insisted that, although all art expresses this intentionality in different ways, all stages and expressions are of equal value. All discussions about both progress and decline are problematic and therefore must be approached carefully. He opposed all forms of analysis, such as that of Gottfried Semper, which focused on technique and material.

In contrast to such mechanistic models, Riegl interpreted artistic creativity in a much more complex way, emphasizing both the way the artist is "the supreme fulfillment of the *Kunstwollen* of his nation and age," and a view of the artist as an individual seeking to resolve unique artistic problems.[20] Finally, though, he tended to negate the importance of the individual in favor of larger creative forces in history. In this, he followed the trend of late nineteenth-century

thought, which valorized evolutionary ideas over individual in-
novation.[21] Riegl's formalism was modified by his interest in the
acting agent, the creator in artistic activity, but his emphasis must
be understood as clearly different from Bakhtin's, and this is what
Bakhtin's criticism points to.

In view of the foregoing discussion, Bakhtin's judgment of Riegl
seems too reductionistic. Although Riegl did not use the language
of consciousness, self, and other that Bakhtin preferred, he certainly
did attempt to think inclusively about the relationship of artist,
artwork, and context. As Henri Zerner has written, Riegl's con-
tribution to art history may be summarized by saying that he at-
tacked many traditional methods of art history, which included
factual positivistic history, iconographical study that stressed subject
matter, biographical criticism or any criticism that focused on the
artist's individual consciousness, mechanistic explanations of stylis-
tic evolution, aesthetics severed from history, and hierarchical dis-
tinctions between the arts.[22]

In her recent book on Riegl, Margaret Iverson has further ar-
gued that a major, though often unrecognized, contribution of
Riegl's thought to art history was his theory of the role of the
spectator. In his work on Dutch portraits, Riegl anticipated de-
velopments in poststructuralism and late-twentieth-century theo-
ries, by inquiring about the way an artwork either excludes or calls
upon the viewer or spectator. As he had written in notes prepared
while working on *Spätrömische Kunstindustrie*, "Aesthetics: Relation
of parts to the whole. Relation of parts among themselves. Has not
taken the relation to the beholder into consideration."[23]

Bakhtin, had he known or written more about Riegl, might
have seen in his work the ideas of a congenial thinker. In fact, this
is precisely what Medvedev was able to do a few years later in *The
Formal Method in Literary Scholarship*, which was published in 1928.
In contrast to his disdain for Gottfried Semper's utilitarian positiv-
ism, which defined the work of art as a "mechanical product, con-
sisting of a particular purpose, raw material, and technique" (M:
FM, 9), Medvedev praised Riegl's definition of *Kunstwollen*. Es-
pecially, he asserted, Marxism (with which Medvedev was sym-
pathetic) should "completely accept the critical aspect of contem-
porary art scholarship [for example, Riegl] which is directed against
positivism in both its forms (naturalism and, esp. utilitarianism)"
(M: FM, 10).

Bakhtin acknowledged that there is at least one other option

among aestheticians: the "content aesthetics" of Hegel and Schelling. In contrast to the subjectivity of expressive aesthetics, content aesthetics interprets the aesthetic object as expressing an idea or an objective state in an immediate way. From this aesthetic standpoint, there is no room for a coexperiencing subject. Although Bakhtin did not develop this idea, the implication is that the viewer passively perceives but does not actively coexperience a work of art. Thus, he effectively dismissed impressive and content aesthetics, because neither could account for the interaction of two discrete consciousnesses.

Earlier, I described briefly how expressive aesthetics grew out of the idea that art is the expression of feelings and the inner self. Bakhtin placed a diverse group of writers (Theodor Lipps, Herman Cohen, Robert Vischer, Johannes Volkelt, Wilhelm Wundt, Karl Groos, Konrad Lange, Arthur Schopenhauer, and Henri Bergson) in this category of expressive aesthetics.

Expressive aesthethics was especially known for the way empathy and coexperience were conceptualized. To empathize is to feel one's own inner state into an object (that is, to coexperience with the object or other person). As Bakhtin put it, "an object of aesthetic activity (works of art, phenomena of nature and of life) expresses a certain inner state, and aesthetic cognition of such an object is the act of co-experiencing that inner state" (AH, 61). In expressive aesthetics the emphasis is on this outward expression of an inner state.

Expressive aesthetics takes the human being as its primary object. It is decidedly anthropocentric, because everything – even lines and colors – is animated and given human attributes. Expressive aesthetics then studies the features and movements of that animate and animated aesthetic object.

The goal of aesthetic perception and the aesthetic act within expressive aesthetics is to experience the object as if from within. The contemplator and the object literally coincide. There is, in this sense, a single consciousness. There is no juxtaposition of an I and an other, but rather a relationship to oneself where all experience is correlated with the "I" (AH, 64).

Bakhtin based his critique of expressive aesthetics on three main points. First, empathy occurs in all aspects of life, not just in aesthetic experience, and philosophers such as Theodor Lipps and Hermann Cohen did not describe how aesthetic coexperiencing is different from coexperiencing and empathy in general. Second,

expressive aesthetics cannot adequately account for the entirety of a work of art. Third, it cannot provide the basis for understanding and interpreting form. He focused his critique on the second and third points.

Expressive aesthetics, Bakhtin wrote, "cannot account for the whole of a work of art" (AH, 65). This is especially vivid when one is evaluating a work like Leonardo's *Last Supper* (Figure 12), which contains so many different figures. With whom should one empathize? If one tries to empathize with all of the figures in the painting, then what can it mean to experience and understand the work as an aesthetic whole? In order to understand the complex event of the work as a whole, one must occupy a position outside each of the participants and outside all of them together. One way out of this dilemma is to invoke the artist, to try to imagine, and thus coexperience, what the artist experienced in creating the work. But this is ultimately not the same

Figure 12 Leonardo, *The Last Supper*, 1495–7, oil and tempera on wall, S. Maria delle Grazie, Milan, courtesy of Alinari/Art Resource, NY.

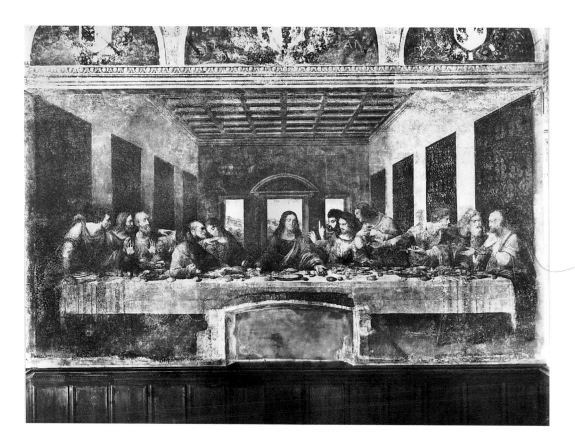

act as coexperiencing or empathizing with the consciousness within the work.

The main error in this approach is that the work is not perceived as a whole, but as a set of elements or images that can be taken apart. An aesthetic whole cannot simply be coexperienced, it must be actively *produced* by both the artist and viewer. In this sense, empathy or coexperiencing remains too passive (AH, 67).

Bakhtin described aesthetic activity as a three-part process. The first moment is projecting the self (*vzhivanie*): I must experience, that is, see and know, what the other experiences by putting myself in the other's place. "But is this plenitude of internal fusion the ultimate end of aesthetic activity? . . . Not at all: properly speaking, aesthetic activity has not even begun" (AH, 26). This moment is similar to the NeoKantian notion of *Einfühlung*, empathy. The second moment of aesthetic activity properly begins only when one returns within oneself to one's singular place, outside of the other person or object, and when one gives form and finalization to the experience of projecting the self. Then, in the third moment, from my own place, I "fill in" the other's horizon, "enframe him, create a consummating, that is, finalizing, environment for him out of this surplus of my own seeing, knowing, desiring, and feeling" (AH, 25). In Bakhtin's model, all power seems to reside in the self, and this power to "enframe" is dangerously close to the power to imprison. Certainly, with his benign view of the universe, this would have been far from Bakhtin's thought, but the implications of such language cannot escape the notice of a late twentieth-century reader.

According to Bakhtin, NeoKantian expressive theories with their emphasis on empathy know only the doubling act of *coex*-periencing; they refuse "to admit the contraposition of the *I* to the *other*."[24] And in order to have veracity, an aesthetic theory must allow for two discrete consciousnesses.

In what way will the event be enriched if I succeed in fusing with the other? If instead of two, there is now just one? What do I gain by having the other fuse with me? He will know and see but what I know and see, he will but repeat within himself the tragic dimension of my life. Let him rather stay on the outside because from there he can know and see what I cannot see or know from my vantage point, and he can thus essentially enrich the event of my life. (AH, 87)

Specifically, Bakhtin stressed that the artist is not directly involved in the event of being, that the artist must stay outside the event.

[I]nstead, he occupies an essential position outside the event as disinterested viewer but with an understanding of the axiological meaning of what is happening; he does not experience it, but coexperiences it. . . . This outsideness (which is not indifference) allows artistic activity to give the event unity, form and completion from outside. Such a unification and such a completion are radically impossible from inside this knowledge and from inside this act. (PS, 33)

Discipline is necessary to sustain such responsible outsideness.

To explain how the aesthetic process actually might work, Bakhtin used the example of a person who is suffering. First, I project myself, experiencing what the other experiences, insofar as this is possible. "I must appropriate to myself the concrete life-horizon of the person as he [or she] experiences it" (AH, 25). But even this act entails more than the experiencing one can see. For instance, I see the facial expression and the physical background of the suffering one. The other person does not see his or her own body, the expression of suffering, the body posture, and so on. My experience finalizes the experience of the other insofar as it fills in the gaps in the horizon where the other cannot see. The same applies to the other person who thereby finalizes me.

Merging with the other or coexperiencing is not the goal in Bakhtin's model. An experience with another person's suffering may prompt ethical action, but it must be followed by a return to the self, for only from that outside place is suffering rendered meaningful, ethically, cognitively, or aesthetically. The idea of infection, as Tolstoy had articulated it, means that I would allow myself to be totally absorbed by the other, and would not be capable of returning to that other position outside. Projecting myself into the other, I experience suffering not as a "cry of pain," but as a "word of consolation" or "act of assistance." Aesthetic activity begins when I return into myself. "The clear blue sky that enframes him becomes a pictorial feature which consummates and resolves his suffering" (AH, 25). These moments of empathy and outsideness that complete the other are not necessarily sequential or chronological. They fuse together and are intertwined, though at a given moment in time, one will dominate or prevail over the other.

Yet from another perspective, Bakhtin's example is clearly problematic. Suffering, real suffering, is not resolved by "seeing it against a clear blue sky." This act may resolve *my* feeling about the other's

suffering, but it does not in any way resolve the *other's* suffering. Further, Bakhtin did not offer any way of understanding how structures of power influence and afflict suffering on scores of others. Such suffering is not so easily mitigated as Bakhtin would like us to think.

Bakhtin's third major criticism of expressive aesthetics was that it cannot provide a foundation for interpreting and understanding form. Form, from an expressive perspective, functions to give expression to the artist's or hero's inner life. "Form does not consummate content . . . but merely expresses it. Form may deepen, clarify the inner life that is being expressed, but it introduces nothing that is in principle new . . ." (AH, 67).

But such an interpretation is obviously inadequate. In one of his rare mentions of visual art, Bakhtin asks us to consider Raphael's *Sistine Madonna* (Figure 13). Does the form of the painting express the Madonna, does it express Raphael's view of the Madonna as Mother-of-God, or does it express Raphael-as-a-man? Expressive aesthetics will not help us to understand this relationship of artist to form and to content; and this is the fundamental fault of expressive aesthetics. It places form and content on the same plane. By deriving form from content, it places them within the purview of a single consciousness. "Content itself – as inner life – creates a form *for* itself as the expression *of* itself" (AH, 69). But this is not really possible: "a lived life is incapable of expressing and shaping itself as a tragedy from within itself" (AH, 70). Genuine meaning and value can only be added by another consciousness, a new creative standpoint that is inaccessible to the person experiencing a set of events.

To Bakhtin this problem with expressive aesthetics was not simply a problem of representation. Realism, naturalism (rendering a naturalistic reproduction of life), and idealism (transfiguring life idealistically): All could be used in order to perceive and understand the position of the other.

He insisted that the errors of expressive aesthetics become clear when discussing play or an art form such as theater. Nineteenth-century German aestheticians such as Karl Groos and Konrad Lange had written about the aesthetic experience as a form of play.[25] Groos, a psychologist, had concentrated on "inner imitation," *innere Nachahmung*, through which we literally mimic the mental or physical characteristics of an external object. He identified this same process in both the aesthetic experience of adults and the play of

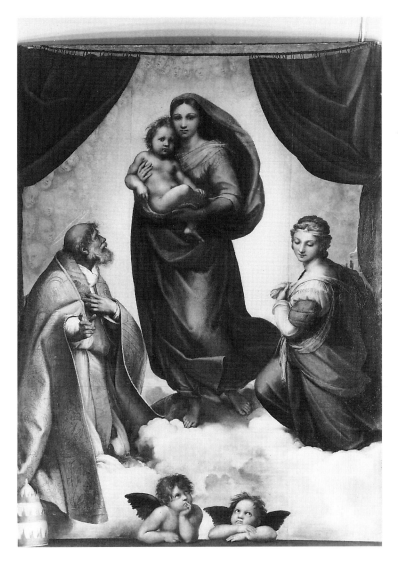

Figure 13 Raphael, *The Sistine Madonna*, n.d., oil on canvas, Gemäldegalerie Alte Meister, Dresden, Germany.

children and animals. Lange characterized the similarity between play and aesthetic experience as a deliberate self-deception, a desire to sustain the illusions of the moment.

Bakhtin was highly critical of such ideas. Play, he thought, should be distinguished from art because of the absence of a spectator. "Play *images* nothing – it merely *imagines*." Or, "it is only in art that life is *imaged forth*, whereas in play it is imagined . . . this *imagined* life becomes an imaged life only in the active and creative contemplation of a spectator." Play is a "surrogate of life," he said, as are daydreams and wishful dreams; "it is not an active aesthetic

relationship to life" (AH, 74–6). In his numerous references to Groos in particular, Bakhtin tried to distance himself from the idea that inner imitation (like empathy) was sufficient to describe aesthetic experience.

Similarly, Bakhtin asked, what would happen in the theater if there were only one consciousness, one participant in the aesthetic event? What would become of the spectators, or even the author who might be in the audience? In that case there would be "no drama . . . no artistic event" (AH, 73). The actor could be aesthetically creative only when that person is "a co-author, a stage director, and an active spectator of the portrayed hero and of the whole play" (AH, 76). The actor as hero is created in front of the director, using makeup, costume, demeanor, movements and positions, training the voice, creation of character. "The actor both *imagines* a life and *images* it in his playacting" (AH, 78). Thus, the actor becomes an artist. In the theater, Bakhtin suggested that a good example of outsideness would be the perception of a naive person watching a play, unless that person steps across the lights and tries to help the hero. This, of course, is precisely what has happened in some performance art since the 1960s.

Finally, all expressive aesthetic theories operate on the basis of a single consciousness, where self-experience and the relationship *to* oneself are all-important. "The axiological category of the other continues to be excluded" (AH, 80). This is, of course, a real loss, because art is a primary vehicle for experiencing the richness of life from many perspectives. "Art gives me the possibility of experiencing not just one but several lives, and this enables me to enrich the accumulated experience of my own actual life" (AH, 80). To see another life for its significance *qua* life: That is the goal of aesthetic experience and of art.

But there was an important deviation from the idea of empathy that Bakhtin wanted to acknowledge: sympathetic and compassionate coexperiencing, developed by Cohen and Groos. As mentioned earlier, in his *Aesthetics,* Cohen had mounted his own critique of empathy, claiming that the many attempts to define empathy had resulted in an unstable concept. But all such attempts have ultimately failed, according to Cohen, because the main problem lies in the name itself. Empathy is not just pure feeling of a subject toward or *into* an object, but it is simultaneously *Erfühlung*, a mutual realization of feeling between the subject *and* the object.[26]

Such coexperiencing is the basis of aesthetic love, which is the

original source of art. Here Cohen insisted on differentiating be-

tween the "moral love of the relative virtues" and a form of love that moves beyond this relative state and grows into a new form of consciousness. Though the same word is used to describe both forms of love, the "higher" aesthetic love is what produces art. This love is "real feeling; it is creative feeling. Without this love art would never have emerged, and without it, art cannot be continued. Love is the elementary power (*Urkraft*) of art."[27]

Clearly, the concept of love involves the relationship of the self and the other. According to Bakhtin, when we experience the lived experiences of another, it is as if they have an "interior exterior," an inside that is turned toward the self; and this inner exterior should be regarded with loving sympathy. This is what Bakhtin called "sympathetic understanding." But the word understanding, interpreted naively, is misleading because it still implies the mirroring or duplicating of the other's experience within me. As Bakhtin so often repeated, the point is not to duplicate the other's inner experience, but to transpose it to another axiological plane, thus giving it new value. "Sympathetic understanding is not a mirroring, but a fundamentally and essentially new valuation" (AH, 103). Sympathetic coexperiencing is "akin to love" in Cohen; it is not just coexperiencing – it is "lovelike sympathy" that alters the inner experience of the hero (AH, 81).

How and why does this inner alteration occur? Because sympathetic coexperiencing permeates both the outer and inner life, it transforms the object that already has a body [the outer] and soul [inner life]. "A sympathetically co-experiencing life is given form not in the category of the I, but in the category of the other, as the life of another human being, another I" (AH, 82).

Love unites one's horizon with an environment. Whereas to coexperience means to be within the coexperienced life, sympathetic coexperiencing implies that the other's life has meaning within another new context, a context in which that life can be "rhythmicized" temporally and given form spatially. This activity is described by the word *izobrazhenie*, which means "imaging forth" (AH, 84).

Expressive theories are not alone in seeking to explain aesthetic and creative activity in terms of this solitary consciousness. There are other ethical, philosophical, historical, metaphysical, and religious theories that do this as well. These "impoverishing theories" are founded on a renunciation of the idea of outsideness and the

importance of the distinctness of the self from others. Chief among these impoverishing theories is "epistemologism," the consciousness of science, which claims to be able to know everything by knowing itself. This stance, of course, denies the consciousness of the other.

To sum up, "aesthetic self-activity always operates on the boundaries . . . of a life-experienced-from-within" (AH, 85). These boundaries might be spatial, temporal, or boundaries of meaning where one comes up against (or comes to meet) another's self-activity. Aesthetic activity begins with love, the love of another who coexperiences one's life. Or again, "aesthetic creation cannot be explained or made intelligible as something immanent to a single consciousness" (AH, 86). A life is not most productive when it merges with another as one. Rather, it is one's outsideness with respect to others, one's distinctness from others, that makes a life productive and creative. Aesthetic consciousness is a "loving and value-positing consciousness," a "consciousness of a consciousness" (AH, 89). It is founded on an essential outsideness.

SUMMARY/ASSESSMENT

As the illustrations in this chapter attest, much of the language Bakhtin used might easily be appropriated for analyzing figurative art. His discussions about the body and the problems of representing the self, as well as terms such as the surplus of seeing, and horizon and environment, may be used by art historians interested in analyzing how the human figure is organized in space and time.

But the most significant issue raised by Bakhtin's criticism of both impressive and expressive aesthetics concerns the way he challenges major trends in modernism. Especially, it is now worth considering some of the implications of Bakhtin's critique of expressive aesthetics and his idea of outsideness for the history and theory of art.

In Chapter 2, I briefly discussed what is meant by the term expression. Following Rousseau, many philosophers and artists understood that human passions demand more than verbal language: The languages of color and sound are, from an expressivist perspective, more direct emotional expressions than words. The expressivist aesthetics of John Dewey, Susanne K. Langer, and others derive from this point of view.

But much earlier than this, theorists and artists recognized the significance of expression in the visual arts.[28] From the time of Alberti's 1436 treatise, *Della Pittura libri tre*, others such as Leonardo (1452–1519), Nicolas Poussin (1593/4–1665), Charles Lebrun (1619–90), Georges Seurat (1859–91), and Henri Matisse (1869–1954) articulated a vital role for expression in the arts. There are several aspects to the meaning of the term expression as it was used by these artists and writers. First, art can express the artist's personality. Second, the work of art can communicate and thus express the artist's feelings to the viewer. Third, this expression can occur through a process similar to Tolstoy's "infection," whereby the artist infects the viewer with his or her own emotions. Whatever the nuances of the process, however, the doctrine of expression was linked to the Kantian concept of genius.

Earlier, I discussed similarities and differences between Bakhtin and Alois Riegl. Riegl described the history and theory of art as a dialectic between "the claim that objects have an independent existence, and the view that no such object or external world exists because my thought and the object of my thought cannot be separated out in this way."[29] Riegl had described these positions as two evolutionary poles: Classical antiquity recognized only objects, whereas modern art (prior to 1931 when he published these ideas in *Das holländische Gruppenporträt*) only recognized the subject, "because in its view so-called objects are reducible to the sensation of the subject."[30]

Expressionist art, best exemplified in the French Fauve artists, and in the German groups Die Brücke and Der Blaue Reiter, rests on the idea that art should be an expression of the inner self of the artist. This art objectifies the subjective experience of the artist. Using bold colors and simplified forms, artists such as Matisse typify this development. His own words best describe his view of art:

What I am after, above all, is expression. . . . I am unable to distinguish between the feeling I have for life and my way of expressing it. Expression to my way of thinking does not consist of the passion mirrored upon a human face or betrayed by a violent gesture. The whole arrangement of my picture is expressive. The place occupied by figures or objects, the empty spaces around them, the proportions, everything plays a part. Composition is the art of arranging in a decorative manner the various elements at the painter's disposal for the expression of his feelings.[31]

Similarly, Matisse would also claim that other visual elements such

as color, line, and form should be vehicles for personal expression. Like other forms of expressionist art that focus on and emanate from the creator's consciousness, Matisse's work precludes the idea of another consciousness that would be central to the creative process. Both Bakhtin's idea of the outsideness of the artist and the otherness implied in the viewer or spectator are absent from expressivist aesthetics and from expressionist art. Bakhtin's point of view would suggest that the path away from both religious and historical painting was therefore a wrong turn, because in the latter forms of art at least two consciousnesses are always implied. Not surprisingly, although for different reasons, many recent postmodern artists have both rejected and revised expressionist ideas, seeking new ways to depict the fragmentation of life and the multiplicity of identity. This is a major theme in the final chapter of *Bakhtin and the Visual Arts*.

UN/FINALIZABILITY

To review, Bakhtin's definition of art and of the artistic act is based on the need for a value-related dimension to the work and on the fundamental answerability of art and life, of the artist to and in the world. Creative activity is not random and indifferent to value, but it always is axiologically oriented: that is, it is related to values. Both the work and the world in which it lives are alive, cognitively, socially, politically, economically, and religiously. "It [the artistic act] lives and moves not in a vacuum but in an intense axiological atmosphere of responsible answerable interdetermination" (CMF, 275).

Furthermore, boundaries define the outsideness of the artist. Creative activity takes places at the boundaries, where one consciousness meets another, where one point of view meets another. "A cultural domain has no inner territory. It is located entirely upon boundaries, boundaries intersect it everywhere. . . . Every cultural act lives essentially on the boundaries, and it derives its seriousness and significance from this fact" (CMF, 274).

As I have tried to show, Bakhtin made an important distinction between cognitive-ethical activity and aesthetic activity. Cognitive and ethical activity create nature and social humanity, whereas aesthetic activity and art humanize nature and naturalize the human. The receptive nature of art is expressed by the fact that "the kind, accepting and enriching, optimistic categories of human thinking about the world and man . . . are aesthetic in character." Art creates a new axiological relationship toward the reality that has emerged through cognition and action: "in art, we recognize everything and we remember everything . . ." (CMF, 279). That new axiological relationship is expressed through answerability and outsideness.

We turn now to the third main constituent of Bakhtin's aesthetics, un/finalizability. With the slash mark between un- and finalizability, I bring attention to the fact that in his essays and books

Bakhtin equivocated about the degree of finalization that is necessary or possible. In the early essays, he tended to argue that it was possible to finalize a work of art, but that a person's life was only finalized at death. Toward the end of his life, he gave more weight to the ultimate unfinalizability of both art and life.[1]

Further, aesthetic finalization takes place through the artist's interaction with content, material, and form.[2] None of these three intricately interrelated constituents in a work of art can be understood in isolation from the others. Content derives in part through the interaction of style and tradition. Material can be understood as both material artifact and aesthetic object. Form is both inner and outer, architectonic and compositional.

CONTENT

Content is the way that cognition and ethical action are given form, are isolated and consummated, in a work of art. Outside of content, they have no meaning. Through content, the artist shapes cognition and action into "the event of reality" (CMF, 281). The artist is not a direct participant in the event, but maintains a position of outsideness from which it is possible to give form to and consummate the event. But this outsideness is not indifference or Kantian disinterest; it is an engaged and active relationship to objects and events.

Aesthetic form "descends upon content from outside. . . . Form, embracing content from outside, externalizes it, that is, embodies it" (CMF, 282). Bakhtin shared this understanding of the relationship of form and content with traditional aesthetics. But he thought that in contemporary poetics, there were two distortions of this insight: first, content (the expression of cognitive and ethical values) was being interpreted solely in formal terms; or second, content was being interpreted solely in terms of the material.

Both of these "distortions" can also be seen in the minimalist sculpture of artists since the 1960s such as Carl Andre (Figure 14) and Donald Judd (Figure 15). Judd, in particular, has written extensively about the significance of his minimalist work. Especially, he has repeatedly denied that one should seek to define a meaningful content in his "specific objects."

I wanted work that didn't involve incredible assumptions about everything. I couldn't begin to think about the order of the universe, or the nature of American society. . . . I didn't want to claim too much. . . . A

shape, a volume, a color, a surface is something itself. It shouldn't be concealed as part of a fairly different whole. The shapes and materials shouldn't be altered by their context. One or four boxes in a row, any single thing or such a series, is local order, just an arrangement, barely order at all. It has nothing to do with either order or disorder in general. Both are matters of fact.[3]

Neither painting nor sculpture, Judd's specific objects are challenging to describe. They are three-dimensional objects, made with industrial materials and processes, constructed as a whole rather than as a series of parts. Color is of central importance, and they exist in real space rather than illusionistic space. If specific objects have any reference, it is usually single and explicit: power. The meaning of such minimalist work lies in the way it asserts its own power, both toward the conventions of art and art history and, literally, toward the viewer.[4] In Judd's work, the material and form actually become the content.

But according to Bakhtin, form needs the "extra-aesthetic weightiness" of content; otherwise, it would be only empty form

Figure 14 Carl Andre, *Lead–Aluminum Plain*, 1969, lead and aluminum, Seattle Art Museum, Seattle, "Seattle Art Museum," gift of Sidney and Anne Gerber, by exchange, and funds from the Margaret E. Fuller Purchase Fund, photograph by Paul Macapia.

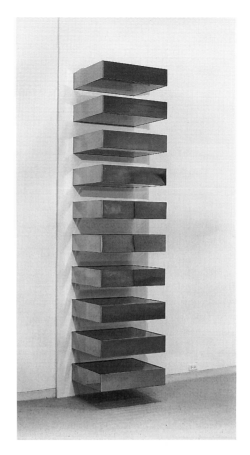

Figure 15 Donald Judd, *Untitled (1969)*, 1972, brass and colored plexiglass on steel brackets, Hirshhorn Museum and Sculpture Garden, Smithsonian Institution, gift of Joseph H. Hirshhorn, photograph by Lee Stalsworth.

(CMF, 283). The cognitive and ethical dimensions of art would not be present. Using a rhetoric of "purity, primacy, and immediacy," most critics of minimalism have concentrated on the formal innovations of artists like Judd, and not on the moral implications of their valorization of plain power, strength, and aggressivity.[5]

Bakhtin also observed that there are works that do not deal with the world, but that imitate the world or other literature. This is what has happened in much contemporary art. Strategies of appropriation in the art of Sherrie Levine and Cindy Sherman are good examples of this, as I show in Chapter 7. These artists imitate the past either by appropriating the images of other artists – as Levine has done with photographs by Alexander Rodchenko (Figure 16), Edward Weston (Figure 28), Walker Evans, and others – or by reiterating cultural stereotypes – as Sherman did in many photographs of the 1970s and 1980s (Figure 17). Certainly, an artist must use, combine, or resist older artistic forms. But Bakhtin said that

essentially the artist must act as the "first artist," assuming an aesthetic position in relation to action and cognition. To be such a first artist entails both answerability and outsideness.

In describing how content is realized in artistic creativity, Bakhtin made three points. First, one must distinguish "between the cognitive-ethical moment, which truly is content," and the cognitive and ethical judgments one makes *about* content (CMF, 285). Second, content is not based on cognitive ideas alone, but must be related to ethical action. Third, this ethical aspect of the aesthetic object is known through empathizing and coexperiencing.

How does one analyze content aesthetically? One must analyze

Figure 16 Sherrie Levine, *After Rodchenko*, 1985, black-and-white appropriated photograph, courtesy of the artist.

the cognitive content, the theoretical element of content. Just how this is done is obscure in Bakhtin's essays, although he did say that one tries to isolate cognitive (profound) insights that are related to the ethical moment in content. The ethical moment may be lifted from the artistic whole by means of "retelling," for in retelling a story, we simplify it so that the "purely ethical, responsible character of what is co-experienced . . . stands out more clearly" (CMF, 289).

Both the cognitive and ethical moments may be the objects of various kinds of study: philosophical, ethical, and sociological. For instance, in the earlier discussion of Donald Judd minimalist sculpture, I briefly discussed ethical and social implications of the work. But all of such analysis goes beyond the bounds of aesthetic analysis as Bakhtin understood it. From his perspective, artistic creation and contemplation are concerned with ethical subjects and the ethical-social relationships among people, not with psychology or broad social or political interrelationships. Finally, the analysis of content is difficult, and because of the nature of the aesthetic object, it inevitably involves one's subjective opinion.

STYLE AND TRADITION

Figure 17 Cindy Sherman, *Untitled #93*, 1981, color photograph, courtesy of the artist.

Bakhtin essentially took a traditional and tradition-oriented stance toward style. A consistent and unified style was important to him.

In his concern with the unity of style, Bakhtin insisted that there are two necessary preconditions. First, there must be a unity of life's cognitive-ethical purposes; and, second, there must be a religious faith in the fact that life is not solitary, that it does not proceed in an axiological void. These two conditions are interdependent: A great style encompasses all dimensions of life. He was not so concerned with the way styles change and develop following cyclical or evolutionary patterns, but with their stability.

Bakhtin's musings on style circled around three questions, none of which he answered completely. Nevertheless, even in their incompleteness, they are important for his interpretation of aesthetics. First, he asked, how does an individual artist relate to style? Verbal style is determined by the author's relationship to language and the means of using language. An aesthetic or artistic style is determined by an artist's relationship to life and the world. Verbal style needs to be understood as subordinate to and a reflection of the artist's aesthetic style, which can be defined as "the sum total of the devices for giving form to and consummating [or finalizing] a human being and his world" (AH, 195).

Second, how is style related to content? Style is, in Bakhtin's interpretation, a way of seeing the world, as well as a way of working a material. Style unifies the outer person (one's costume and deportment) with the world. A world view organizes a life, it imparts a unified meaning to life. Style gives the world its boundaries. A world view unifies a person's horizon. Style unifies the environment surrounding the person (AH, 205).

Third, what is the significance of tradition for the artist? For Bakhtin, responsible individual creativity is only possible within a style sustained by tradition. The existence of tension and innovation is a sign of a crisis of authorship. Thus, the crisis of authorship that so concerned Bakhtin in the early 1920s was, he thought, partly due to a breakdown of style and tradition.

There are many lacunae in Bakhtin's comments on style: Here I would mention just two. Like Hegel and modern NeoHegelians, Bakhtin believed it was possible to identify so-called "great styles," styles that derive greatness from their longevity, coherence, and unity. In his *In Search of Cultural History,* for instance, Ernst Gombrich described the theory of *Volksgeist:* that at any given time cultural forms, including style, demonstrate an organic unity.[6] From this perspective, all the arts, religion, morality, the law, social customs, even the sciences, share a unifying theme. Such a claim was

based on the Hegelian intuition that nothing in life is ever isolated, that all events or creations of a given period are connected thematically and stylistically. Needless to say, this is a problematic claim, which does not account sufficiently for the fact that a culture cannot be mapped out so completely and systematically, or that there exists a diversity of individual forms (and persons) within cultures that do not fit neatly into such a unified theory.

Further, there may be differences in style between the marginal and dominant forms of certain arts, which demonstrate the "unhomogenous, unstable aspect, the obscure tendencies toward new forms," that are present at a given historical moment.[7] The ideal of consistency and unity of style is a modern ideal, and may not be the most appropriate standard for judging works of the past (such as medieval cathedrals) or the art of the postmodern present. In fact, I see a paradox in Bakhtin's insistence on the unity and stability of style at the same time that he valued the open-endedness and unfinishedness of things. If life and art are ultimately unfinalizable, then it would seem natural to accept and esteem a more unfinished and heterogenous notion of style that constantly disrupts tradition.

MATERIAL AND THE AESTHETIC OBJECT

Most of Bakhtin's writing about material in the early essays dealt with the limits of linguisitics and the nature of language as a material. This is not surprising, given that he saw his adversary as formal method and formalist linguistics. Bakhtin would continue to be in dialogue with others such as P. N. Medvedev, whose book, *The Formal Method in Literary Scholarship,* is a sustained critique of formalist ideas.

Bakhtin cautioned that we must be careful not to assume that the word is the center of culture, that "all of culture is nothing more than a phenomenon of language" (CMF, 291). Linguistics, although it is especially helpful in analyzing poetry, needs to be complemented by a general aesthetics, by a theory of cognition and other aspects of philosophy, in order to interpret such diverse cultural events as artistic creation and religious worship. Another way of saying this is that linguistics is indifferent to "extralinguistic" values, such as syntax, semantics, and verbal structures larger than the sentence.

Language is to poetry as nature is to science, as materials such as

stone, clay, paint are to the visual arts. But whatever the material, artistic creativity is characterized by overcoming or surmounting the given material. Any artist can make purely material or technical experiments. But a more difficult and essential artistic task can be described as "surmounting the material" (AH, 193). For Bakhtin, material was secondary to, though interconnected with, form and content. Materials should not determine the artist's content; they should *be determined* by the content of the artist's creativity. He drew his example from sculpture: "What is surmounted in the material is its extra-aesthetic determination: marble must cease to persist as marble, i.e., as a particular physical phenomenon; it must give plastic expression to the forms of the body . . ." (AH, 193).

It is just this attempt to give plastic form to the body that enlivens Mary Edmonia Lewis' *Forever Free* of 1867 (Figure 18). Here she not only surmounted the material *qua* material, but she was able to create a vivid expression of the universal human yearning for freedom and the particular struggle of African-Americans for emancipation before, during, and after the Civil War. As Lewis' work demonstrates, material itself is indifferent to values; it serves the artist's goals rather than being the goal.

Consider the difference in values expressed in her figures and in Hiram Powers' *The Greek Slave* of 1843 (Figure 19). The subject of Powers' sculpture, a nude (white) woman in chains, was considered an explosive subject for nineteenth-century American viewers. It served to focus the intense, yet ambivalent, interest of viewers in the human body and in female sexuality. On the one hand, the sculpture shows the female as vulnerable and at risk. On the other, she seems passionless, and this fit very well into Victorian gender stereotypes. As Joy Kasson recently noted, the figure of *The Greek Slave*, chained and acquiescent in the face of imminent sexual violation, served as the epitome of female sexuality as many people understood it at the time: passive, resigned, aloof, and passionless.[8] In depicting engaged and passionate figures, the values expressed in *Forever Free* move in the opposite direction. In short, the values of each work are independent of the fact that they are both marble sculptures.

For Bakhtin, the main problem with approaches such as naive positivism is that they seek to explain the world in terms of material and the technical apparatus of creative activity. But we can see with the Lewis and Powers examples, a positivistic approach could never be adequate to describe the complexities of human-world relation-

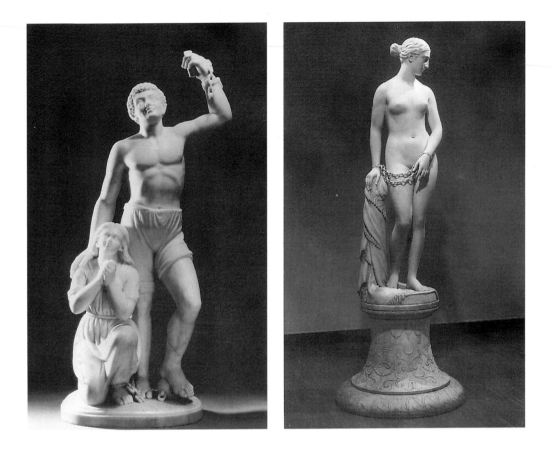

Figure 18 (top left) Mary Edmonia Lewis, *Forever Free*, Howard University, 1867, marble, Howard University Gallery of Art, Permanent Collection, Washington, DC.

Figure 19 (top right) Hiram Powers, *The Greek Slave*, 1843, marble after original plaster, Yale University Art Gallery, New Haven, Olive Louise Dann Fund.

ships expressed in the sculptures. Bakhtin adopted the term "aesthetic object" to describe those relationships as they are expressed in a work of art.

Bakhtin distinguished two further moments in dealing with material. The first is when the artist works with the physical material; the second is when the aesthetic object comes into being. The first moment does not enter into the second: "all of this [technical work carried out by the artist] is removed at the moment of artistic apprehension, just as the scaffolding is removed when a building is completed" (CMF, 295). For Bakhtin technique and technical elements may be factors in shaping an artistic impression, but they are not part of the aesthetic object.

In contrast, the aesthetic object proper is composed of "artistically shaped content (or of content-bearing artistic form)" (CMF, 296). The artist must literally conquer the material, must force the material to surpass itself, in order for the content to become clear.

Creative activity necessitates force; the material is conquered, surpassed.

Although it remains unclear whether there was any direct connection between Bakhtin and Lev Vygotsky,[9] there is a curious similarity between their understandings of this aspect of the creative act. Bakhtin emphasized overcoming or surpassing the material, whereas Vygotsky emphasized overcoming feeling. In discussing the overall significance of art, Vygotsky wrote:

If we consider art to be catharsis, it is perfectly clear that it cannot arise where there is nothing but live and vivid feeling. A sincere feeling taken per se cannot create art. It lacks more than technique or mastery, because a feeling expressed by a technique will never generate a lyric poem or a musical composition. *To do this we require the creative act of overcoming the feeling, resolving it, conquering it. Only when this act has been performed – then and only then is art born.*[10] (italics mine)

Bakhtin's, and Vygotsky's, infrequent but notable use of such language describes relationships of domination and subordination, and fits within the parameters of what Jessica Benjamin called "erotic domination."[11]

In Bakhtin's view, the process of realizing the aesthetic object is linked to architectonics: "realizing the artistic task in its essence, is a process of consistently transforming a linguistically and compositionally conceived verbal whole into the architectonic whole of an aesthetically consummated event" (CMF, 297). The aesthetic object becomes an image, but, still, it is an image that cannot be seen.

It should be noted, however, that Bakhtin thought one could not see an image in the visual arts either. "[I]t is, of course, completely impossible to see *with the eyes alone* a represented human being *as a human being*, as an ethical-aesthetic value, an image, to see his body as a value, the expression of his exterior, and so on" (CMF, 300). The simple visual image of a person is not adequate for seeing that person as a unique and singular event.

Thus, the aesthetic component (we shall call it for the present an image) is neither a concept, nor a word, nor a visual representation, but a distinctive aesthetic formation which is realized in poetry with the help of the word, and in the visual arts – with the help of visually apprehended material, but which does not coincide anywhere with the material or with any material combination (CMF, 300).

Bakhtin's assertion that the aesthetic object does not lie in the external material work or in the psychic process of creation and perception does not mean that it is therefore to be conceived as a mystical or metaphysical essence. Like a concept such as the state or the law, the material and psychic dimensions of art are important, but one cannot develop a complete definition or description of them with metaphysical language alone.

Finally, one should not disparage the study of material and technique or deny its usefulness in understanding a work of art. But in order to give the work of art meaning and life, one must augment that study with consideration of the aesthetic object and with the study of content and form. Bakhtin's criticisms of material aesthetics demonstrate this idea.

MATERIAL AESTHETICS

Bakhtin criticized material aesthetics, those theories (such as formal method) founded on the study of materials. He knew that material aesthetics could offer a useful perspective for understanding the role of technique in artistic creativity, but that it could not be taken as the basis for studying artistic creativity as a whole.

Bakhtin identified five major problems with material aesthetics. First, material aesthetics cannot be the foundation for artistic form. Artistic form is more than the purely external organization of the material. It also includes emotional-volitional tones; and it expresses axiological relationships of the creator to something other than the material. Certainly a creator works a particular material (Bakhtin's example was the sculptor who works a piece of marble), but ultimately the way the artist works has more to do with values than with the material itself. For Bakhtin, to be artistically valid, a work must be "directed axiologically toward something apart from the material . . . it is necessary to admit the moment of content . . ." (CMF, 264). I think this may be true of many arts, but it is not universal. Where there is art without an object, such as music or abstract art, material aesthetics would seem more appropriate. But even in a case such as Judd's specific objects (Figure 15), an analysis of the material alone cannot exhaust the conceptual meanings of the piece, especially the way power relations are inscribed in it.

Second, material aesthetics cannot demonstrate the difference between the aesthetic object and the external work; instead, it tends to confuse them. Aesthetic analysis must understand the architec-

tonics of the aesthetic object, its distinctiveness and structure. The aesthetic object is "the content of aesthetic activity (contemplation) directed toward a work." Aesthetic analysis must also analyze the external work in its givenness, as well as understand how the aesthetic object is actualized in the external material work through composition. This last is accomplished by what Bakhtin called the "teleological method," that is, analyzing how all the parts are teleologically linked within a whole. The *composition* of a work is the structure that actualizes the aesthetic object; it is the "sum total of the factors that produce an artistic impression" (CMF, 267). Material aesthetics does not offer a way to analyze composition adequately.

Third, material aesthetics also confuses architectonic and compositional forms, and unfortunately tends to undervalue the role of architectonic form. Aesthetic individuality is an architectonic form of the aesthetic object: the way the individuality of the author enters the object, the way an event, a person, or an animated object enters it. Self-sufficiency or self-containment is a compositional form.

As an example, Bakhtin mentioned that the novel is a compositional form through which the architectonic form of an historical or social event is realized. Drama is a compositional form through which the tragic or comic architectonic forms are realized. Every architectonic form is realized through compositional devices, and in fact, they may coincide in genres. But only the architectonic forms enter into the aesthetic object, and they help to determine the choice of compositional forms.

Architectonic forms are forms of the inner and bodily value of aesthetic man, they are forms of nature – as his environment, forms of the event in his individual-experiential, social, and historical dimensions. . . . Compositional forms, organizing the material, have a teleological, implemental character, a "restless" character. . . . (CMF, 270)

Finally, Bakhtin asserted that architectonic forms are common to all the arts, whereas compositional forms vary. A proper interpretation of the problem of style therefore must be based on this distinction between architectonic and compositional forms.

Fourth, material aesthetics cannot explain aesthetic experience outside of art, for example, in nature. This may be the most obvious and clear objection that Bakhtin had to material aesthetics. Because

material aesthetics is based on the analysis of material and technique, it cannot find an approach to the unstable and multiple manifestations of the aesthetic or sublime in nature. But an adequate aesthetic perspective must be able to account for this, too.

Fifth, material aesthetics cannot be the basis for the history of art. The main thing that a material aesthetics can do is describe the chronological changes in the technical devices that have been used within a given art form. Only a general aesthetics can interpret the interaction of all forms of creative activity within culture as a whole. Bakhtin's goal, though he never completely fulfilled this goal, was to create that foundation for general aesthetics.

FORM

Bakhtin's comments on form took two main directions, and these will serve to organize the following discussion. In "Author and Hero," he concentrated on inner and outer form as they relate to both an aesthetic object and the hero in a work. In "Content, Material and Form," he focused more on the differences between architectonic and compositional form, and on how isolation evolved through the interaction of form, content, and material.

The first direction of Bakhtin's ideas on aesthetic form emphasized the fact that it has both inner and outer (empirical) dimensions. As inner form, it is the aesthetic object: "The form of the world which is constructed on the basis of a given work of art but does not coincide with that work" (AH, 92). As outer form, it is the material artifact. This distinction between aesthetic object and material artifact is important throughout these early essays. The material form of a work helps determine the aesthetic object by the way it accentuates a particular aspect of the work.

In visual art, inner spatial form is imaged through colors and lines, which also give form to the concrete object. But "inner spatial form is never actualized as a visually full and complete form," because that quality of fullness only is possible externally in the material artifact (AH, 94). It may be experienced as if it were complete on an emotional and volitional level, but this fullness cannot be actualized in a visual representation. The perception and interpretation of inner spatial form (the aesthetic object) are always subjective; it can never be objectively finalized or objectively verified.

Yet, Bakhtin's phrase "spatial form" refers not just to the "form of a work as an object, but the form of a hero and his world – the form of a *subiectum*" (AH, 89). This form is expressed in and through relationship, particularly of the author to the hero. "Aesthetic form is founded and validated from within the other – the author, as the author's creative reaction to the hero and his life" (AH, 90).

Bakhtin asserted that the hero in verbal art does not have spatial form, because verbal art works with language, which is nonspatial. To understand the problem of form correctly, one must take account of both inner and outer form. But in distinction to this position, it seems to me that visual art has both spatial and temporal form.

Form itself is a boundary of the body, soul, and spirit. Our interpretation of form is based on boundaries. We experience our own boundaries differently than we experience those of another. Whereas in personal action, one always crosses one's own boundaries (even though they may seem an impediment), another's boundaries are what allow her to be concentrated and finalized. When we identify with a hero, we open those boundaries, thus experiencing something of the other's life from within. When we finalize the hero, we close the boundaries, thus remaining on the outside of the other's life.

For Bakhtin, the nature of the hero produces the content; the artist produces the form. Both positions are necessary. Even if there is no hero in a work of art, we must be about to feel another consciousness: "to feel the form, to feel its saving power, its axiological weight – to feel its beauty. (I said 'to feel,' for in feeling it, we do not necessarily have to be conscious of it in a theoretical, cognitively distinct, manner)" (AH, 200). Here Bakhtin privileged feeling over thinking and sensory perception. Even in an abstract objectless art form such as music, we may "feel the resistance, the persistent presence of a possible consciousness, a lived-life consciousness . . ." (AH, 201). For it is this sense of another life, another consciousness, that gives a work of art its axiological reality and validity. American abstract expressionists like Mark Rothko (Figure 4), or Russian avant-garde artists like Mikhail Matiushin (Figure 20) and Wassily Kandinsky (Figure 21) were convinced that color and line, like music, could take on emotional valences and become a content in themselves.[12] Matiushin's *Harmonious Chart* attempts to document the way in which color contrasts produce changes in

Figure 20 Mikhail Matiushin, *Harmonious Chart*, n.d., gouache on paper, Stedelijk Museum, Amsterdam.

Figure 21 Wassily Kandinsky, *Jocular Sounds*, 1929, oil on cardboard, Fogg Art Museum, Cambridge, purchase in memory of Eda K. Loeb and Association Fund.

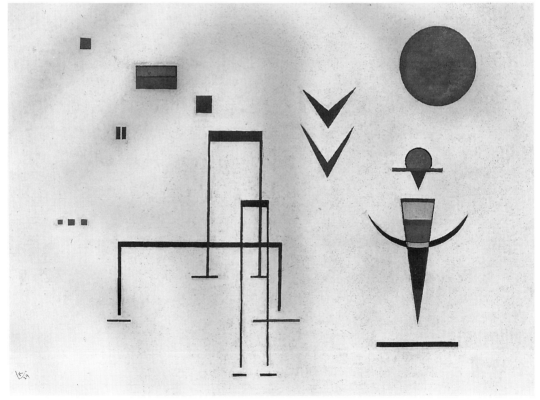

perception. In *Jocular Sounds,* Kandinsky has created a quasirepresentational picture, with allusions to a figure, birds, a sun, and buildings. But the painting might also be read more abstractly, as a series of relationships of a circles, cones, squares, rectangles, chevrons, and lines that have both stability and dynamism.

The second direction of Bakhtin's reflections on form concerned architectonics, composition, and isolation. Form, he thought, could be studied as architectonic form, from within the aesthetic object, and as compositional form, the study of the technique of form (the idea that form is partially determined by the material). Most of Bakhtin's comments focused on the first direction; he offered a method for the "aesthetic analysis of form as architectonic form." His main question was: How does compositional form realize architectonic form? Or, in other words, how does the way a given material is organized affect the organization of cognitive and ethical values?

In form I *find myself,* find my own productive, axiologically form-giving, activity, *I feel intensely my own movement that is creating the object,* and I do so not only in primary creation, not only during my own performance, but also during the contemplation of a work of art. *I must to some extent experience myself as the creator of form, in order to actualize the artistically valid form as such.* (CMF, 304)

The main difference between this understanding of artistic form, on the one hand, and cognitive form, on the other, is that cognitive form does not have an author or creator. Cognitive form lies in the object, and the viewer does not experience any creative or productive activity.

But artistic form is experienced more actively, as the axiological relationship to content: "in form and through form, I sing, recount, and depict; through form, I express my love, my affirmation, my acceptance." In order to experience artistic form, one must enter into the aesthetic object in the same way as a creator. If we only see or hear something, we cannot perceive artistic form; form remains only cognitive. "Thus, form is the expression of the active, axiological relationship of the author-creator and of the recipient (who co-creates the form) to content" (CMF, 305–6). But, he asked, how can form as a subjective relationship to content become creative and consummate content?

Composition realizes form not through a formal unity, but

through "the feeling of the *activity* of meaningful speaking" (CMF, 310). There is a sense of a subjective activity and unity, but this is not in the object or the creative event. It is the unity of "encompassing, embracing the object and the event. Thus, the beginning and the end of a work are, from the perspective of the unity of form, the beginning and the end of activity: I begin something, and I end something" (CMF, 311). The emphasis here is on the subjectivity of the creator and viewer in realizing form. Form is not something intrinsic to the object.

The unity of aesthetic form therefore results from the unity of the acting human being. Form ceases to be aesthetic form once it is projected into the content. But this should not be interpreted as meaning that form is therefore sufficient onto itself. The activity of generating form is not self-sufficient, but "it turns outside of itself"; it is an axiological activity, "the activity of loving, elevating, denigrating, lauding, lamenting, etc." (CMF, 311). The active creativity of the artist must be distinguished from the more passive and imitative activity of the viewer who coexperiences and empathizes with what is already created. Form has, or can have, unity because of the active axiological position of the creator, which also relates to content.

One final aspect of Bakhtin's interpretation of form was his discussion of isolation, an idea that had particular vibrancy in late nineteenth- and early twentieth-century aesthetics. Writers as diverse as Edward Bullough, José Ortega y Gasset, Lev Vygotsky, and Hugo Muensterberg were concerned with the nature of aesthetic distance and isolation. For example, in his 1905 *Principles of Art Education*, Muensterberg sought to distinguish the methods of science and art. Science, he said, uses methods of description and explanation to *connect* objects and events, whereas art separates and *isolates* the object of contemplation from its environment.

Thus, if you really want the thing itself, there is only one way to get it: you must separate it from everything else, you must disconnect it from causes and effects, you must bring it before the mind so that nothing else but this one presentation fills the mind, so that there remains no room for anything besides it. If that ever can be reached, the result must be clear: for the object it means complete isolation. . . .[13]

Similarly, with the concept of isolation, Bakhtin was seeking another way of saying that in order to perceive it clearly, an aesthetic

object must be demarcated from its surroundings in some way. By creating boundaries or a frame so that it is set off from what surrounds it, one can experience the aesthetic object more clearly.

In his later essay, "Content, Material, and Form," Bakhtin wrote about isolation or detachment as the primary function of form in relation to content. The literary device of the formalists, defamiliarization, is an example of isolation, but Bakhtin thought that it was a somewhat fuzzy concept. "Isolation is the first step taken by the form-giving consciousness, the first gift bestowed by form upon content, making possible for the first time all the subsequent, purely positive, enriching gifts bestowed by form" (CMF, 306). Or, in other words, "Isolation makes possible for the first time positive realization of artistic form," because through it the author may freely shape content (CMF, 307). Through isolation the author assumes control.

But what is isolated? Isolation foregrounds the material and the way it is organized in a composition. As the artist works a material, she or he is, in fact, working with and isolating values.

Making use of the material alone, form brings any event and ethical tension to fullness of completion. With the help of the material alone, the author assumes a creative, productive position with regard to content, that is, with regard to cognitive and ethical values. The author enters, as it were, the isolated event and becomes the creator in it, without becoming a participant. (CMF, 308)

Isolation is what makes the material creative.

In the concept of isolation, theorists such as Bakhtin and Muensterberg saw a way to describe the unique properties and the unique function of art. From a late-twentieth-century perspective, however, the ideal of isolating the material, form, or content of a work of art from its larger cultural context seems misguided. For, I would argue, one can only really see or understand creative activity, and the objects that result from such activity, in relation to the unique situation in which it arose. A work of art is shaped as much by its social-economic-political context as by the purely aesthetic issues that engaged the artist.

In sum, aesthetic form may be defined as "my organically moving, evaluating, and meaning-giving activity, and at the same time it is the form of an event and its participant standing over against me (his individuality, the form of his body and soul)" (CMF, 316).

Aesthetic form requires a consciousness, a body, and a soul. And the existence of both body and soul leads inexorably to confrontation with the ultimate unfinalizability of life (and art), except in death.

In his later work, Bakhtin's orientation shifted from how the act, in conjunction with the other person's outsideness, finalizes the self to how the word in dialogue is ultimately unfinalizable. By the time he wrote *Rabelais and His World,* Bakhtin would celebrate the unfinalizable.[14]

AUTHOR/ARTIST AND HERO

Bakhtin's comments on the artist were fragmentary and sparse. He assumed a distinctly modernist position in discussing the role of the author or artist, saying that the creator must be understood as an authoritative guide to the work. Yet he also asserted that everything an author says about her or his creative process, or about creative activity, must be treated with caution, because ultimately the process of creation is best expressed in the object. It is not really possible to experience the process of creating. When an artist does speak about a work, that speech or writing is actually based on a later receptive relationship to the created work. The created object becomes independent of the creator.

An artist's comments on the process of creating an image are then inevitably shaped by various factors: critical response to this and earlier work; the artist's world view, which may have changed since a particular image was created; the artist's aspirations and pretensions. There is a distinctly biographical value in such commentary; it helps the viewer to gain insight into the artist-as-person. But to try to understand the artist or author in an historical time, a social collective, or from a class position for Bakhtin meant to go outside the event of the work and to enter the domain of history. Marxists and feminists do not shy away from this approach; they insist that such interpretation is important. The author as an active principle of seeing in the work must be placed alongside the creative activity of the reader, critic, or historian.

So precisely what was an author (or artist) in Bakhtin's words? "An author is the uniquely active form-giving energy that is manifested . . . in a durably valid cultural product . . ." (AH, 8). Durable? For how long? Valid? For whom? Cultural? In what cultural

context? Bakhtin seemed compelled to explore such issues and questions because he thought that literary history and aesthetics were in such complete chaos, but he was vague about the exact meaning of his definitions.

In another equally teasing formulation, he wrote: "The [artist] is the bearer and sustainer of the intently active unity of a consummated whole (the whole of the hero and the whole of the work) which is transgredient to each and every one of its particular moments or constituent features" (AH, 12). In other words, the artist is the consciousness, transgredient to all the individual parts of the work, that creates and sustains the unity of a work of art. Bakhtin's use of religious images (for instance, bearer and sustainer) is interesting, but like so many other suggestive images, he did not develop them.[15]

In most of his early essays, Bakhtin focused on the nature of author-hero relationships in literary works, and he developed a fascinating typology based on his understanding of genres such as confession, biography, and saints' lives.[16] Bakhtin complained that too often the explanations for a particular work are sought in the biography of the author, thus ignoring a variety of possible juxtapositions between author and hero and artist and image. Of course, an artist can put his or her own ideas, values, and so on into the image to show their truth or to propagandize. But Bakhtin felt that we must not confound the author-creator, who is a constituent in the work, with the author-person, who lives within the ethical and social events of life. Although he was writing primarily about verbal creation, clearly Bakhtin anticipated New Criticism and the poststructuralism of Roland Barthes and Michel Foucault in the 1960s.

If the author or artist is the primary consciousness that creates the work, then the "hero" is the other consciousness expressed in a work, a consciousness that is given form through the author's creative consciousness, through the artist's surplus or excess of seeing and knowing. The hero functions on cognitive and ethical levels, whereas the author alone functions in the more inclusive aesthetic realm. The hero's feeling, desire, and consciousness are enclosed by the author's finalizing consciousness of the hero and the world. "Aesthetic objectivity . . . encompasses and comprises cognitive-ethical objectivity" (AH, 13). The author knows more and sees more than the hero. In order to find the author, one must (a) find elements in the hero and his or her life that are transgredient

to that consciousness, and (b) determine the active, creative, and necessary unity of all the finalizing moments.

The author remains essentially outside the hero: outside in space, time, value, and meaning. This essential outsideness allows the author, first, to concentrate all of the hero; second, to form the hero into a whole; and, third, to justify the hero. In this sense, the hero cannot stand beside the author as a partner in the event of life, nor can the hero be the author's true antagonist or be inside the author. "The author's position of being situated outside the hero is gained by conquest, and the struggle for it is often a struggle for life . . ." (AH, 15).

The activities of the author and hero differ considerably: the hero is a "shaped determinateness," where the body and soul are externalized and embodied (CMF, 316). The author is invisible and inaudible, and is experienced as the embodying activity – the seeing, hearing, moving, and remembering presence that forms the hero. The aesthetic object is "a creation as it looks from the eyes of the creator . . . who freely and lovingly created it . . . " (CMF, 316). In this sense, the aesthetic object includes the creator *in* the object.

Bakhtin's formulations about the relationship of author and hero are among his most difficult ideas to relate to the visual arts. In portraits or images of people, such as Stieglitz' photographs of Georgia O'Keeffe or Lewis' *Forever Free*, the viewer clearly senses another consciousness – the hero who is given form through the author's creativity. In some cases (for example, the O'Keeffe photographs), one knows that the artist's attempt to finalize the hero must ultimately fail, because the living person who is represented always exceeds the ability of the artist to finalize her. In other cases (*Forever Free*), one knows that the man and woman in the sculpture have been shaped, their feelings embodied and finalized, by the artist's consciousness. Whereas the heroes (the figures in the sculpture) embody cognitive and ethical ideals, the artist alone has given them aesthetic form.

But as I earlier implied, the language of self and individual consciousness that is so appropriate when discussing characters in a text or people represented in a work of art fails when approaching a wide variety of other genres and artistic media. Where, for example, is the hero in Levitan's *The Birch Grove*, Andre's *Lead-Aluminum Plain*, or Malevich's *Black Square?* Still-life, landscape, certain forms of sculpture, and abstract painting are only a few of the genres and

media that demonstrate the difficulties of using Bakhtin's formulations with any coherence.

Nevertheless, one of the primary values of Bakhtin's notion of unfinalizability lies in his assertion that a person is fully creative only in art. For Bakhtin, this meant that only the embodied human being – a person who breathes, moves, sees, hears, remembers, loves, and understands – could create. Even the viewer of the artist's creative activity must use the whole body (heart and soul), the whole person, in trying to understand a work of art.

An author's or artist's axiological position and context in the world should determine the material and literary context of a work, and not vice versa. A *primary artist* is one who understands and uses this insight. This artist "collides and contends immediately with the raw cognitive-ethical element of a lived life, with the chaos of a lived life . . . and it is only this collision that ignites the purely artistic spark" (AH, 197). If the artist tries to begin with purely formal aesthetic elements, the result is contrived and empty.

Finally, it is the sense of "axiological weightiness" that gives meaning to artistic creativity, the feeling of another consciousness as an *other* to which we relate. "To feel this means to feel the form, to feel its saving power, its axiological weight – to feel its beauty" (AH, 200). With comments like these, Bakhtin acted like the oxherder pointing his finger to the moon in the traditional Zen story, trying to indicate the importance of religious and moral values without didacticism.

SUMMARY/ASSESSMENT

There are many ways of analyzing the artifacts of culture. Variations are seemingly endless. The Symbolists chose a language of mystical content and symbolic form. Futurists used an extremely formalist vocabulary of terms such as pictorial dynamism and linear displacement. Formalists preferred to speak of materials and the literary device. One of Bakhtin's major contributions to visual and aesthetic theory is to offer a more balanced way of interpreting artifacts through consideration of content, form, *and* material. Just as his criticism of expressive aesthetics gave rise to his claim for the significance of outsideness and the meeting of consciousnesses that must constitute a true aesthetic event, so his criticism of material

aesthetics gave rise to a way of understanding the complexity of content and form in relation to material.

The categories of author and hero are harder to appropriate for analysis in the visual arts, as I inferred throughout my earlier discussion. More generally, this pair of terms points out that there may be a dynamic relationship between the artist, as creator or author of a work of art, and the other consciousness that is expressed in and through the work.

Recognition of the phenomenon of unfinalizability is not new, but Bakhtin's name is useful for the historian, theorist, or critic, as I try to show in the following two chapters. The term points to the open-ended quality of interpretation that is inherent in Gadamer's and Ricoeur's explications of the hermeneutical process.

As I stated in the introduction, Bakhtin's reflections in the early essays not only offer analytical tools for art historians and theorists, but they also are part of a larger philosophical inquiry. This is particularly true of his writing about unfinalizability in life and death. For me, this more general sense of unfinalizability is more significant than its narrower applicability in the visual arts.

What is it that allows one to live life and to face death, "to straighten the spine, to lift the head, to direct the gaze forward?" (AH, 126). The future is important to the self because it represents the possible, and we always see ourselves in terms of what is possible, what does not yet exist, but might be. This insight is what carries an artist forward into the creative unknown. This sense that "I do not exist yet" propels one to work, to move forward.

Life is carried forward by ongoing faith and hope, by the possibility of new birth: "I cannot, axiologically, fit my whole life into time – I cannot justify it and consummate it in full within the dimension of time. A temporally consummated life is a life without hope from the standpoint of the meaning that keeps it in motion" (AH, 127). A temporally consummated life would be one in which all possibilities had been fulfilled, all visions realized, or one in which all hopes had been dashed.

This faith and hope are a "last word" in life. "In my last word, I turn to the outside of myself and surrender myself to the mercy of the other" (AH, 128). This, in fact, is precisely what a deathbed confession is. But my own last word needs to be heard by another, one who is completely outside my life, one whose spatial, temporal, and meaning-related outsideness can consummate or finalize my own last word.

No neutral position about the I and the other is possible, for any valuation or action assumes an individual position in relation to the other; "even God had to incarnate himself in order to bestow mercy, to suffer, and to forgive – had to descend, as it were, from the abstract standpoint of justice" (AH, 129). For Bakhtin, this necessity of being situated, of always being in a relationship to an other, is fundamental. My standpoint is defined by the fact that I alone can be an *I-for-myself*; all others are *others-for-me*. Neutrality within life is simply not possible, because the ongoing eventness of life has meaning only from my unique place. The more I root myself in that unique place, the clearer its meaning becomes. As Bakhtin observed, if we participate with, empathize or coexperience with, another person, then consummation of the other becomes difficult because we are not outside the other.

Likewise, we can never finalize ourselves: "our own consciousness would never say to itself the word that would consummate it. After looking at ourselves through the eyes of another, we always return – in life – into ourselves again . . ." (AH, 17).

From within one's own consciousness, birth and death are not events in one's life. "My birth, my axiological abiding in the world, and, finally, my death are events that occur neither in me nor for me." As much as I might try to think the world as it was before my birth, or to think how it will be after my death, this is impossible. "In my own life, people are born, pass by, and die, and their life/death is often the most important event of my own life – an event that determines the content of my life. . . . The terminal points of my own life cannot have this plot-determining significance; my own life is that which temporally encompasses the existence of others" (AH, 105). Just as I cannot experience the environment that surrounds me, the spatial whole in which I exist, so I cannot experience the time that encompasses me.

Only with the other do I have the possibility of joy, abiding peace, sorrow, or grief. In this sense, the life of another is totally *in* time and space, but I never can be totally in time or in space.

The other always stands over against me as an object. The exterior image of him stands over against me in space; and his inner life stands over against me in time. I myself as *subiectum* never coincide with me, myself. . . . I evidently do not experience the whole of myself in time. . . . Time is instrumental for me, just as space is. (AH, 109)

For me (for Bakhtin, for you the reader), living experience never

stops; it never becomes consummated. In this sense, experience is infinite; it does not stop and I cannot stop being active in it. In other words, there can never be a completed memory of my own life for me, because it is ongoing. My own unity is never experienced as complete; it is always yet-to-be. This is why the future is so important for Bakhtin.

> It is not only that I want to appear to be more than I am in reality, but that I am really unable to see my own pure givenness – I really never believe completely that I am only that which I actually am here and now; I render myself complete out of what is yet-to-be, what ought to be, what is desired. That is, the real center of gravity of my own self-determination is located solely in the future. (AH, 127)

And even if I achieve everything I previously imagined or anticipated, still I continue to project myself into the future.

The self is not a complex *system* and never attains unity or fixity, except in death. It is "much looser, an aggregate of habits, contingent facts, and clusters of order that continually interact with one another and with the 100 million diverse facts of daily life. Whatever wholeness we achieve requires enormous work, which is the effort of life and that work is never complete."[17] Only death marks a person's aesthetic finalization or consummation.[18]

"If I am consummated and my life is consummated," Bakhtin wrote, "I no longer am capable of living and acting. For in order to live I need to be unconsummated, I need to be open for myself. . . . I have to be, for myself, someone who is axiologically yet-to-be" (AH, 13). Therefore, death is the ultimate aesthetic act. It makes the entire life of the other "available" for memory. Death is a gift, but is paid for by feelings of loss.

We find meaning through our singularity of place, and especially through death. In this sense, all people are not equal. "No one lives in a world where all people are mortal in an axiologically equal way . . ." (KFP, 118). Death, as well as the possibility of sacrifice, make my unique place in existence possible and meaningful. The anticipation of death is essential in consummating a person: "We anticipate the other's death as the inevitable nonrealization or failure of his entire life in respect to meaning, and we seek to create forms of justification for his life, forms of justification that he is in principle incapable of finding from his own place" (AH, 130). This idea is especially significant for the biographer.

The most direct relationship between the self and the other or

an artist and artwork occurs when the self maintains the kind of outsideness that allows her to finalize the other, to form a unified whole. In life, we do this constantly in several ways. We evaluate and shape our appearance according to the effect it will create in others. We try to attend to "the background behind our back," which includes not just the visual or physical backdrop, but also our axiological (value-related) orientation (AH, 16). Yet this is what remains invisible and unknown. We may even attempt to anticipate our own death, to evaluate what our life has meant for others. But all such activities do not really "gain body," they cannot consolidate into a self-sufficient whole. Life is usually directed ahead of itself, toward an ever-receding horizon or goal. In this sense, life is an event "yet-to-come."

Bakhtin's view of the necessary openness of a philosophy and the world shared much with Rudolf Hermann Lotze's ideas: "Lotze objected to any philosophical system that claimed completeness. All philosophical systems, like his own, must remain open and un-dogmatic. . . . He thought it was far better for a philosopher to raise questions and to stimulate inquiry than to offer sterile answers lacking any reasonable foundation in fact."[19]

In the essays of his last years, Bakhtin asked himself what was unique about his work, and there concluded that it was precisely this unfinishedness that he "praised as the loophole in any text that guarantees the possibility of others entering into dialogue with it: the loophole guarantees freedom for the reader, and thus future life for the text."[20] With the concept of unfinalizability, Bakhtin wanted to overcome the dichotomy between religious/metaphysical and positivist/determinist/scientific world views, those that are based on creativity and freedom and those that are not.[21] Unfinalizability may be efficacious for aesthetics, but it is an even more powerful way of understanding the relationship of life to death.

THE USEFULNESS
OF BAKHTIN'S AESTHETICS

Part Three

INTERPRETING WORKS OF ART

Answerability, outsideness, unfinalizability: I have tried to show that these three ideas form the basis of Mikhail Bakhtin's early aesthetic essays. In distinction to his nineteenth-century predecessors, Bakhtin's aesthetic categories draw attention to the role of moral and religious values in the creative activity of the artist. His early aesthetic essays offer both subtle and specific suggestions concerning how one might discern those values.

What kind of faith or trust is encouraged through the work? I have interpreted Bakhtin's writing as suggesting that an attitude of faith and trust in an answerable other (either another person or God) is essential in life and in art. What kind of boundaries are established in and through the work? Bakhtin's emphasis on "outsideness" as a corrective to identification and aesthetic empathy is crucial. He asserted that an artwork should express the meeting of consciousnesses, but not their merging. Is the image complete and finalized, or open and unfinalized? Bakhtin insisted that the creative process and the work of art are ultimately unfinalizable.

Finally, what do these questions and statements mean in relation to a particular work of art? An examination of the twelfth-century Novgorod icon, *Spas nerukotvornyi* (Figure 22), and Kasimir Malevich's *Black Square* of 1915 (Figure 23) will provide us with an opportunity to evaluate Bakhtin's ideas vis-à-vis actual works of art.

My goal is to incorporate Bakhtin's ideas as part of my interpretive framework. In approaching these issues, I take an eclectic approach. I engage in theological interpretation in order to explain how the particular constellation of form, content, and material in the *Spas* functions to communicate traditional Russian Orthodox theological insights, or how Malevich's seemingly abstract secular painting, *Black Square,* communicates an obscured theological con-

tent. I also address specifically art historical questions: the role of
the personal, social, and political context in interpreting the paint-
ings; and how their formal elements, such as composition, color,
line, and so on, focus perception. Following Bakhtin's injunction
to analyze texts in context, I discuss general historical and cultural
issues concerning each painting, as both were created in particular
social contexts for specific functions.

Figure 22 Anonymous, *Spas
nerukotvornyi*, twelfth century,
tempera on wood, State Tre-
tyakov Gallery, Moscow.

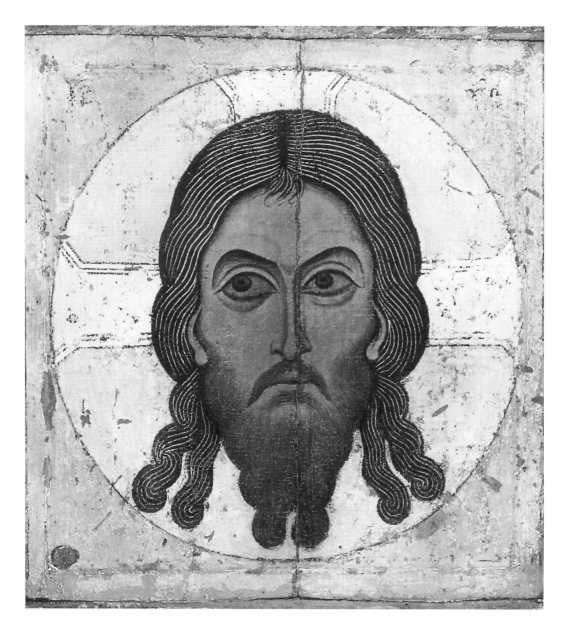

132

I have chosen these two Russian paintings because they are from Bakhtin's own culture.[1] Further, in the few scattered references to the visual arts in his early texts, Bakhtin refers to the icon tradition; and he makes critical allusions to the abstract art that had just begun to appear in Russia. Though I am sympathetic to Bakhtin's attempt to establish a new basis for philosophy using aesthetics, I am also cognizant of his insistence on grounding theoretical discourse in the particular, personal, and everyday. Thus, I focus on the utility of Bakhtin's theoretical formulations for analyzing particular art-

Figure 23 Kasimir Malevich, *Black Square*, 1915, oil on canvas, State Tretyakov Gallery, Moscow.

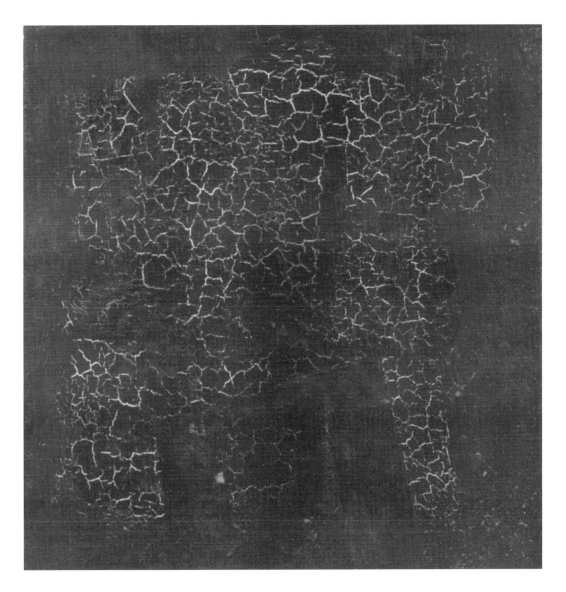

works rather than engaging in further discussion of abstract aesthetic issues.

The relationship between representational and abstract art also fascinates me, and a comparison of these two paintings will allow me to investigate differences and similarities in how moral and religious values are expressed. Only one of the images analyzed here is explicitly religious. The *Spas nerukotvornyi* offers an excellent point of departure, because as a religious icon we expect it to be religiously and morally informed. But my primary interest as a theorist and critic lies with contemporary art of the twentieth century, where artists have seldom explicitly claimed that religious and moral values have centrality in their creative process or product. Malevich's *Black Square* is an intermediate example: It lies between the explicitly religious *Spas* and the secular art of the late twentieth century. As will be clear, although *Black Square* is opaque and difficult to interpret, Malevich gave many clues to the meaning of the painting in his voluminous writings.

Bakhtin's essays not only provide us with subtle tools for formal analysis of verbal and visual texts; his work also helps us to rethink our understanding of creativity. As I argued near the end of Chapter 1, his work does not function as an authoritative discourse, a "word of the father," or the "distanced word of the past" that is closed and finalized. Instead, his work is internally persuasive, open to development, application and extension. By contrast, both the *Spas nerukotvornyi* and *Black Square* might be seen as examples of authoritative visual discourse. Certainly, both have been highly regarded in their respective traditions, the Russian Orthodox icon traditions and modernist art history.

Within their own traditions, each painting is a minimalist work. When the term "minimalism" or "minimalist" evolved in the 1960s, it referred to nonrepresentational art that consisted chiefly of basic geometric shapes and forms.[2] The word also has been used to denote visual simplicity. Within the icon tradition, the *Spas* is an unusually stark and rarefied image, comprised of a square, circle, cross, and face in essentially three colors. Although the early twentieth-century avant-garde in Russia evolved a variety of abstract forms, *Black Square* is one of the earliest and one of the most severe, consisting of only one black quadrilateral with a white border. To speak of these paintings as minimal works is thus one way of pointing to their interpretive difficulties.

Not the least of these difficulties concerns the fact that I cannot

134

here describe and analyze the entire Russian Orthodox religious tradition to which an icon such as the *Spas* belongs, nor fully describe the theology and semiotics of icons. Nor, in the case of *Black Square*, do I summarize the international developments that led to the first abstract paintings around 1910 simultaneously in Russia (Wassily Kandinsky and Kasimir Malevich), Western Europe (Frantichek Kupka and Piet Mondrian), and the United States (Arthur Dove).

Such limitations notwithstanding, a few further comments about the theme of transformation and transfiguration are called for, as this theme recurs in my treatment of the *Spas* and *Black Square*. I would suggest that Bakhtin's interest in self-other relations and especially his focus on the two consciousnesses that must be present in an aesthetic event also expresses, in veiled form, the theme of transformation. In the Orthodox tradition, the final goal is for each Christian to attain *theosis,* divination or deification.[3] Several presuppositions lie behind this idea that redemption, salvation, and radical transformation are possible. The process of deification is available to all Orthodox Christians in the present, through the practices of daily religious life: going to church, receiving the sacraments, praying, reading scripture, venerating icons. This process is social: It must be expressed through practical and loving action toward others, and life in the Church is essential. Finally, repentence is a continuous act; transformation is never final.

Of these basic assumptions the first and last are especially relevant here. Veneration of an icon such as the *Spas* is an essential part of the daily rituals through which an Orthodox believer hopes to attain *theosis.* Such an icon serves as a channel of grace, enabling a change of identity of the person who venerates it. But this change must be continuously affirmed. As I will further discuss, Malevich's *Black Square* also was intended as a vehicle for transformation; in his many writings, he considered it an icon for his time. For Bakhtin, however, transformation of the self does not just involve revelation and grace, as the use of the icon implies. It means work: continuous moral action with and for others. In this, he shared in the traditional antiquietism of Orthodoxy.

In discussing each image, I limit my remarks to the following: first, issues arising from their particular historical contexts; second, formal elements such as material, composition, and so on; third, the way the role of the artist was understood; fourth, those general

religious issues pertinent to each painting. Finally, my analysis is organized around the four questions derived from Bakhtin's work.

In approaching these two images, I seek what Bakhtin has called "creative understanding." In this view, the fact that one does *not* belong to or share in the specific time, space, or culture of the artifact one analyzes is a necessary precondition for real dialogue, creativity, and understanding. Our outsideness from the artifact or culture and the boundaries that separate us are what make creative understanding possible. Creative understanding, wrote Bakhtin:

> does not renounce itself, its own place in time, its own culture; and it forgets nothing. In order to understand, it is immensely important for the person who understands to be *located outside* the object of his or her creative understanding – in time, in space, in culture. For one cannot even really see one's own exterior and comprehend it as a whole, and no mirrors or photographs can help; our real exterior can be seen and understood only by other people, because they are located outside us in space and because they are *others*. (SG, 7)

This theme of outsideness is crucial to my interpretation of the icon and Malevich's abstract painting.

Finally, a few remarks about the specific art historical methodology I employ here. If I were discussing this icon in the shadow of nineteenth-century rationalism, which culminated in the art historical writings of Heinrich Wölfflin and Alois Riegl, I would focus on formal analysis of the structure of the icon (for example, its composition) rather than any of the religious or mythic content of the *Spas*. If I had been writing just after 1920, following Erwin Panofsky's campaign against formalism, I might have focused not only on iconographical problems, but also on what Panofsky called iconology, the cultural and historical context of the work.

But I have been influenced by what T. J. Clark has called "more general historical structures and processes." The main premise of this approach is that "art is not hermetic and autonomous [within culture], but is bound up with the social and economic movements of its time, as well as conditioned by both artistic tradition and aesthetic ideology."[4] This starting point is consistent with Bakhtin's view as well.

SPAS NERUKOTVORNYI

In beginning to examine the historical context of the icon, let us first focus on the question of boundaries. What are the implied and

actual boundaries in the *Spas*? Are we inclined to identify and em-
pathize with Christ through the image, or are we prompted to
become cognizant of our historical and religious outsideness? In a
sense, the obvious answer to the latter question is yes, but why?

The *Spas nerukotvornyi* is the icon traditionally venerated on the
first Sunday of Lent, when the Church celebrates the dogma of the
Incarnation and the victory of the use of holy images at the Seventh
Council of 787 in Nicea. The *Spas nerukotvornyi* serves as the focus
of the ceremony during the Orthodox service when decisions of
this Council are celebrated. On this Sunday of the Triumph of
Orthodoxy, the words of the Kontakion are sung – "The Word of
the Father, transcending all determination, determined Itself in Its
incarnation through Thee, Bearer of God. He made the defiled
image as of old, and penetrated it with Divine Beauty."[5] Thus, as
Sherwin Simmons observes, "the *Spas nerukotvornyi* is the ultimate
example of the iconic tradition just as the *Mona Lisa* had become
the supreme image of Renaissance-based Western painting."[6]

The title of this icon is a translation of the Greek *acheiropoietos*,
"made without hands." It tells us that the subject matter is Christ,
the Savior, who was not made by human hands. The icon was
painted (or more properly, *written*) in the town of Novgorod in the
late twelfth century, and was for many years in the Cathedral of
the Assumption in the Kremlin. It now hangs in the Tretiakov
Gallery in Moscow.

A special note must be made about the meaning of *acheiropoietos*,
especially in this context where Bakhtin's ideas are used. Generally,
an *acheiropoietos* is of two kinds: "Either they are images believed
to have been made by hands other than those of ordinary mortals
or else they are claimed to be mechanical, though miraculous, im-
pressions of the original."[7] The story behind the *Spas* (as will be
clear shortly) is based on the latter. *Acheiropoietos* meant the opposite
of *cheiropoietos*, which literally means man-made, and has the spe-
cific connotation of being idolatrous. "*Acheiropoietos*, therefore,
perhaps may mean not only 'not idolatric', but also 'not in the realm
of art'."[8] Such an image would not need to be evaluated by tra-
ditional standards for judging human handicraft. This was certainly
true of the Russian icon tradition, where icon painters were spe-
cially trained and prepared for their vocation. In this context, Bakh-
tin's ideas about answerability, about the aesthetic event and the
act or deed, are directly relevant to the analysis of an icon such as

the *Spas*, for the icon painter was trained according to and bound by a very particular set of moral obligations and responsibilities.

Another perspective on the visual conventions of the form and content of the icon may be gained from considering the creator. The role of the traditional Russian icon painter was very carefully prescribed. Initially, icon painters were anonymous. They usually followed pattern books, *podlinniki,* for painting their subjects. The icon painter had to be a "transformed person in order to be able to present in his work a transfigured being and a transfigured universe."[9] As the priest was supposed to "constitute the Lord's Body through the Divine Word," so the icon painter "in place of the Word, paints and depicts and gives life to the body."[10] The act of painting an icon is described with the linguistic metaphor of translation: The painter quite literally creates a *perevod*, a translation. Though the form and iconography of the image were carefully prescribed, painters often added individual stylistic touches. The aesthetic act of the painter thus enlivens the image for generations of subsequent viewers of the icon. However, just as the icons became marketable objects in later centuries, so the painter's role changed radically from priest-figure to producer for a consumer market. The earlier anonymity of the icon painter was replaced by painters who signed each icon.[11] Thus, the painter's answerable other shifted from the Church to the consumer market.

In churches of the pre-Mongolian period, icons hung on low iconostases or on small pillars. Such churches of the eleventh and twelfth centuries may have possessed a few dozen icons each.[12] Evidence that the *Spas* is a Novgorod icon is discernible through its stylistic similarities to Novgorod miniatures and to frescoes in the cupola of a nearby church in Nereditsa.

Several different forms of the *Spas* had begun to appear in the sixth century in the Byzantine world, and played a role in ecclesiastical life. In the seventh century, it was used in Syria and Cappadocia, and the image continued to migrate from there, becoming very popular in Rus'.[13]

The tale behind this icon belongs to a complex tradition that any viewer in the twelfth century would probably have known. The legend probably originated in third-century stories about a sculpture set up at Paneas, which showed Christ healing a bleeding woman, as in Luke 8:44.[14] By the seventh century, a new story had evolved. In this version, Veronica went out in search of a painter for an image of Christ. When she accidentally met Christ, he took

her cloth and left an impression of his face on it. Hence, one of the titles of this icon: the Veil of Veronica. By the twelfth century, this story was conflated with the incident of Christ wiping his face while on the road to Calvary with a cloth that later was kept at St. Peter's in Rome. It was called the *vera eikon*, the Veronica. Then popular legend arose that a woman named Veronica actually was the one who offered her headcloth to Christ, and he returned it to her with his image on it.

Further complicating this tradition were the stories around the mandylion of Edessa and Abgar.[15] King Abgar the Black of Edessa had leprosy. Hearing of Jesus' ability to perform miracles, he sent his scribe Hannan with a letter asking Jesus to come and heal him. While there, Hannan tried to paint a portrait of Jesus, but could not, because of Jesus' changeable face. Seeing Hannan's frustration, Jesus pressed his face to the cloth, leaving an imprint of his image. Hannan returned to Edessa, taking also a letter in which Jesus praised the king for his faith. Abgar was healed.

Two common elements in all of these legends emerge: first, that none of the images was made by human hands; and second, that they supposedly offered an exact likeness of Christ. An image such as the *Spas nerukotvornyi* was seen as a direct embodiment of the Incarnation because it was understood as not made by human hands. It was, rather, "the exact terrestrial image of a heavenly prototype."[16] As already suggested, in the twelfth century while Orthodox Christianity was still new in its transplanted Russian context, such an image was important as justification for the use of icons in churches.[17]

Very little is known about the actual historical context of *Spas*. Only a few confused verbal records remain that tell of Rus' in the twelfth century, less than two hundred years after Byzantine Orthodoxy was introduced by St. Vladimir.[18] Of these, the *Chronicle of Novgorod* provides the most evidence concerning life in that city during this period.[19]

Begun in 1016, the *Chronicle of Novgorod* was compiled mostly by ecclesiastical writers, as is evidenced by multiple references to the construction, consecration, adornment, or destruction by fire of churches and monasteries in almost every year in the twelfth century. There were thirty-four small churches and thirteen monasteries plus St. Sophia, the one cathedral in the environs of twelfth-century Novgorod. Specifically, in the entry for 1144, the chronicler identifies himself as a priest. Other topics mentioned include

politics, war, and government as well as climate and natural conditions affecting the production of food.

But the ecclesiastical perspective explicitly given in the *Chronicle* must be held in tension with another possibility: that pre-Christian paganism was still prevalent at this time. Scholars have named this phenomenon *dvoeverie*, "dual faith." Consider, for example, the twelfth-century prohibitions given by a bishop of Novgorod against consulting shamans (*volkhvy*) and against performing sacrifice.[20] Christianity had been imposed from above in ancient Russia, and it remained for centuries a religion of the rulers. Active resistance to this new cult remained until at least the eleventh century, when more passive practices were prevalent. Still, remnants of pagan rituals continued in the country, and included "magic rites of fertility, sacrificial offerings of food and animals, the continued popularity of soothsayers, the belief in vampires, the cult of fire, and the wild revelry of popular feasts."[21] Evidence that these rituals were still practiced as late as the seventeenth century comes from sermons of this period.[22] Conversion from paganism to Orthodox Christianity was not completed until this later period.

A relevant example of how pagan symbols were Christianized is the chaplet of birch leaves that were hung with rags and linen and placed in the *peredni ugol*, or front corner, of the hut during particular pagan festivals. Later, converts to Christianity developed the practice of installing the icon in that same corner with a burning wax candle in front of it.

From much of the historical scholarship, one gleans the impression of an early Russian monasticism based not on knowledge of the scriptures, but on living a pious and ascetic life. In the larger population, few people were inclined toward Christianity. "[T]he mass of the population in ancient Russia of the pre-Mongol period [prior to the early thirteenth century] had not the time to assimilate anything – either the external form, or the inner meaning of the Christian faith."[23]

Although no records exist that indicate its exact location in Novgorod, the *Spas* was probably in a monastic church where it would have been used for meditation and devotion primarily by monks and priests, and other early members of the Church. The Church Ordinance issued to St. Sophia in Novgorod in the twelfth century identified the early members of the Church other than priests and monks as *izgoi*, literally persons of changed status: the illiterate sons of priests, ruined merchants, or freed slaves.

To return to the question posed earlier, I submit that we are indeed compelled to acknowledge our position as historical viewers; we are forced into awareness of our own consciousness. The boundaries between our everyday reality, the spiritual reality on which the icon rests, and its historical importance thereby are maintained. In his early texts, Bakhtin began to develop his understanding of the active role of the audience in provisionally completing a work. He told us that for the scholar, analysis of content is especially difficult because of that person's subjectivity.[24] Further, the nature of the *Spas* as a religious icon prevents the viewer's complete identification with Christ. The formal stylization of his face and the rich gold material used in its construction suggest otherworldliness and transformation.

What else can we say of the kind of faith or trust that was and is encouraged through this painting? As a traditional religious icon, the *Spas* is obviously meant to encourage faith and trust in God, and in Christ as the Savior and Redeemer. But as Anthony Ugolnik has pointed out, "Divine life comes to us in community. No Russian Orthodox believer would think to call this Jesus 'personal'. He is a cosmic Savior – he does not belong to me alone."[25]

According to Bakhtin, Christianity developed through a process of assimilating heterogeneous elements from Judaism, Hellenistic culture, Gnosticism, and, of course, the teachings of Christ. In particular from Christ, Orthodox Christianity took over a twofold attitude of severity toward the self coupled with kindness toward the other. This marks the appearance of what Bakhtin calls a deeper spirit, or I-for-myself.

For the first time, [in Christ] there appeared an infinitely deepened *I-for-myself*, not a cold *I-for-myself*, but one of boundless kindness toward the other; an *I-for-myself* that renders full justice to the other as such, disclosing and affirming the other's axiological distinctiveness in all its fullness. (AH, 56)

Faith and trust in Christ is powerfully communicated through this image and others like it.

What kind of consciousness does the *Spas* imply and/or elicit? Does it imply a solitary consciousness or a meeting of at least two consciousnesses? In answering this question, let us examine some of the formal elements of the icon.

The material of the icon consists of a 30¼″ × 28″ wood panel, which was painted with tempera. The icon contains only a few

hues: gold in the background, white for the partial cross, and vary-
ing shades of brown to yellow for Christ's face and hair. The se-
lection of colors for this image is extremely restrained and laconic;
the painter's sparse coloristic scale is built on a combination of olive
and yellow tones.[26] The icon thus has a strong value contrast. The
use of gold is ubiquitous in icons because of its symbolism. For the
Byzantine and Russian churches and their icon painters, gold was
a form of light; and light itself was a special and privileged symbol
of the divine. As suggested in John 1, light is the metaphor for God.
Gold symbolized not just light as transparency, but light as the
brilliance and glory of divine energy acting in and through matter.[27]

It is obligatory for inscriptions of the divine name to appear on
all icons of Christ.[28] Here only traces remain in the upper corners
outside the nimbus suggesting the letters IC XC – Jesus Christos.
In the areas of the cross, one can see the outlines of further orna-
mentation that have also disappeared or been removed. According
to Andre Grabar, who studied the resemblance of this icon to oth-
ers, additional ornaments of colored and pearly white stones or
gems may have been attached to the icon.[29] Yet, traditionally, on
the three branches of the cross, the Greek letters for the name of
God as it was revealed to Moses in Exodus 3:14 were supposed to
appear.[30]

The composition is symmetrically balanced. Two similar curls
of hair hang from each side of Christ's head. His beard also has two
knobby curls. His ears, following proper icon tradition, are the
same length as his nose. The two sides of his face are similarly
shaded. The Savior's head is centered in the icon; his eyes appear
to look to the right. (The interpreter must keep in mind that we
interpret the icon from within, as it were, from the Savior's per-
spective. The left was considered evil and impure, and Christ would
not have looked in that direction.) On closer inspection, the viewer
may notice that one eye looks ahead, whereas the other looks to
the right. Like faces in most other icons, this face is frontal; it turns
toward the viewer. A partial cross appears behind his head. Both
cross and head are contained within a light gold circle, a nimbus,
that nearly fills the darker gold square of the wood panel. The
straight lines of the cross and the edges of the icon differ sharply
from the curving lines of the circle around Christ's face. This sense
of contrast is also heightened by contrasts in the rendering of his
head. On the one hand, Christ's hair is painted with highly stylized
light lines that imitate stone carving. His eyes and eyebrows are

also drawn very formally, with strong dark and light contrast. On
the other hand, his mouth, moustache, and beard are rendered
more naturalistically.

Because the image of Christ's head partially obscures the white
cross, and because of the realistic shading in parts of his face, the
image seems to move out into three dimensions. Yet the circle that
encloses the face and cross creates a boundary that holds the image
in the two-dimensional plane. Spatially, the image hangs in limbo
between two and three dimensions. Like the linear and coloristic
elements, the general composition works to give the impression
that the face both *is and is not* of this world. Like many other icons
of Christ or the Virgin, it does not employ the usual inverted per-
spective of most icons.

The visual balance of the image is broken only by the oblique
direction of Christ's eyes, which become a major focal point. The
viewer is drawn immediately to his eyes. Here the form "exter-
nalizes" content.[31] The *Spas* might be thought of as a "borderline
face" analogous to the kind of "borderline consciousness" Bakhtin
advocates. This face simultaneously suggests the boundaries of the
material and spiritual worlds and the boundaries that separate one
person's consciousness from another. Such a face is the opposite of
the fraudulent image one sees when looking in a mirror.

Where does Christ look? What does he see? His sidelong glance
seems to affirm the duality already noted. The Savior seems to look
into *our* space; and also into an unknown, perhaps otherworldly
dimension. The world represented in the icon is a self-contained
space. We, as viewers, enter the picture and "the dynamics of our
gaze follow the laws governing the construction of this microcosm.
In this microcosm there is an external and internal sphere, so that
we look at it as if simultaneously both from the outside and the
inside."[32] According to the tradition, we are given a vision not of
what appeared before an artist's eye, but rather of what Christ, or
God, really *is*.[33]

Clearly, though it represents one person – Christ as the Savior
– this image implies communion with and salvation for others. In
this image, we see a representation of Bakhtin's words:

[I]n all of Christ's norms the I and the other are contraposed. For myself,
absolute sacrifice; for the other, loving mercy. But I-for-myself is the other
for God. . . . God is now the heavenly father who is over me and can be
merciful to me and justify me where I from within myself cannot be
merciful to myself and cannot justify myself in principle. . . . What I must

be for the other, God is for me. What the other surmounts and repudiates within himself as unworthy, as an unworthy given, I accept and treat with loving mercy as the other's cherished flesh. (AH, 56)

This is what God through Christ offers to us; this, in turn, is what we offer to others. The *Spas* is considered a vision of God, and therefore it makes this relationship of consciousness to consciousness – of God to the self and of the self to other persons – explicit.

This icon not only embodies the duality of "this world" and an "other world," as in the King Abgar legend, but the three-armed cross also suggests the trinity. Further, as was common in Orthodox icons, the Christ represented here is not a crucified or suffering person, but Christ as the Savior or Redeemer. Thus, for monks untrained in the literary traditions of Christianity, this icon not only is its own self-justification, but it presents a theology of salvation as well.

We now come to the final question: To what extent is the *Spas* finalized and complete? As a form of "authoritative discourse," this icon has a hallowed place in the Orthodox icon tradition. In this sense, its significance is established and given. But from another perspective, the *Spas* remains open. It is an image *of* and an image *for* transformation. The legend of King Abgar suggests that, quite literally, *Spas* embodies transformation. Yet it also functions to bring forth the transformation of the beholder. What the icon reveals is the significance of the human: Deity is embodied in human form; mystery has a face. In the icon, we find our dignified place within the "heavenly hierarchy" as an integral part of the world order.[34]

BLACK SQUARE

Malevich's painting presents a considerable challenge to an interpreter. On the one hand, it seems as though there is little to say about such a minimal painting. Its otherness and seeming nonreferentiality aroused antipathy and curiosity when it was first exhibited, and the painting continues to arouse such responses today. On the other hand, it is a vivid painting that in many ways refers to and parallels the *Spas*. Using the questions derived from Bakhtin's work, much of my argument here centers on how this image refers to icon painting and functions as a contemporary icon.

What of the issue of boundaries? *Black Square* does not encourage the viewer's empathy or identification. Visually, this lack of empathy results from the lack of spatial depth and because the square seems to rest on the surface of the canvas. The viewer is deliberately kept outside and encouraged to contemplate the nature of this mysterious form and his or her relationship to it. How does this relationship of the viewer to the painting come about and what are its historical implications?

The situation surrounding Kasimir Malevich's *Black Square* was markedly different from the origin of the *Spas*. Like the years following the October Revolution, prerevolutionary Russia was a time of tremendous creativity in many disciplines, including philosophy, theology, music, dance, theater, and the visual arts. In particular, Nataliia Goncharova was responsible for introducing a generation of artists to the icon tradition. This group included Malevich, often called the key theorist of Suprematism.

As a movement, Suprematism was one of several attempts in the early twentieth century to address the viewer's spirit (or soul, in Bakhtin's technical use of the term) directly through pure form and color. Specifically, it tried to establish a spiritual basis for abstract art. The spiritual was understood by artists such as Kandinsky and Malevich as "that quality that expresses the highest human potential," including all forms of knowledge to which human beings aspire.[35] In his writing about this and other paintings, Malevich focused on the "supremacy of pure feeling," trying to rediscover a more "pure art which, in the course of time, had become obscured by the accumulation of 'things'."[36] Suprematist feeling, however, was never meant to be synonymous with personal emotion. Rather, Malevich referred to a *supra*personal or spiritual feeling to be conveyed through the work. He used phrases such as "supremacy of pure feeling," "feeling as such," "feeling of nonobjectivity," and "this desert filled with the spirit of nonobjective sensation" to describe what is essentially beyond our cognitive power:

The keys of Suprematism are leading me to the discovery of what is still not realized. My new painting does not belong to the earth exclusively. The earth has been deserted like a house destroyed by maggots. And in fact, in the human being, in his consciousness lies a striving toward space, a gravitation to "separate from the sphere of the earth."[37]

Although this statement can be interpreted as a literal desire to ascend, float, or fly, it more directly relates to the theme of mate-

rialist versus spiritual values that pervades much of Malevich's writing between 1915–22. As Troels Andersen put it, "Suprematism represents a phase in Malevich's artistic existence in which he wholly dedicated himself to the idea of an expansion of man's psychic possibilities beyond the earthly range of ideas relating to things."[38] In the context of revolutionary and postrevolutionary Russia where people were struggling to develop a functional materialist and communist ideology, Malevich wanted to maintain a place for the spiritual.[39]

Nevertheless, according to his own account, Malevich's family was not religious. He had first encountered icons in the home, where they hung more for the sake of tradition than from religious feeling. "Neither my father nor my mother were particularly religious, as they always had some reason for not going to church."[40] Later, near the end of his life, Malevich wrote that his acquaintance with icons had convinced him that the study of anatomy, perspective, and naturalistic rendering was not essential. To depict nature was not as important to him as "the sensing of art and artistic reality through emotions."[41]

Through icon art, I understood the emotional art of the peasants, which I had loved earlier, but whose meaning I hadn't fully understood. In what way did this art overturn my striving for lifelikeness and the sciences – anatomy, perspective, the study of nature through the drawing of sketches? All of the Itinerants' convictions regarding nature and naturalism were overturned by the fact that the icon painters, who had achieved a great mastery of technique, conveyed meaning outside of spatial and linear perspective. They employed color and form on the basis of a purely emotional interpretation of theme.[42]

Simultaneously in 1913, Nataliia Goncharova and others exhibited their paintings based on icons, and actual icons were cleaned – many for the first time – and shown in an historic exhibition celebrating 300 years of Romanov rule in Russia. From the icon tradition, painters such as Goncharova and Malevich appropriated such qualities as flattened forms, bright colors, stark color contrast, and a theory that the image could be a window to the divine. I. S. Ostroukhov, owner of a collection of icons, and one of those involved in their systematic cleaning, wrote at that time: "The icon takes us into an absolutely special world, one that has nothing in common with the world of painting – into the world beyond, a world created by faith and filled with representations of the Spirit, not of the flesh."[43]

Evidently, Malevich neither knew nor understood the precise
meaning of *Black Square* when he first painted it. Nevertheless,
according to one of his students, he later told them that he realized
this was such an important event in his artistic life that for a week
he could not drink, eat, or sleep.[44]

When it was first exhibited in the *krasnyi ugol* of the "0–10" Last
Futurist Painting Exhibition in Petrograd,[45] Malevich's *Black Square*
was seen as a contemporary icon (Figure 24). Critic Alexander Be-
nois wrote: "Undoubtedly this is really that 'icon' which the fu-
turists posit in place of madonnas and 'shameless' Venuses. . . ."[46]
Further, he argued,

Black Square on a White Background – is not just a joke, not a simple chal-
lenge, not a small chance episode which happened to take place on the
Field of Mars. It is an act of self-affirmation – of the principle of vile
desolation. Through its aloofness, arrogance, and desecration of all that is
beloved and cherished, it flaunts its desire to lead everything to *destruc-
tion.*[47]

Figure 24 "0–10" Last Futur-
ist Exhibition, Petrograd, De-
cember 17, 1915–January 19,
1916.

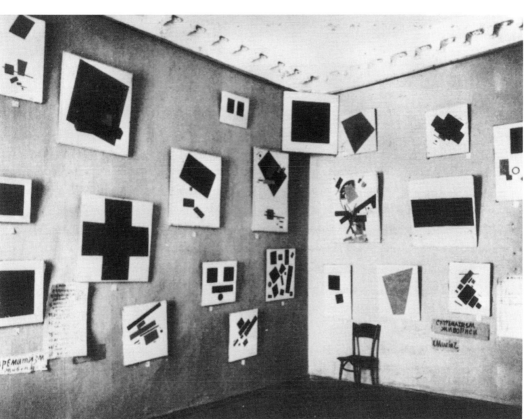

In this context, Malevich's work was widely known and criticized. On the one hand, some considered it purely a nihilistic symbol, a demonstration of the death of painting. On the other, his friends and students considered it "a kind of *tabula rasa* manifesting the end of the ancient order of representation."[48]

In countering this accusation of nihilism, Malevich announced that *Black Square* symbolized the birth of new painting; and in this sense, it was profoundly answerable to and within its historical context. "Suprematism is the beginning of a new culture: the savage is conquered like the ape. . . . The square is not a subconscious form. It is the creation of intuitive reason. The face of the new art."[49] Further, in his essay "To the New Image," Malevich wrote of his attitude toward icons such as the *Spas*:

Your face is rubbed as smooth as an old coin; for many centuries it has been cleaned by authorities, and with the ray of past beauties they have rubbed your bold image smooth. They tried to file down your soul and creative spirit in the image of gods long dead, and in this way ironed out your acute "ego." . . . But we form our own time, with our time and forms, and place the stamp of our face, leaving it in the flow of centuries where it will be recognized.[50]

Curiously, the word "image" in the title of Malevich's essay is a translation of the Russian *lik*, which means the representation of a face on an icon. In his own "icon," Malevich wanted to create an image that would be recognized as representative of *his* historical time and values. (His use of the symbol of the face here is also notable, and I return to this shortly.) Both the historical and visual boundaries of *Black Square* are distinct, and may be read as a metaphorical statement regarding our separation from it.

How do the formal elements of this painting communicate, and what kind of consciousness is implied here, and can we find in it the kind of personal answerability Bakhtin touted? *Black Square* is in Russia; like the *Spas,* it is owned by the Tretiakov Gallery.[51] The 79.5 cm × 79.5 cm oil painting consists of a black square with a white border measuring approximately 7.6 cm on each side.[52] Unlike the *Spas,* there are no identifiable objects, incidents, or characters represented in the picture. It has no hue, because it is black, and is of the lowest value. This defines its material.

Here we see a similar spatial ambiguity as in the *Spas nerukotvornyi.* The black square suggests both volume and empty space. Because it is positioned with the edges in the horizontal and vertical

(rather than diagonal), it is static, implying stillness and lack of
movement. Looked at from one perspective, *Black Square* has no
depth but seems to rest on the two-dimensional surface of the can-
vas. However, the blackness also suggests night, space, and great
distance. This duality also typifies the *Spas*. One could say, using
Bakhtin's language, that the compositional form reveals the paint-
ing's architectonics: Form quite literally embodies content. Qual-
ities such as heaviness, weight, displacement, and spaciousness are
embodied in the form of the black square; Malevich did not choose
to paint them in ways that refer to worldly phenomena.[53]

Two further interpretations focus on the *Black Square*'s formal
qualities. First, the square seems to express binary thought through
the juxtaposition of black and white, something and nothing, form
and spatial border. In Malevich's words: "The square = feeling,
the white field = the void beyond this feeling."[54] Second, the
square appears in "floating fields of light permeated by *Urspannun-
gen des Werdenden . . .* [and] can seemingly with equal justification
be understood as the result of elementary thought processes and as
a primary emotional structure."[55] Representing the source of the
tension or pressure of becoming, the image coalesces as a result of
both cognition and feeling.

Malevich's own attitude toward the painting vacillated in his
writing about it as he tried to rationalize the early experiments. The
square gradually became a symbol for the fact that reality can never
be adequately interpreted or reproduced realistically; it is "simply
a *locus standi* for our experience of form and space."[56] "What, in
fact, is the [Suprematist] canvas?" asked Malevich. "What do we
see represented on it? Analysing the canvas, we see, primarily, a
window through which we discover life."[57] If indeed we only re-
main outside the work, then its impact would be minimal. We
would be separated from the image historically and visually. But
the fact that *Black Square* can function as a window implies both an
outside and an inside; it implies a first consciousness that creates
(the artist), and a second consciousness that recreates through con-
templating the completed work (the viewer).

Malevich himself wrote briefly about the nature of consciousness
in a 1922 essay, "On the Subjective and Objective in Art or on Art
in General." By the word "consciousness," he claimed:

we should understand the simple action of a particular complex of ele-
ments upon a second complex which it encounters en route. This action

is the simple effect of two phenomena which change each other. . . . Take a man walking in a certain direction: he comes across a stone on his path and he has to remove it: both complexes have changed each other immediately. The first made various movements and connected them with the stone until the stone itself was changed from one position to another.[58]

It is notable here that Malevich, unlike Bakhtin, chose an inanimate object to interact with his consciousness. But his emphasis was not just on the conscious movement of the man who moves the stone; rather, through this example, he suggested the interaction of two forces, two "complexes." Bakhtin was adamant that both sides of any encounter – both consciousnesses – must be capable of being transformed through the encounter.

For Malevich, the creative principle lives in each person: "for every human skull bears the same power and principle: hence the receptibility of mutual understanding and agreement; only in this way can the [creative] idea develop."[59] Though difficult to interpret, in my view, *Black Square* succeeds in communicating the presence of two consciousnesses.

How did Malevich understand the role of the artist of a painting and the degree of finalization of an artwork? Malevich's earliest attempt to sketch out a view of the role of the artist was in his short 1915 essay, "The Artist":

The artist of color, the artist of sound and the artist of volume – these are the people who open the hidden world and reincarnate it into the real. The mystery remains – an open reality and each reality is endlessly multifaceted and polyhedral. . . . The artist discovers the world and shows it to man. . . .[60]

As already noted, Malevich was not concerned with the world of objects and nature. Instead, he wanted artists to portray the "hidden world," the "mystery"; and this is what links his understanding of the modern artist's cultural function with that of the icon painter.

The icon is being saved in the attic of the arrieregarde's scalps, and now they want to marry it off to contemporary life with a dowry of silver and gold clothes made by the popes. Dressed up in new meaning, and not religious meaning either . . . she has by now almost acquired a new meaning, appropriate to contemporary life. . . . The icon can no longer be the same meaning, goal and means that it was formerly; it has already passed on into the museum where it can be preserved under a new meaning, not of religious conception but of art. But as we go deeper into the new creative meaning it loses even that significance and nothing can be in-

vested in it for it will be the soulless mannequin of a past spiritual and utilitarian life.[61]

Like Gotthold Lessing, Malevich separated religion and art; he distinguished between religious ritual and an object destined for a museum.

In the lively postrevolutionary context, Malevich saw two sides pitted in a struggle for power. On the one side, "the fighting, destructive avant-garde with the banner of economics, politics, rights and freedom"; on the other, "the creative army which appears after it." On the first side, revolutionaries who became counterrevolutionaries and creative people who became academics; on the other, those who believe that "creativity is the essence of man, as the highest being in nature, and everyone should take up this [creative] activity."[62] Bakhtin, although he did not write directly about the avant-garde or the revolution, would have agreed with Malevich that creative activity is as integral to human life as love.

In defending his painting against the attack of Alexander Benois, Malevich wrote, "I have a single bare and frameless icon of our times (like a pocket) and it's difficult to fight. But my happiness in not being like you will give me the strength to go further and further into the empty wilderness. For it is only there that transformation can take place."[63] Although this statement is obscure, Malevich made three assertions here.

First, *Black Square* was his "naked, frameless icon." His icon, however, was not to be the "soulless mannequin of a past spiritual life," but a vibrant, even shocking statement relevant, answerable, to his time. Second, this painting offered the necessary strength for entering into the void or the wilderness. Indeed, as described earlier, Bakhtin, Berdyaev, and others had written of the years that immediately preceded and followed the revolution as a time of continuous cultural upheaval and change. Strength and fortitude were essential. Third, transformation was possible through the process of confrontation and determination. Whether Malevich meant "transformation" to refer to Christ's transformation in the wilderness, or to a more general human transformation, is impossible to know.

But this idea also links him with the tradition of the icon painter, who had to transform himself before he could paint images of transfiguration. As expressed in many of his essays of this period, Malevich seemed to believe that he was different from people of the past, and that in his era, the past was being radically transformed.

It is necessary to consciously place creativity as the aim of life, as the perfection of oneself, and therefore current views of art must be changed: art is not a picture of pleasures, decoration, mood, experience or the conveyance of beautiful nature. . . . We are entering a new paradise and creating our new image, throwing off the mask of the old deity.[64]

Malevich would have agreed with Bakhtin that transformation requires work.

At the end of "The Problem of Content, Material and Form," Bakhtin asserted that, because the visual arts involve the use of tools, form *and* content *and* artist are more inseparable than in verbal creation. Certainly, it is obvious that the form and content of *Black Square* cannot be separated. But I would suggest that, Malevich's writing about the painting notwithstanding, the artist and the artist's intentions may be more readily detached from the meaning than would be possible in a naturalistic or representational painting, or in a verbal text. The subjectivity of the viewer becomes even more important than that of the creator in constituting and defining this aesthetic object. In other words, the consciousness of the viewer is crucial, even determinative, for completing the work. Through the process of understanding it, the viewer gives the painting meaning. In this sense, *Black Square* is finalized in the consciousness of the other, just as it simultaneously refers to Bakhtin's absolute and mysterious Other.

As I asked earlier regarding the *Spas*, what kind of faith or trust is encouraged via this painting? Much of the rhetoric surrounding *Black Square* would suggest that it should be viewed as an icon that communicates similar religious feeling as the *Spas*. But can the viewer avoid attributing to Malevich more nihilistic intentions, or experiencing a nihilistic emptiness in viewing the painting? Can we reasonably speak of faith or trust in God when faced with a large black square?

Malevich seldom wrote explicitly about God. One of the most direct statements is found in his 1915 "I Am the Beginning": "I search for God, I search within myself for myself. God is all-seeing, all-knowing, all-powerful. . . . I search for God, I search for my face, I have already drawn its outline and I strive to incarnate myself."[65] This might be taken as yet another affirmation of his understanding of *Black Square* as a symbol for the divine. Much of this essay is a meditation on the trinitarian God.

Later, in his 1920 "God Is Not Cast Down," Malevich tried to come to terms with the relationships of God and humans, of church

and factory, of spirit and matter. Malevich there talked of four basic reasons for human production.[66] First, he suggested that humans create in order to appease a vengeful God who pursues us in order to punish us. Second, by producing, we express our central humanity and thereby cease self-flagellation. Third, we simply participate in the struggle for survival. Finally, we create as part of our striving toward God. "Different peoples portray God in different ways, but, however they do it, all the representations have one thing in common – that God is perfection."[67] And human beings hope to reach God or perfection through all that they produce.

In sum, *Black Square* may be considered an icon of the divine from several perspectives. As already discussed, Malevich's writings about this painting give clues about why this is a reasonable answer. It is his "naked, frameless icon" that offers the experience of and perhaps the strength for confronting the void, that is, God. Transfiguration of the viewer is possible. Like the icon painter, who had to be a transformed person in order to be able to represent spiritual transfiguration and the divine, Malevich invites the viewer to be transformed through the work. In his view, there were three paths to God: the spiritual or religious, the scientific or mechanical (for example, in the factory), and the artistic. His *Black Square* combines the artistic and the spiritual.[68]

Further, as mentioned earlier, it was hung in the "0–10" Exhibition in the place usually reserved for icons. And, finally, Malevich's statements about the "face" suggest direct parallels with the *Spas*. As mentioned earlier, he calls it "the face of the new art." Olga Rozanova had written in 1913:

There is nothing more awful in the World than an artist's immutable Face, by which his friends and old buyers recognize him at exhibitions – this accursed mask that shuts off his view of the future, this contemptible hide in which are arrayed all the "venerable" tradesmen of art clinging to their material security.[69]

Here "Face" referred to the artist's style expressed through the work, which served to identify him or her to the public. Malevich built on Rozanova's comment when he wrote: "In the last analysis, what each individual knows about himself is precious little, because the 'actual human face' cannot be discerned behind the mask, which is mistaken for the 'actual face'."[70]

This tension between the face of God and the human face is made even more explicit in Malevich's "Kor re rezh":

Not having found a beginning for myself I yelled out: "And the Lord has created me according to his own image and likeness" and thus now I hold a notion of God, His face and my face bear a similar identity. Over the centuries of my creation I have lost in many ways parts of my face. . . . The beginning of my face has been engendered in the desert but it is on the Sixth Day of Creation that I became alive, so complicated was my face. . . . Now is the first day of the creation of the New Dimension, of the basis of the beginning of My Face transformed into a new being.[71]

If we assume that Malevich used the word "face" consciously, we might interpret this painting, like the *Spas*, as a face. Malevich was even more specific about this: "I see in it what people at one time used to see before the face of God."[72] This, however, is a very ambiguous statement. What did people see before the face of God? What was the "face of God"? Perhaps he was alluding to the mystery that surrounds all speculation about God and the spiritual dimension of life. The effect of Malevich's words is to isolate the content from direct identification with nature and life, yet *Black Square* remains open to ethical and religious evaluation.

Finally, we might say that the painting is a cultural icon in a more colloquial sense: It remains one of the most significant paintings marking the development of abstraction in the twentieth century.

CONCLUDING REMARKS

Thus far, in analyzing the *Spas* and *Black Square*, I have preferred to use as aids the central ideas that constitute Bakhtin's aesthetics: answerability, outsideness, and unfinalizability. Besides these three key ideas, however, Bakhtin's work offers to art historians and theorists a number of other concepts that I have enumerated and discussed. Many of these have somewhat obvious applications, as I tried to show in earlier chapters. These concepts include the aesthetic event, living-into, the act or deed, obligation, the non-alibi in being versus the pretender, spirit and soul, rhythm, intonation, surplus of seeing, horizon and environment, the artist/hero dichotomy, style, and tradition.

By way of conclusion here, I would suggest that his idea of the aesthetic act — the aesthetic event coupled with the act or deed — helps to reveal one of the most important dimensions of the *Spas* and the *Black Square*. What can it mean to speak of the "aesthetic

act" in relation to the *Spas nerukotvornyi* and *Black Square*? Bakhtin spoke of the aesthetic or artistic act as existing in a value-laden atmosphere of mutual responsibility. This "value-laden atmosphere" means that both cognitive and ethical demands are made on both creator and viewer of a work. Yet a work also engages us beyond either cognitive understanding or ethical evaluation. In Kantian terms, through the cognitive sphere, we create or construct reality; through the practical ethical sphere with its categorical imperative, we create human society. Only in the aesthetic sphere are these two unified. As Bakhtin wrote, "aesthetic activity . . . humanizes nature and naturalizes the human."

Spas nerukotvornyi and *Black Square* are images *of* and images *for* transformation. *Spas* is an expression of Russian Orthodox theology. The *Spas* evokes a strong sense of this mystery, through its allusions to duality and trinity. *Black Square* leads one simply toward contemplation of ultimate mystery. *Black Square* evokes mystery through its blackness and opacity. In the tradition of negative theology, God has long been associated with mystery; and many theologians have argued that this is an especially appropriate way to speak about God. I should at least note that Bakhtin would have found such valorizing of mystery unattractive. In the early texts, his understanding of creativity does not have an explicit place for mystery. Yet, I think that his notions of God as the absolute other and the divinity of the artist cannot avoid an implicit ineffability. In the aesthetic act, not only is the text or artwork created, but self and world are constructed.

BAKHTIN AND POSTMODERN
ART THEORY

Within the discourse about contemporary art, especially since the late 1960s, attention has shifted from interest in the artist and the artist's biography to concern with either the object or the viewer. Modernist theories of art from Clement Greenberg to Michael Fried have focused almost exclusively on the object as the center of aesthetic contemplation. Criticism of the object (including both verbal and visual texts) has taken the form of formalist, structuralist, semiotic, and deconstructive analyses. Postmodernists, drawing on Roland Barthes and Michel Foucault, have directed attention to the crucial role of the viewer in completing (or "finalizing," to use Bakhtin's phrase) a work of art. Reader- or viewer-response criticism has focused on the formative role of the receiver in the creative process. Both object- and viewer-centered theorists have rejected the artist's biography and intentions as determinative of the meaning of an image. Many of these interpretive strategies have involved a breakdown of the standard stereotypes of the artist and "his" activity.

But much of value has also been lost with this realignment of critical interests. Feminists have pointed to the curious and even dangerous fact that white male theorists such as Roland Barthes and Michel Foucault have concentrated on the object and on the "death of the subject" or the "death of the author" precisely as women of all races and men of color have entered the public sphere in increasing numbers.

Moreover, the shift from concern about the artist to an object- or viewer-centered criticism signals another loss: This is the sense that the artist has a *vocatio*, a calling to do artistic work of religious and moral significance. With his reflections about answerability in art and in life, the spirit and soul, boundaries and outsideness, the open-ended and unfinalizable, in short, with his emphasis on the

ethical implications of the creative act, Bakhtin brings us back to the artist as an acting agent and to the artist's cultural function. My intention here is twofold: to show how his perspective balances some of the current theoretical emphases; and to demonstrate how postmodern theory addresses the inadequacies in Bakhtin's modernist positions.

But before entering into this specific dialogue between Bakhtin and postmodern art theory, let us turn to definitions of the postmodern and to the relationship of creator, object, and viewer in discussions about postmodernism.

DEFINING THE POSTMODERN

The word "postmodern" was first used in 1934 by a Spanish writer Frederico De Onis to describe a reaction from within modernism by Spanish and Latin American writers. In 1938, Arnold Toynbee suggested that the postmodern era had begun in 1875 and was characterized by the end of western dominance, the decline of individualism, capitalism, and Christianity, and the rise to power of non-western nations. Clearly, even these early uses of the term presume an interpretation of modernism. Here one needs to differentiate the modern period or modernity from the modernist art that developed in the mid-nineteenth century.

The beginnings of the modern era can be located in the Age of Enlightenment, from revolution in England in 1688 to the French Revolution in 1789.[1] Enlightenment ideals included rationalism, the prestige of the natural sciences, progress, and what may broadly be called the subjectivist turn in philosophy, which gave primary importance to the individual subject, ego or self. Values of equality, toleration, and freedom all had as their basis a rapidly developing individualism, which in turn reflected the Renaissance shift of perspective from the medieval God-centered universe to a "man"-oriented vision of the cosmos. Leonardo's famous drawing, which depicts "Man the Measure of All Things," exemplifies this shift. However, this period was also marked by an increasing alienation of the individual, as bourgeois capitalism began to grow, as religious struggles between Christianity and neoclassical paganism arose, and as gaps began to develop between philosophy, ethics, and art.

The project of modernity was essentially determined by the Enlightenment: to develop the spheres of science, morality, and art

according to their own inner logic with an emphasis on the development of rationality. Philosophers such as Jurgen Habermas assert that the enlightenment project was never completed or perfected, and therefore that such work must continue. Art critics from Alfred Barr to Greenberg have understood art as having developed by its own immanent logic, its autonomy from all other spheres of culture. Other critics such as Richard Rorty say that this project represents a "wrong turn," that science, morality, and art should never have been separated from each other.

The so-called Golden Age of the modern period extended from 1789 to the unification of the German Empire in 1871. The growing authority of science was challenged by the Romantic defense of tradition and nature as historical givens that must not be eclipsed by mechanistic models and methods. Instead, creative imagination was venerated, and the idea of the artist as having privileged access to the sacred or spiritual dimension prevailed. However, Romantic ideals were not to hold sway. Technological innovation and the increase of wealth in the Industrial Revolution reinforced belief that "man" could and would finally dominate nature.

The period between 1871 and 1950 – from the unification of Germany to the emergence of the United States as a world power – could be seen as the decline of modernity. It is also the period often referred to as distinctly "modernist" in terms of cultural practices, especially in art and literature: "something happened in the history of art around Manet which set painting and the other arts upon a new course."[2] Even this very general definition gives the sense that, as W. B. Yeats put it, "things fell apart, the center could not hold."[3] Revolution in Russia and China; devastating world wars; fascism and the Holocaust; the Bomb; struggles against racist and sexist oppression, and for national self-determination (Israel, India, Spain, Central America); the proliferation of mass culture; crises and paradigm shifts in the sciences, especially physics and mathematics; the rise of psychoanalysis; and philosophical attacks against the primacy of the subject (for example, formalism, phenomenology, structuralism): All of these contributed to a radical questioning of modern ideals.

Since 1950, the postmodernist era has been marked by crises in science – in its claims to objectivity and universality – by generalized cynicism, fatalism, and narcissism, and by philosophical, theological, and artistic pandemonium. In short, whereas modernity might be described as the attempt to realize Enlightenment ideals,

with particular focus on the individual, and on scientific objectivity
and rationality, postmodernity has emerged with a profound sense
of uncertainty about what is to follow.

Whatever one's position on the project of modernity, postmod-
ernism has been the subject of voluminous writings during the past
few decades and continues to be hotly debated.[4] Many of the no-
tions about what constitutes the postmodern are incommensurable.
It may be generally conceived as embodying a conflict of old and
new modes – sexual, social, political, economic, religious, and ar-
tistic. Some theorists identify this conflict in terms of a break be-
tween the past and present; others see the relationships more in
terms of continuity.[5] Although it is arguable whether there are
"new modes" as such, I think that Lyotard and others are wrong
in saying that postmodernism is simply a recycling of modern ide-
ologies and values. New cultural forms and social relations are
emerging, as I suggest in what follows, and these challenge the
myths of modernism.

Several writers, among them Hal Foster and Suzi Gablik, have
identified two poles in the postmodernist discussion.[6] Foster calls
these a postmodernism of reaction and a postmodernism of resis-
tance. Postmodernism of reaction seeks to celebrate the status quo;
whereas postmodernism of resistance repudiates and challenges it.
Gablik talks about deconstructive and reconstructive postmodern-
ism. Deconstructive postmodernists reject many of the modernist
myths about art, ideas such as originality, uniqueness, and stylistic
innovation. It is reactive, and according to this definition, many of
the strategies of appropriation fall into this category. A reconstruc-
tive postmodernism, according to Gablik, challenges the material-
istic world view that dominates our culture and tries to awaken a
sense of responsibility for the fate of the earth and for the toxicity
of our environment. Both Foster and Gablik share the view that
the modernist world view is no longer viable. I find such distinc-
tions useful because they emphasize the fact that postmodernist
strategies move in diverse directions.

Yet from another perspective, there are at least three fundamen-
tally different positions among postmodernists. The first position is
the most historical, identifying a shift out of the modern age into
what Prague's Charles University Rector, Radim Palous, calls a
new, not yet fully developed "world age."[7] This view concentrates
on specific historical events in order to demarcate the boundaries
between the modern and postmodern. Palous and others identify

1969, the year of the moon landing, as the historical moment marking that fundamental change. For in that year, we saw the earth as a whole for the first time. Quite literally, we saw that we are terrestrials. "The world," as Palous put it in a Bakhtinian locution, "becomes the horizon of horizons."

Others such as Henry Nelson Wieman and Gordon Kaufman identify 1945 as the decisive moment, the year European-Americans confronted in new ways the enormity of our power and our human capacity for evil. Feminists might point to Simone de Beauvoir's 1949 *The Second Sex* or Betty Friedan's 1953 *The Feminine Mystique* as marking the reemergence of women as a powerful historical force in the second wave of feminism in the twentieth century. Quibbling over a specific date is not the point here. However it is identified, the new *historical* situation we now confront is a primary focus of many postmodern theorists of culture.

A second group is not so concerned about historical relationships, but rather with culture. These theorists identify postmodernism in terms of cultural practices, which often take the form of critiques of modernist positions vis-à-vis the author and subjectivity (Foucault), or totality (Lyotard), or other aspects of modernist ideology.

The third position conflates or embraces the other two, incorporating analyses of historical developments with cultural factors. Fredric Jameson's comprehensive neo-Marxist position is one of the best known. He has articulated a Marxist interpretation of postmodernism as a "cultural dominant" or "force field" of cultural practices that are intrinsically political and, following Ernest Mandel's central thesis, as the third moment or stage in capitalism.[8] In *Late Capitalism,* Mandel had posited three fundamental stages of capitalism: market, monopoly, and multinational. Jameson links market capitalism to realism, and to space organized on the logic of the grid, to a space that is desacralized. Monopoly capitalism, also called by Lenin the "stage of imperialism," is linked to artistic modernism. It is based on a bifurcation of individual experience into essence and appearance. No longer does the truth of experience coincide with actual space. Space is defined through a "fixed-camera view." Finally, in multinational capitalism, postmodern space is both homogenized and fractured. The decentering, dispersion, and death of the subject result in the disoriented experience of "hyperspace." Even though Jameson does not offer examples to justify or explain his position, my interpretation of postmodernism

shares much with this third position, especially because in my view historical and cultural factors are indeed inseparable.

POSTMODERN ART THEORY

It is perhaps misleading to use the phrase "postmodern art theory," for there is no monolithic or agreed-upon definition of the postmodern, of contemporary art, or of the role of theory in relation to art. Nevertheless, I use the phrase for its heuristic value.

In order to understand the critical element of the postmodern, it is useful to take the late 1950s as a starting point. Historically, this is justifiable on the basis of the new situation we confronted after World War II. But it is also justifiable aesthetically. As Andreas Huyssen has put it, "codification of modernism as the canon of the twentieth century took place during the 1940s and 1950s, preceding and during the Cold War."[9] Great modernist works of this period were not simply "cultural strategies of the Cold War,"[10] but neither these works nor the modernist theories that supported them (for example, those of Clement Greenberg and Theodor Adorno) can be divorced from their ideological and historical period. In the age of detente and the ending of the Cold War, the problems of abstraction versus realism and of high culture versus mass culture as they were formulated by earlier modernists have been (and still are being) reassessed.

Postmodernism of the early 1960s may be distinguished from its later manifestations in the seventies and eighties. In the sixties, postmodernists rejected or criticized high modernism, and tried to revitalize the heritage of the European avant-garde. Four major characteristics of this early postmodernism point to its continuity with the modern. The art of this period showed: (1) a powerful sense of the future, of crisis and generational conflict; (2) an attack on and revolt from institutionalized "high" art, as it was packaged in the museum, gallery, concert, record, and paperback industries of the 1950s; (3) a technological optimism and euphoric vision for postindustrial society; and (4) an uncritical attempt to validate popular culture as a challenge to high art.

In the seventies and eighties, a different response developed, which was more affirmative. This form of postmodernist practice abandoned earlier claims to critique; its eclecticism was most apparent in architecture. But simultaneously an alternative postmod-

ernism arose, which defined critique, resistance to, and negation of the status quo in nonmodernist and nonavant-garde terms. Especially in these two decades, artists have drawn on the resources of mass culture, which had previously been rejected as a source of energy, materials, or subjects for "high art."[11]

During this period, women and minority artists have offered significant critiques of high modernism. Traditional Western modes of representation, which tended to be centered, unitary, and masculine, are changing. For example, in the work of Martha Rosler (Figures 25 and 26) or Luis Cruz Azaceta (Figure 27), the modernist impulse toward mastery and domination is now challenged in favor of a more reciprocal and mutual understanding of relationships.[12] Rosler's work brings attention to the way our social spaces are permeated by structures of oppression and repression, "containment and control," as her text says. From a subway to an airline terminal, from the bank to the mall, from the museum to a bar, our movement is directed through both overt and tacit systems of control. Azaceta reminds us that we are all connected, connected through our mortality, if not through compassion and respect.

Women, once relegated to the domain of object in artistic representation, or often absent altogether from the creative domain, are now establishing themselves as subjects: theorists and practitioners in the cultural sphere. Exploration of the gender and race biases of modernist canons and traditions, of images of sexuality, of subjectivity, and of the politics of creation and representation: All of these became issues within the postmodern because of the work of women and minority critics, writers, and artists.

Three phenomena must be taken into account in describing postmodern culture for the present and into the future. First, the emergence of women as a creative presence, even a force, in the arts, literature, film, and criticism is guiding discussion of how gender, the construction of subjectivity, and social and political agendas are related to race, ethnicity, and sexual preference. Feminists of various racial and ethnic backgrounds are not only revising the history of modernism, but they are also formulating directions for the postmodernist future. Because I understand the postmodern in both historical and cultural terms, I interpret feminism(s) as the most potentially transformative form of postmodernist theory and practice. This is clearly a point of debate in feminist writing, but I agree with Rita Felski that feminism is an example of a postmodern

Figure 25 Martha Rosler, excerpts from *In the Place of the Public*, 1993, installation, Jay Gorney Modern Art, New York, courtesy of Jay Gorney Modern Art.

Figure 26 Martha Rosler, excerpts from *In the Place of the Public*, 1993, installation, Jay Gorney Modern Art, New York, courtesy of Jay Gorney Modern Art.

worldview, "fundamentally pluralistic rather than holistic and self-contained, embracing differing and often conflicting positions."[13]

Second, ecological and environmental catastrophes will continue to fuel a critique of modernity and modernization. Third, the recognition of cultural pluralism, that other cultures can be met in ways other than by conquest or domination, will also continue. So-called enlightened modernity has been a culture of inner and outer imperialism. Such imperialism will continue to be challenged cul-

turally, politically, economically, and artistically. Neither this second nor third phenomenon is a primary topic of discussion here, but both are central to my view of the crises and problems that confront us now and that will continue to confront us in the years to come. A comprehensive historically and culturally based interpretation of postmodernism can provide insight and motivation for change. And change is essential for human and planetary survival.

CREATOR, OBJECT, OR VIEWER

Postmodernist art theorists as well as art historians draw on a variety of methods in exploring the complex relationships of creator, object, viewer, and context. Each method, and each theorist, places the emphasis on particular aspects of these relationships; and Bakhtin's ideas can help to balance some of these emphases.

New historicists, for example, draw the critic and theorist away from causal linear narration about an object or artist toward seeing each in a complex network of relationships. Their method is akin to what anthropologist Clifford Geertz calls "thick description." One might take an object or event and analyze its particulars to

Figure 27 Luis Cruz Azaceta, *Aids Count III*, 1988, oil on canvas, courtesy of Frumkin/Adams Gallery, New York.

reveal the behavioral codes, logic, and motive forces that not only control the particulars of the event under study, but also control society. New historicists are more interested in coincidences than in overarching constructs or grand schemes that explain events or objects. All of this we hope leads to a new way of studying objects and/in history and a new awareness of how history and culture mutually define each other.

Visual semioticians try to move from an analysis of a work of art in terms of perception to an analysis of visual signs. Bakhtin was especially critical of traditional semiotics because he thought that, like dialectics, it reifies language by separating it from history, culture, and life. "Semiotics deals primarily with the transmission of ready-made communication using a ready-made code. But in live speech, strictly speaking, communication is first created in the process of transmission, and there is, in essence, no code" (SG, 147). In the broadest definition and in recent critical writing, visual semiotics has met the criticism Bakhtin leveled at semiotics in general by including consideration of contextual issues such as patronage, museum relations, cultural ideology, social history, events in the world, and earlier representations.

Critics drawings on the insights of deconstruction follow a different analytical procedure. They might take an image, examine its overt gestures and claims, show how these are based on binary oppositions that produce particular points of view, and show how the binary oppositions are not neutral, but have a hierarchical relationship, which means that power operates in the relationship in certain ways. Then, using material in the image, a critic might show that this hierarchy is not based on something given or "natural," but is instead a construction. The point of such analysis is to demonstrate how an image makes claims on its viewers, and in particular, how it claims authority.

Still, like new historicism and semiotics, deconstruction does not offer a way of interpreting the agency or role of the artist in culture. Many contemporary theories, having disclaimed master narratives, are often agnostic about agency and what the Annales School calls "*longue durée*" or Bakhtin, "great time." In discussing our contexts for understanding cultures and cultural artifacts, Bakhtin differentiated between small time, "the present day, the recent past, and the foreseeable [desired] future," and great time, "infinite and unfinalized dialogue in which no meaning dies" (SG, 169). The ability to perceive "great time" is based not on a grand historical metanar-

rative, but on a nuanced appreciation of outsideness and the chronotope.

The chronotope is fairly easy to understand: There is no experience outside of space and time, and both of these always change. In fact, change is essential. Therefore, subjectivity and created objects are always constituted differently. In short, all conditions of experience are determined by space and time, which are themselves variable. Within any situation there may be many different chronotopes, values and beliefs; but what the idea of the chronotope shows is that those values and beliefs derive from actual social relations.

So, how do we gain understanding of a chronotope different from our own? If a work of art is only understood in relation to the local and particular (something new historicists especially are keen to trace), then it will ultimately die or be of only narrow scholarly significance. An art historian or critic must recognize not only his or her own chronotope, but also the unique chronotopes of the artist and object. Only then can one give an object a place in great time. An historian therefore straddles two chronotopes, his or her own *and* the historical; and this necessitates recognition of one's essential outsideness.

Why does all of this matter? Bakhtin's emphasis is on the act, the determinative deed of a particular person, the artist or creator in great time, which includes a special relationship to the future. For him, "analysis usually fusses about in the narrow space of small time, that is, in the space of the present day and the recent past and the imaginable – desired or frightening – future." But mutual and creative understanding of "centuries and millenia, of peoples, nations, and cultures" is only revealed "on the level of great time" (SG, 167). In particular, we anticipate the future in and through language, through giving orders, stating our desire, giving warning or offering incantations. We may take trivial attitudes toward the future, attitudes such as desire, hope, or fear. But often these actions and attitudes do not account for the unfinalizable nature of things, the unexpected and surprising, innovation, and even miracles. Such a perspective is only gained when one acknowledges the role of consciousness, agency, and creative activity by a human being with all her or his singularity.

Analysis that focuses mainly on the role of the viewer may also be complex. For instance, reader- or viewer-response criticism moves away from a monolithic or monotheistic model of viewing,

166

toward a more polymorphous or polytheistic model that acknowledges the multiplicity and incompleteness – the unfinalizability – of any given act of viewing. Considerable attention has also been given to the nature of the gaze and spectatorship. Whether analyzed using the image of Foucault's panopticon, a Lacanian psychoanalytic perspective, a feminist interpretation that emphasizes the gendered nature of the gaze, or other approaches, such critical and interpretive work seeks to add new dimensions to the understanding of the role of the viewer.

Of particular importance for my argument here is the discussion about the "death of the author," which has emerged from the poststructuralist writings of Roland Barthes and Michel Foucault. Roland Barthes provided the ideology of high consumerism for the arts, including literature, by identifying the critic, and hence the viewer or reader in general, as the archconsumer. His and Foucault's essays represent a shift in emphasis from the process of artistic production, where the artist is the important agent, to the process and products of consumption, where the goal of reading or viewing is to become the most refined consumer.

In 1968 and 1969, Roland Barthes and Michel Foucault, respectively, dramatically proclaimed the "disappearance" and the "death of the author."[14] Following nineteenth-century writers such as Mallarme and Nietzsche, they located this "death" within the context of the "deaths" of God and Enlightenment "Man," and primarily within a literary field. Neither Foucault nor Barthes attempted to articulate the implications of this notion for the visual arts. And neither writer tackled the question of what such proclamations mean for women or artists of color. In his short essay "The Death of the Author," Barthes had claimed "to give a text an Author is to impose a limit on that text . . . to close the writing." Instead, he preferred to open a space for the reader. "The reader is the space on which all the quotations that make up a writing are inscribed without any of them being lost; a text's unity lies not in its origin but in its destination." That is, the unity of a text is not given by the author, but by the reader of the text. Thus, Barthes insisted, "the birth of the reader must be at the cost of the death of the Author."[15]

In countering and extending Barthes' argument, Foucault said that it is not enough to simply say that God/Man/author have died; we must locate the space left by the author's disappearance. Therefore, he posed the question: What is the author's name and how

does it function? He described how Jerome's fourth-century criteria for defining an author have essentially made their way into modern literary criticism. According to this model, the author is: (a) a constant level of value identifiable in different texts; (b) a field of conceptual and theoretical coherence; (c) a stylistic unity; (d) an historical figure at the crossroads of events. In general, the author's name has functioned for classification, to establish relationships between texts, and to characterize certain modes of discourse.

These criteria are discernible in both Cindy Sherman's and Sherrie Levine's work. Sherman's name, for instance, has become synonymous with images of herself that are not supposed to be her.[16] Levine's name has become synonymous with a certain kind of appropriation, although in recent years, she has set about changing this image. As one reviewer observed, Levine's art can be reduced to a signature.[17] But, according to Foucault, the artist's name is no longer an adequate marker for characterizing work.

In place of the artist's name, we may identify a separate "artist function," also characterized in four ways.[18] First, visual languages and discourse become an object of appropriation through rules concerning the artist's rights, artist-publisher relations, and rights of reproduction. Thus, it is linked to the institutional system that determines discourse. Levine, for instance, ran into problems when she tried to violate this rule. In 1980, she pirated one of Edward Weston's photographs of his son Neil, by copying a poster published by the Witkin Gallery (Figure 28). When lawyers for the Weston estate saw these, they threatened a court suit. Levine simply moved on to other images that were not copyrighted.[19]

The notion of originality is unquestionably tied to the commodity status of artworks on today's market. In my view, Levine's work is a more effective strategy for criticizing late twentieth-century consumerism than Sherman's. Critics from Krauss to Gablik to Owens and Crimp have extolled Levine's work from precisely this vantage point. Although it has had that "positive" effect on critics and dealers, that is, challenging art market values, buyers have been few (until recently). Levine has acknowledged that she never intended her work to be anything but commodities. "It's taken a while for the work to sell but it has always been my hope that it would, and it would wind up in collections and in museums."[20] On the one hand, her work is perceived as challenging the structures of late twentieth-century capitalism (and in many ways, she has collaborated in that radical reading of it), whereas on the other,

Figure 28 Sherrie Levine, *After Edward Weston*, 1981, black-and-white appropriated photograph, courtesy of the artist.

she wants it to sell and be in important collections. We are left with rather ambiguous questions about the work.

Foucault's second point about the "artist function" is that all forms of creativity are not affected by these institutions in the same way. For instance, one can distinguish painting or printmaking from commercial design on the basis of their anonymity. Levine told a story about artist Richard Prince that illustrates this point.[21] In 1979, he was basically homeless, and carried around in a portfolio rephotographed, enlarged, and cropped magazine images that he juxtaposed on gallery walls. Levine described this as a turning point for her, the important thing being that if "Richard wanted an im-

age, he took it, just like that." She realized that images are at least partly anonymous.

Third, the process of creating is not spontaneous, but develops through a complex set of operations. The general cultural definition of a painter is different from that of a photographer or appropriator. Artists like Elizabeth Murray or Joan Snyder are viewed differently than Levine or Sherman. The former are more "original" or "expressive"; whereas the latter group challenges those definitions through a complex creative process.

What Sherman has said about her creative process is an example of this. In the 1970s, Sherman used to spend two or three hours at a time in front of the mirror, making herself up, getting ready for a date. She loved playing "dress-up." At Robert Longo's suggestion, she decided to turn her love of this process into "art." Later, when David Salle showed her pornographic images that he had brought home from his job at a porno magazine publishing house, she responded by making her own "horizontal" series (Figure 17). One series of her photographs were done for the boutique, Dianne B, as full-page ads for Benson's stores (Figure 29). She describes her actual working process as a play with the mirror. "Once I'm set up, the camera starts clicking, then I just start to move and watch how I move in the mirror." She was quoted in a *New York Times* article as saying that people think her work is narcissistic. Indeed, I think it is very difficult to avoid dealing with the apparent narcissism in both the photographs, and the process as she has described it.

Another part of this question concerning the cultural definition of the artist relates to women. To the question "who can be an artist?" our culture has usually provided a single answer. What does it mean when a woman identifies herself as an artist within pervasively patriarchal ideological structures? What does it mean that Levine has appropriated only images made by men, and that Sherman's work of the 1970s and 1980s presented us only with stereotypical images of women?

Whereas Sherman has steadfastly refused to speak directly about the relationship of her work to the themes of domination and submission that are part of feminist discourse, Levine has been very articulate about her process in two different interviews. "A lot of what my work has been about since the beginning has been realizing the difficulties of situating myself in the art world as a woman,

Figure 29 Cindy Sherman, *Untitled #118*, 1983, color photograph, private collection, courtesy of the artist.

because the art world is so much an arena for the celebration of male desire."[22]

When I look back on it . . . I felt angry at being excluded. As a woman, I felt there was no room for me. There was all this representation . . . of male desire. The whole art system was geared to celebrating these objects of male desire. . . . What I was doing was making this explicit: how this oedipal relationship artists have with artists of the past gets repressed; and how I, as a woman, was only allowed to represent male desire.[23]

It is noteworthy that in her paintings (a new genre in the past few

years), she no longer copies or appropriates actual works of other artists.

Finally, wrote Foucault, all discourses with an author/artist function show a "plurality of selves." Nowhere is there a real individual or self. Many voices speak in a given text. Sherman's work most directly embodies this idea. But her photographs depict not only the plurality of selves that is typical of postmodern identity, but also the way identities are constructed. As Norman Bryson wrote, she "exposes the material underpinnings of identity-production, not only the theatrical codes of costume and gesture, but the photographic codes that come to join them."[24]

To claim the death of the author or artist – whether for shock value, market purposes, or out of conviction – is simply a reversal of the ideology that glorified the artist as magician or genius.[25] And again, we might well ask, who benefits by such proclamations? To refuse to acknowledge that the artist is important in interpreting works, or to refuse to discuss the artist's cultural function, is to deny the lessons of feminist and political criticism. Discourse about the death of the author or artist, the self and subjective agency also overlooks the fact that selfhood has not really come to an end. Although they are articulated neither in terms of gender and difference, nor in sociopolitical terms, Bakhtin's reflections on answerability, obligation, and self-other relations are consistent with this point of view.

What we see is the emergence of a "new authorship," the birth of new selves, the reclamation of subjectivity for Others. As theologian Nellie Morton has said, "We are hearing ourselves into speech." Women, who have previously not had the same historical relation to the institutions that govern discourse as men have had, are now establishing new relationships both within and outside of those institutions. Further, if focus on the author or artist is completely jettisoned, that is, if we accept the theory that the author or artist is, in fact, dead, then the chances of challenging the ideology of the typical male, white, middle-class subject are lessened.[26] I am urging here that we must ultimately challenge the meaning of this idea. Our life and livelihood may well be at stake.

Finally, now, we may return to Mikhail Bakhtin's ideas, for in the early aesthetic essays of the 1920s, he offered a powerful, if at times problematic, perspective on creativity and the artist that balances the overemphasis on the role of the object and/or viewer in much postmodern art theory.

If, indeed, the author and artist have not disappeared, then we might ask, are there previously overlooked or still-to-be-discovered resources within the modernist canon for rethinking the relationship of creator, object, and viewer? Bakhtin's aesthetic categories not only can offer a useful interpretive framework for analyzing works of art, but his perspective is also a refreshing counter to more cynical and nihilistic views of the artist's cultural function. His insights are especially significant for contemporary practicing artists.

The artist is in fact someone who knows how to be active outside lived life, someone who not only partakes in life from within practical, social, political, moral and religious life, and understands it from within, but someone who also loves it from without, loves life where it does not exist for itself, where it is turned outside itself and is in need of a self activity. . . . The divinity of the artist consists in partaking of this supreme outsideness, but the situatedness of the artist outside the event of other people's life and outside the world of this life is, of course, a special and justified kind of participation in the event of being. To find an essential approach to life from outside, this is the task an artist must accomplish. In doing this the artist and art as a whole create a completely new vision of the world, a new image of the world, a new reality of the world's mortal flesh, unknown to any of the other culturally creative activities. . . . The aesthetic act gives birth to being on a new axiological plane of the world: a new human being is born and a new axiological context – a new plane of thinking about the human world. (AH, 191)

In this long statement, Bakhtin made a series of interconnected assertions regarding answerability, outsideness, and unfinalizability.

Through aesthetic activity, the artist "collects" and "organizes" the world: "the spatial world with its own axiological center – the living body, the temporal world with its own center – the soul, and finally, the world of meaning – all in their concrete interpenetrating unity" (AH, 190). The artist's aesthetic activity "collects the world scattered in meaning and condenses it into a finished and self-contained image" (AH, 191). The artist collects and condenses the world, forming an image that literally gives birth to a new way of thinking about the world. For Bakhtin, the artist must be situated on the "boundary of the world," both a participant and an observer of people and events. The artist answers life, while remaining outside of life.

Answerability was Bakhtin's way of naming the fact that art, and

hence the creative activity of the artist, is always related – *answerable* – to life. For him, the idea that we are answerable, indeed obligated, through our deeds is the basis of the architectonic structure of the world. We exist in spirit, but the soul is formed through the answerable interactions of the self in the world. Artistic creativity might be thought of as a microcosm within the larger universe where answerability is the key. In this sense, his interpretation of creativity emphasized the profound moral obligation we bear toward others. Such obligation is never solely theoretical, but is an individual's concrete response to actual persons in specific situations. Because we do not exist alone, as isolated consciousnesses, our creative work is always answering the other, if only we would recognize it. Answerability contains the moral imperative that the artist remain engaged with life, that the artist answer for life. At every point Bakhtin insisted upon obvious ethical aspects of creativity: namely, that we are responsible, answerable, and obligated toward other human beings in and through the creative process.

With the concept of outsideness, Bakhtin defined the divinity of the artist as consisting in being outside the event of the other's life and world. The self and the other are only knowable because of boundaries, boundaries that frame and define the self over against others and the world. The creative activity of the artist is therefore only possible because of these boundaries. The artist works at the temporal and spatial boundaries of the outer body, as well as at the axiological boundaries of inner life. This enables the artist to create new visions. But even this is a special kind of participation in the event of being. By finding an approach to life from outside, a new image of the world can be formed. To give birth through the work of art to a new human being and to a new way of thinking about the world is also directly ethical. In contrast to the NeoKantian attitude of empathy, Bakhtin's understanding of outsideness emphasizes the importance of boundaries of self and other, of self and world, and of art and life. As authors and artists, the works we create must express the meeting of our consciousness with that of another.

Unfinalizability was Bakhtin's term for the ultimate open-endedness of art and life. Even though a person's life is finalized in death, that person's work lives on, to be extended and developed by others. The creative process, too, is unfinalizable, except insofar as an artist says, I stop here. But because it is always open to change

and transformation, artistic work can be a model for the possibility of change in the larger world outside the studio.

Artistic creativity is ethical because we not only create ourselves in relation to others, but we also help to finalize other persons. Moral values such as mutuality, risk taking, and obligation are inherent in this process. Like God, human beings, the world, and life itself, the creative process is open and ultimately unfinalizable. This has profound implications for how we understand the possibility for transformative change in both individual consciousness and the larger world.

My interpretation of Bakhtin's theory of creativity rests on these three fundamental ideas: answerability, outsideness, and unfinalizability. As I have tried to show, each can help to correct the blind spots in contemporary theory in significant ways. Yet, each of these concepts also is based on modernist suppositions that can be usefully criticized from a postmodernist perspective.

Bakhtin's model of answerability offers an individual-centered and gendered image of responsibility because it is based on an assumption that all are equally free to act. Bakhtin recognized that selves are always constituted through complex social processes that involve phenomenal experience: the nature of seeing, appearance, boundaries of the body, outward actions, and differing senses of the inner and outer body. But just as his analysis did not account for the way representations are ideologically shaped, it did not acknowledge the way ideologies influence both the possibility of responsible answering and the way privilege operates in this process. Specifically, I have in mind feminist criticism of traditional models of selfhood that are based on an assumption that everyone (whether male or female, black or white, rich or poor, old or young) is equally able to act responsibly in the world. The exigencies of actual life, however, suggest otherwise.[27]

Further, Bakhtin's understanding of answerability was primarily oriented to the individual. This is certainly understandable, given his philosophical and historical context, but it is not adequate today. Feminist theorists have repeatedly cautioned that individual responsibility is not sufficient. Social and political accountability and solidarity are necessary because individuals never live in isolated units, but they are always part of social matrices.

Like the phrase "political accountability," solidarity points to the fact that resistance to oppression is most effective in groups and coalitions. Yet in order to develop coalitions, women must be will-

ing "to accept responsibility for fighting oppressions that may not directly affect us as individuals."[28] Solidarity between, rather than support for, other women is necessary:

Solidarity is not the same as support. To experience solidarity, we must have a community of interests, shared beliefs and goals around which to unite, to build Sisterhood. Support can be occasional. It can be given and just as easily withdrawn. Solidarity requires sustained, ongoing commitment.[29]

Solidarity is not based on the eradication of difference. We can be "united by shared interests and beliefs, united in our appreciation for diversity, united in our struggle to end sexist oppression, united in political solidarity."[30] Solidarity also need not rest on the presumption of a common victimization of all women. Early in the feminist movement, white bourgeois women articulated a notion of sisterhood that was based on shared oppression and victimization. Women who identified themselves as victims then could and often did abdicate responsibility for maintaining and perpetuating the racist, sexist, and classist structures of oppression by insisting that white men were the enemies. But as women of color have increasingly entered the public domain, white women have had to acknowledge responsibility for helping to maintain the status quo. Now, in order to develop political solidarity, women must redefine what this will be and how it will occur. "Rather than bond on the basis of shared victimization or in response to a false sense of a common enemy, we can bond on the basis of our political commitment to a feminist movement that aims to end sexist oppression."[31] Bakhtin's ethic, with its emphasis on our individual answerability and obligation toward others, must finally be balanced by recognition of the importance of such communal and collective solidarity. In terms of the visual arts, this would suggest that fully answerable art would take a stand on issues of social and political significance.

Bakhtin's interpretation of answerability entailed a particular emphasis on boundaries; and boundaries define the condition he called outsideness. As Bakhtin so eloquently put it: "To find an essential approach to life from outside – this is the task the artist must accomplish. In doing this, the artist and art . . . create a completely new vision of the world . . ." (AH, 191).

But I do not think Bakhtin imagined the artist capable of establishing a new Archimedean point that would somehow allay modern Cartesian anxiety. Through imaginative activity, the artist can

accomplish the kind of metanoia that occurs when we see ourselves and the world with fresh eyes. This kind of approach from outside was given when we saw pictures of the earth from space for the first time and slowly began to realize that the planet is, indeed, one integrated whole.

The idea of outsideness (*vnenakhodimost'*) was developed by Bakhtin as a corrective for aesthetic empathy. Empathy, especially as it had been interpreted by aestheticians such as Lipps, tended to emphasize identification with and melding of one consciousness with another. In Bakhtin's view, this is neither desirable nor possible, given the facts of spatial and temporal specificity – we might say particularity – of each person in any given moment. The notion of outsideness takes account of this necessary difference between persons. Indeed, by emphasizing the boundaries that separate one consciousness from another, one person from another, we actually are more able to act with and on behalf of that other person.

But Bakhtin's discussion of outsideness focused on the relationships between selves, understood basically in Enlightenment terms as free, rational agents. His analysis of the phenomenology of self-other interactions did not acknowledge how power dynamics inevitably influence those interactions or the ways in which relationships of self and other are shaped by ideological factors.

From the late 1920s, Bakhtin was interested in the role of ideology in creative activity, but to him ideology was a "semiotic idea-system": "it involves the concrete exchange of signs in society and in history. Every word/discourse betrays the ideology of its speaker."[32] Ideology was, for Bakhtin, a particular form of monologic thinking.

Nevertheless, the very definitions of human subjectivity, of who and what a person is, are determined by ideology. The word "subject" is ambiguous and normally has two meanings. First, I am a subject insofar as I am a free agent, responsible for my deeds. (This is akin to Bakhtin's *subiectum* in the early texts.) Second, I am also a subject, a "subjected being" insofar as I submit to higher authorities and give up my freedom to those authorities. Louis Althusser expressed this as the insight that human subjectivity is marked by a peculiar relationship between these two meanings. "There are no subjects except by and for their subjection," which is most often accomplished invisibly, through the institutions that govern society.[33] To be a self is finally to be shaped by the ideological structures and institutions of one's immediate surroundings.

177

Any genuine discussion of outsideness in our contemporary cultural climate must acknowledge the ways in which a person, as an individual consciousness, always remains outside another person's consciousness. Bakhtin understood this, as his criticism of aesthetic empathy and traditional notions of unity demonstrates. From a feminist perspective, the idea of the unity of consciousnesses represses and denies difference, that "irreducible particularity of entities, which makes it impossible to reduce them to commonness or bring them into unity without remainder."[34] This "remainder," or surplus in Bakhtin's terms, is unavoidable, because there is always something *more* in perception. In a statement that echoes Bakhtin, Iris Marion Young has observed:

> Other persons never see the world from my perspective, and I am always faced with an experience of myself I do not have in witnessing the other's objective grasp of my body, actions, and words. This mutual intersubjective transcendence, of course, makes sharing between us possible. . . . The sharing, however, is never complete mutual understanding and reciprocity. Sharing . . . is fragile.[35]

We not only need to accept spatial and temporal distance from others, but we also need to understand the impossibility of shared subjectivity and the fragility of shared understanding. Such ideals are based on identity: the belief that I can completely understand you because I am like you. But such ideals also deny difference concretely by making it difficult to respect those with whom I do not identify.[36] This has important implications for how we understand, or think we understand, gender, race, class, and other differences.

Put simply, Bakhtin's phenomenology of self-other relations and his interpretation of outsideness did not take sufficient account of ideology or difference. By highlighting these ideas, a more balanced interpretation of outsideness is possible.

Each of Bakhtin's ideas – answerability, outsideness, and unfinalizability – brings us back to the artist, not to the artist as a particular biographical person, but to the importance of the artist's creative activity. Postmodern theories that emphasize the object or viewer while extolling the death or absence of the artist ultimately fail to acknowledge the fact that the artist has a *vocatio*, a significant role in contemporary culture.

Vocation is a strong, perhaps old-fashioned, word, but in mod-

ern usage, it has lost most of its meaning and power. Therefore, some insight might be gained from examining the history of the term.[37] In its root meaning, the Latin *vocatio* (a call) had a distinctly Christian tenor. Tertullian was evidently the first to translate the Greek *klesis* as *vocatio* in the third century. The history of its use has evolved since its appearance in early Christian texts, including the New Testament and Church fathers such as Basil and Cassian, up to Erasmus and Luther. In its early usage in both the Eastern and Western traditions, *vocatio* meant not only renunciation, but also grace from God; and it was blended with the idea of a special profession based on aptitude and right intention.

Monasticism played a fundamental role in articulating the idea of a special calling, but scholars disagree about the relative importance of that role. One might argue that through its high evaluation of productive work, monasticism prepared the way for later secular usage of the term vocation. Or, from another perspective, the secular occupations themselves helped to strengthen the idea of a special calling.[38] German mystics such as Meister Eckhart articulated a notion of a call from God completely independent of monasticism or entrance into an order. Instead, a call could be related to secular work through which one could experience the ideal of closeness to God. By the late sixteenth century, a complete reversal of the meaning of the word had occurred. At first, the word had meant that the monk alone has a special calling. Martin Luther's assertion that only through work in the world could one genuinely realize the calling of God reflects this reversal. In its contemporary usage, the word vocation has been even more thoroughly secularized, so that it is virtually synonymous with profession, occupation, or work.

The secularization of the artist's vocation took place over a long period and through complex ideological processes – from the Renaissance through the sixteenth-century reformations and the eighteenth-century Enlightenment, to the rise and fall of the modernist paradigms in the late nineteenth and twentieth centuries. In raising the issue of the vocation and cultural function of the artist, I am not proposing that artists should now return to making art for Christian or other religious institutions, or that they should neglect the object or the role of the viewer in finalizing an artwork. Rather, I am urging that consideration of the cultural function of the artist should be an important component of our current theoretical practice.

Earlier I spoke about why, even given Bakhtin's convincing criticisms of theoretism, I would choose to engage in a highly theoretical enterprise. With the exception of the last chapter, I have not endeavored to use his categories for sustained analysis of visual images, but rather to show how they might aid us in turning again toward consideration of the artist's cultural function or vocation. I have treated Bakhtin's own writing as a (theoretical) box of tools, from which I could take what I needed.

Theory is indeed a complex process consisting of many parts and many discursive practices. Among these, and by way of summary, I would mention just four. Aesthetic theory can describe what happens when we look; such a theory of looking (and seeing) is not just phenomenological, but as Bakhtin shows, it must describe a genuine encounter of one consciousness with another. Visual or aesthetic theory can also function to describe, literally and formally, *what* one sees. Analysis of the breakdown of genres and the reemergence of new narrative structures in contemporary art may be better understood from a theoretical perspective. Aesthetic theory, like literary theory, can also create taxonomies, classification schemes for interpreting many works of art, both historical and contemporary, in relation to one another.

But to me, one of the most significant contributions of aesthetic theory to cultural studies is consideration of the place and function of the arts in society, and more specifically, the vocation of the artist. For, to move from general discourse about the place and function of art to the vocation of the artist is to embody the category "art" by giving it a specific body and a voice.

There are certainly many possible ways of defining the role of the artist in contemporary culture, as healer, philosopher, entertainer, political or social critic, producer of commodities, and so forth. There is no "artist" as such, no general or universal artist, just as there is no universal art. Even though Bakhtin did not explore specific paradigms of the artist's vocation or cultural function, he did call attention to the religious and moral dimensions of the artist's work and vocation in the world. As Bakhtin wrote: "The demand is: live in such a way that every given moment of your life would be both the consummating, final moment and, at the same time, the initial moment of a new life" (AH, 122). Although difficult to fulfill, this demand articulates a worthy goal.

AFTERWORD

I began *Bakhtin and the Visual Arts* with an invocation of the Roman god Janus, saying that this image would provide a key to the structure of the book. True to the image of that deity who looks in two directions simultaneously, I have moved back and forth, talking about art *and* life, about theoretical issues *and* practical application, about abstract aesthetic categories *and* concrete bodily experience. Janus, spirit of the doorway, was the god of beginnings, but he was the god of endings as well.

One could say that Janus looked into the past *and* into the future. The past: The man Bakhtin is dead; his work, now finalized, lives on. Yet, from another perspective, it remains unfinalizable. As each moment of the present ends, the future begins. Bakhtin's ideas are being developed, extended, applied by scholars who reaccent them, thereby changing their original meaning. As I end this book, I offer in that spirit one last metaphoric key to understanding Bakhtin's interpretation of aesthetics and creativity.

The gift, *dar*, is a potent and frequent metaphor in Bakhtin's early aesthetic essays. The soul is bestowed as a gift from one person to another. Within ourselves we live in the spirit. The soul comes from our contact with another. It descends on the self, like grace upon the sinner. Loving acceptance comes – it, too, literally "descends" – like a gift, like grace, from others. Love, for Bakhtin, is only possible in relation to an other: We cannot truly love ourselves. Joy is also only possible as a gift. Joy is not an active relationship *to* being; being *itself* can be joyful. Self-activity is serious, and active. Joy is passive; it is possible in God or in the world "only where I partake in being in a justified manner through the other and for the other, where I am passive and receive a bestowed gift" (AH, 136). More technically, aesthetic form is given as a gift by the other. Bakhtin even used the metaphor in talking about biography:

it is bestowed as a gift. "I receive it as a gift from others and for others, yet I possess it naively and calmly" (AH, 166). The world (the outer body and thus the environment) is a gift bestowed on the hero by another consciousness (for example, the artist or viewer). The soul, love, joy, aesthetic form, biography, the world: Each of these is the result of a gift.

A gift implies at least two consciousnesses, a self and an other. It implies a response, an answering consciousness. A gift also implies something given with love by another who is outside the self. That other person can see more than is possible from the self's particular standpoint, and therefore offers the only possible perspective from which the self can be finalized. Self and other, soul and spirit, author and hero: These are ways that Bakhtin described the phenomenology of self-other relations. Answerability, outsideness, and un/finalizability describe aspects of the relationship of self and other, and they are central tenets of his aesthetics. The metaphor of the gift can help us to unlock their meaning.

Written in the early 1920s, years of turmoil in the then new Soviet Union, Bakhtin's essays are a testament to the generosity of his spirit, to his perception of the power of creativity and love. Read in the last decade of the twentieth century, his aesthetic essays may lead us to renewed appreciation for the world-forming potential of the artist's creative activity, the gift of form given by the artist to the world.

NOTES

CHAPTER I

1. "K filosophii postupka," in *Filosofiia i sotsiologiia nauki i tekhniki* (Moscow: Nauka, 1986), pp. 82–160. "Avtor i geroi v esteticheskoi deiatel'nosti," in *Estetika slovesnogo tvorchestva* (Moscow: Iskusstvo, 1979), pp. 7–180. "Problema soderzhaniia, materiala i formy v slovesnom khudozhestvennom tvorchestve," in *Literaturno-kriticheskie stat'i,* eds. S. G. Bocharov and V. V. Kozhinov (Moscow: Khudozhestvennaia literatura, 1986), pp. 26–89. Translations of "K filosofii postupka" and "Problema soderzhaniia" quoted here are, unless otherwise noted, my own. Since writing this book, Vadim Liapunov's superb translation of this essay "K filosofii postupka" has appeared, published as *Toward a Philosophy of the Act* (Austin: University of Texas Press, 1993). I have relied on Liapunov's translation of "Avtor i geroi" in *Art and Answerability: Early Philosophical Essays of M. M. Bakhtin*, eds. Michael Holquist and Vadim Liapunov, trans. Vadim Liapunov and Kenneth Brostrom (Austin: University of Texas Press, 1990). See Katerina Clark and Michael Holquist, *Mikhail Bakhtin* (Cambridge, MA: Harvard University Press, 1984), for a full biography.

2. Gary Saul Morson and Caryl Emerson, *Mikhail Bakhtin: Creation of a Prosaics* (Stanford: Stanford University Press, 1990), p. 63. It would not be surprising to learn at a future date that changes from the original manuscripts had been made, as the early essays were published in a highly politicized atmosphere.

3. In contrast to what I argue here, in "Neither a Formalist Nor a Marxist Be: Notes on the Early Ethical-Aesthetic Writing of Mixail Baxtin," Mathew Roberts has suggested that the Kantian categories of cognition, ethics, and aesthetics were not three different options in Bakhtin's writing. Rather, Roberts writes that they are "three stages in the appropriation, concretization and expression of meaning." Master's thesis, Cornell University, Ithaca, NY, 1989, p. 19.

4. Holquist, "Introduction," *Art and Answerability*, pp. xxiii–xxiv.

5. Raymond Williams, *Keywords, A Vocabulary of Culture and Society* (New York: Oxford University Press, 1983), p. 316.

6. Michel Foucault and Gilles Deleuze have articulated a similar view of theory, which is summarized here. See their "Intellectuals and Power," *Language, Counter-Memory, Practice: Selected Essays and Interviews*, ed. Donald Bouchard, trans. Donald Bouchard and Sherry Simon (Ithaca, NY: Cornell University Press, 1977), pp. 205–217.

7. Morson and Emerson, *Creation of a Prosaics*, p. 66.

8. Ibid., p. 64.

9. Allan Reid, *Literature as Communication and Cognition in Bakhtin and Lotman* (New York: Garland, 1990), p. 91.

10. Bakhtin did not label them as such, however. These models of creativity are extrapolated from his writing and are described by Caryl Emerson and Gary Saul Morson in "Penultimate Words," *The Current in Criticism, Essays on the Present and Future of Literary Theory*, eds. Clayton Koelb and Virgil Lokke (West Lafayette, IN: Purdue University Press, 1987), p. 52. For an expanded discussion, see Chapter Six of Morson's and Emerson's *Creation of a Prosaics*.

11. Shklovsky developed this notion in his 1917 essay, "Art as Technique," *Russian Formalist Criticism: Four Essays*, trans. and intro. Lee T. Lemon and Marion J. Reis (Omaha: University of Nebraska Press, 1965), pp. 5–24.

12. This detail was offered in a lecture by Wlad Godzich, Harvard University, March 1, 1988. I have been unable to corroborate it in any printed sources.

13. Emerson and Morson, "Penultimate Words," p. 52.

14. Ibid.

15. Holquist, "Introduction," in *Art and Answerability*, p. xxxii.

16. The possibility of extending Bakhtin's central ideas is one that Gary Saul Morson and Caryl Emerson have chosen in collecting the essays for *Rethinking Bakhtin, Extensions and Challenges*, eds. Gary Saul Morson and Caryl Emerson (Evanston, IL: Northwestern University Press, 1989).

17. Holquist, "Introduction," *Art and Answerability*, p. xxxii–xlv.

18. Nina Perlina, "Bakhtin and Buber: Problems of Dialogic Imagination," *Studies in Twentieth Century Literature* 9 (Fall 1984): 13–28. Another attempt to relate Bakhtin's ideas to both European and Russian thinkers is B. Groys' wide-ranging essay, "Problema avtorstva," *Russian Literature* 26 (1989): 113–30. Groys focuses on Vladimir Soloviev, but mentions other Russians such as Shpet and Askol'dov. European philosophers include Descartes, Schlegel, Jean-Paul Richter, Hegel, Nietzsche, Husserl, Hartmann, Heidegger, and Sartre.

19. Iurii Lotman, *The Structure of the Artistic Text*, trans. Ronald Vroon (Ann Arbor: University of Michigan Press, 1977), p. 8; quoted in Caryl Emerson, "Discourse in the Novel," p. 430.

20. This idea is developed in "Discourse in the Novel," pp. 417–22. In her essay, "Bakhtin and Intergeneric Shift: The Case of Boris Godunov," *Studies in Twentieth Century Literature* 9 (Fall 1984): 145–67, Caryl Emerson has suggested that through a variety of means (in prose, poetry, music, and so on), the Boris Godunov theme has been "reaccentuated" in Russian culture in unique ways.

21. Caryl Emerson and Gary Saul Morson, "Penultimate Words," p. 48.

22. In "New Aspects in the Study of Early Russian Culture," *The Semiotics of Russian Culture*, ed. Ann Shukman (Ann Arbor: University of Michigan Press, 1984), p. 51.

23. For a full discussion of the way his oeuvre fits into four distinct periods, see Morson and Emerson, *Creation of a Prosaics*, Chapter 2.

24. These ideas are articulated in her essay "Theological Education in a Religiously Diverse World," *Theological Education* 23 (Supplement 1987): 34–52.

25. Ibid., p. 44. Gender asymmetry refers to the way masculine and feminine characteristics are constructed in a relation of uneven value to one another.

26. Paul Ricoeur, *Hermeneutics and the Human Sciences, Essays on Language, Action*

and Interpretation, ed. and trans. John B. Thompson (Cambridge: Cambridge University Press, 1981), p. 7.

27. Hans-Georg Gadamer, "The Hermeneutics of Suspicion," in *Hermeneutics, Questions and Prospects*, eds. Gary Shapiro and Alan Sica (Amherst: University of Massachusetts Press, 1984), p. 58.

28. This situation differs from the reception of his work in Russia during recent years. A growing body of research and writing focuses on Bakhtin as a moral philosopher. For instance, two groups of essays have been published that place considerable emphasis on the early essays. *Bakhtinskii sbornik*, eds. K. G. Isupov et al. (Moscow, 1990); and *Estetika M. M. Bakhtina i sovremennost'*, eds. A. F. Eremeev et al. (Saransk, 1989).

29. For recent, and excellent, examples of scholars working with and developing Bakhtin's concept of the dialogic, see Dale M. Bauer and S. Jaret McKinstry, eds., *Feminism, Bakhtin, and the Dialogic* (Albany: State University of New York Press, 1991) and Michael Holquist, *Dialogism, Bakhtin and his World* (New York: Routledge, 1990).

CHAPTER 2

1. This interpretation of events is given in the *New Cambridge Modern History, Vol XII, The Shifting Balance of World Forces, 1898–1945*, ed. C. L. Mowat (Cambridge: Cambridge University Press, 1968), p. 440.

2. In a letter to Kagan from October–November 1921, in "Pis'ma M. M. Baxtina M. I. Kaganu," *Pamiat': Istoricheskii sbornik* 4 (Paris: YMCA Press, 1981), pp. 262–3.

3. Quoted by Linda Dalrymple Henderson, *The Fourth Dimension and Non-Euclidean Geometry in Modern Art* (Princeton: Princeton University Press, 1983), p. 239. In slightly different form, it appears in Nicolas Berdiaev, *Dream and Reality, An Essay in Autobiography*, trans. Katharine Lampert (New York: Macmillan, 1951), p. 141.

4. James H. Billington in *The Icon and the Axe: An Interpretative History of Russian Culture* (New York: Random House, 1966), pp. 475–519. One could certainly argue that Billington's framework has been superseded by more recent scholarly discussions of this period, but I use it here for its metaphoric vividness.

5. From his essay, "From Cubism and Futurism to Suprematism: The New Painterly Realism," in *Russian Art of the Avant-Garde Theory and Criticism, 1902-1934*, trans. and ed. John E. Bowlt (New York: Viking, 1976), pp. 134–5.

6. Quoted in Billington, *Icon and Axe,* p. 504. For a recent exploration of the theme of apocalypticism, see David M. Bethea, *The Shape of Apocalypse in Modern Russian Fiction* (Princeton: Princeton University Press, 1989).

7. *A Solovyov Anthology*, arr. S. L. Frank, trans. Natalie Duddington, reprint edition (Westport, CT: Greenwood Press, 1974), p. 27.

8. From "Of the Book by Gleizes and Metzinger Du Cubisme," translated by Henderson, *The Fourth Dimension*, p. 368.

9. Petr Ouspensky, *Tertium Organum, A Key to the Enigmas of the World*, 2d ed., trans. Nicholas Bessaraboff and Claude Bragdon (New York: Alfred A. Knopf, 1922), p. 162.

10. See Magdelena Dabrowski, "The Plastic Revolution: New Concepts of Form, Content, Space, and Materials in the Russian Avant-Garde," in *The Avant Garde in Russia, 1910–1930: New Perspectives*, eds. Stephanie Barron and Maurice

Tuchman (Cambridge, MA: MIT Press, 1980), p. 28. The artistic schools promulgated by various artists included Neo-primitivism, Cubo-Futurism, Rayonism, Suprematism, Constructivism, and Productivism. *Neo-Primitivism* owed much to the indigenous folk art and icon traditions. *Cubo-Futurism* was related to its French and Italian counterparts, but had a distinctive character in Russia. *Rayonism* was articulated by Mikhail Larionov, but may have had its roots in the theory of the icon. *Suprematism* was articulated primarily by Malevich in dialogue with others such as Olga Rozanova. *Constructivism*, often identified with Vladimir Tatlin and Alexander Rodchenko, was based on the ideas that: (a) the artist must go into the factory; (b) the factory is the real creative force in the world; (c) traditional definitions of the individualistic artist must be rejected; and (d) Constructivism was to help create the new social and political order. *Productivism* is the term sometimes used to describe the use of art in industrial production. It must be borne in mind that these do not represent a purely linear evolutionary development.

11. Clark and Holquist, *Mikhail Bakhtin*, p. 140, identify these as groups to which Bakhtin belonged. However, this has been disputed. In particular, I. R. Titunik has criticized Clark and Holquist for failing to mention sources for this claim. In "A Continuing Dialogue," *Slavic and East European Journal* 30 (Spring 1986): 97, they responded by saying: " It is not surprising . . . that many of our oral sources are left unnoted. . . . Several people who helped us did so only with the understanding that they would not be identified."

12. Victor Erlich, *Russian Formalism, History-Doctrine*, 3d ed. (New Haven: Yale University Press, 1981), p. 35. I am indebted to Erlich's excellent study of the roots and development of formalism in Russia for the following account. In addition, the reader interested in pursuing some of the issues discussed here might see *Russian Formalism, A Collection of Articles and Texts in Translation*, eds. Stephen Bann and John E. Bowlt (Edinburgh: Scottish Academic Press, 1973), or the more recent *Literary Structure, Evolution and Value, Russian Formalism and Czech Structuralism Reconsidered* by Jurij Striedter (Cambridge, MA: Harvard University Press, 1989).

13. "On the Reasons for the Decline, and the New Currents, in Contemporary Russian Literature," in *The Russian Symbolists, An Anthology of Critical and Theoretical Writings*, ed. and trans. Ronald E. Peterson (Ann Arbor, MI: Ardis, 1986), p. 18.

14. "On the Present Status of Russian Symbolism," in Peterson, *The Russian Symbolists*, p. 158.

15. Quoted in Erlich, *Russian Formalism*, p. 35.

16. In *Russian Art of the Avant Garde, Theory and Criticism*, ed. and trans. John Bowlt, rev. ed. (New York: Thames and Hudson, 1988), p. 108.

17. Quoted in Erlich, *Russian Formalism*, p. 187.

18. Ibid., p. 189. The interested reader might compare my interpretation of the content/form dichotomy to Todorov's discussion in *Mikhail Bakhtin, The Dialogical Principle*, trans. Wlad Godzich (Minneapolis: University of Minnesota Press, 1984), esp. pp. 34–40.

19. In *Kandinsky, Complete Writings on Art, Vol. One* (1901–1921), eds. Kenneth C. Lindsay and Peter Vergo (Boston: G. K. Hall, 1982), p. 87.

20. Ibid., 237.

21. Here I want to note the difference in my approach to this issue and that taken by B. Groys, in "Problema avtorstva," esp. pp. 122–5. Groys concentrates

particularly on Soloviev's view of the crisis of western philosophy as an influence on Bakhtin. He comments, however, that an important difference between the two is that for Bakhtin "acts of philosophical reduction, that is, crises of doubt of the 'hero' . . . prove to be real, described events." This is one example of how Bakhtin secularized Soloviev's philosophy. In my short discussion of how Bakhtin saw the crisis of philosophy, however, I concentrate on Bakhtin's self description, and the links between ethics and aesthetics, rather than on his relationship to other interpreters of Orthodoxy.

22. Morson and Emerson, *Creation of a Prosaics*, p. 176.

23. Gary Saul Morson, "Prosaics: An Approach to the Humanities," *The American Scholar* (Autumn 1988): 518. For an excellent interpretation of Bakhtin's relationship with Tolstoy, see Caryl Emerson, "The Tolstoy Connection in Bakhtin," in *Rethinking Bakhtin*, eds. Gary Saul Morson and Caryl Emerson, pp. 149–70. Some notes also exist that suggest Bakhtin taught Tolstoy's theories to high school students. See B. Kozhinov, "Konspektii leksii M. M. Bakhtina," *Prometei* 12 (1980): 264–5.

24. Iurii N. Davydov suggests these interpretations in his article on one fragment of "K filosofii postupka": "U istokov sotsial'noi filosofii M. M. Bakhtina," *Sotsiologicheskie issledovaniia* 2 (1986): 175.

25. Wilhelm Windelband, *A History of Philosophy*, trans. James H. Tufts (New York: Macmillan, 1935), p. 680.

26. David Carroll, "The Alterity of Discourse: Form, History and the Question of the Political in M. M. Bakhtin," *Diacritics* 13 (Summer 1983): 83.

27. Periodization depends upon interpretation. In her groundbreaking book, *The Russian Experiment in Art 1863–1922* (London: Thames and Hudson, 1962), Camilla Gray identified the avant-garde as having been active between 1863 and 1922. 1863 was the year the group of painters called the "Wanderers" withdrew from the Academy of Art, announcing that art must be useful to society. 1922 marked the year of an exhibition of Russian abstract art at the Van Diemen Gallery in Berlin. John Bowlt, in *Russian Art of the Avant Garde*, notes the convenience of dating the period from 1890–1930 so that it encompasses the birth, life, and death of the avant-garde.

28. For excellent though divergent discussions of this debate, see Rose Frances Egan, *The Genesis of the Theory of "Art for Art's Sake" in Germany and England* (Folcroft, PA: Folcroft Press, 1921), and Irving Singer, "The Aesthetics of 'Art for Art's Sake,' " *Journal of Aesthetics and Art Criticism* 12 (March 1954): 343–59.

29. Guyau's ideas about "art for life's sake" are developed in *The Problems of Contemporary Aesthetics, Book I,* trans. Helen L. Mathews (Los Angeles: De Vorss, 1947).

30. The most important resource on this aspect of Bakhtin's thought is James M. Holquist and Katerina Clark, "The Influence of Kant in the Early Work of M.M. Bakhtin," *Literary Theory and Criticism, Festschrift Presented to René Wellek in Honor of his Eightieth Birthday, Part I: Theory*, ed. Joseph P. Strelka (New York: Peter Lang, 1984), pp. 299–313. Clark and Holquist added to this material in Chapter 3 of their biography, *Mikhail Bakhtin* (Cambridge, MA: Harvard University Press, 1984), pp. 63–94. I am indebted to their work for the following interpretation and for directing me to other sources.

31. Wendell S. Dietrich, *Cohen and Troeltsch: Ethical Monotheistic Religion and Theory of Culture* (Atlanta: Scholar's Press, 1986), pp. 50–1.

32. Holquist, "Introduction," p. 10.

33. Ibid.

34. Hermann Cohen, *Religion of Reason out of the Sources of Judaism*, trans. Simon Kaplan (New York: Frederick Ungar, 1972), passim.

35. Italics mine. For further discussion of the differences between *dan* and *zadan*, see Michael Holquist, "Answering as Authoring: Mikhail Bakhtin's Trans-Linguistics," *Bakhtin, Essays and Dialogues on His Work*, ed. Gary Saul Morson (Chicago: University of Chicago Press, 1986), esp. p. 61.

36. This point is reiterated and discussed in detail by Kenneth Seeskin, *Jewish Philosophy in a Secular Age* (Albany: State University of New York Press, 1990).

37. Holquist and Clark, "Influence of Kant," p. 304.

38. Hermann Cohen, *Ethik des reinen Willens* (Berlin: Bruno Cassirer, 1907), pp. 211–12. Translation mine.

39. Discussed respectively in Hermann Cohen, *Der Begriffe der Religion im System der Philosophie* (Giessen: Verlag von Alfred Toepelmann, 1915), pp. 13, 61; and Cohen, *Aesthetik des reinen Gefühls* (Berlin: Bruno Cassirer, 1912), pp. 6–8.

40. This idea is developed in Cohen, *Religion of Reason*, pp. 11–34.

41. Holquist and Clark, "Influence of Kant," p. 308.

42. Seeskin, *Jewish Philosophy*, p. 115.

43. Cohen, *Religion of Reason*, p. 160.

44. Ibid., pp. 66–7.

45. Ibid., p. 68.

46. Ibid., p. 70.

47. Holquist and Clark, "Influence of Kant," p. 311.

48. The following historical interpretation is adapted from Charles Edward Gauss' article, "Empathy" in *Dictionary of the History of Ideas: Studies of Selected Pivotal Ideas*, ed. Philip P. Weiner (New York: Charles Scribner's Sons, 1973), pp. 85–9. Cf. David A. Stewart, *Preface to Empathy* (New York: Philosophical Library, 1956), pp. 5–6.

49. These are noted in Melvin Rader, ed., *A Modern Book of Esthetics: An Anthology* (New York: Henry Holt, 1935), p. 287.

50. Cohen, *Aesthetic*, p. 185–6. See my further comments on his concepts of empathy and aesthetic love in Chapter 4.

51. Robert Vischer, *Uber das optische Formgefühl: Ein Beitrag zur Aesthetik* (Leipzig: Hermann Credner, 1873). For recent excellent translations and commentary about Vischer and other nineteenth-century German aestheticians such as Konrad Fiedler and Adolf Hildebrand, see Robert Vischer et al., *Empathy, Form, and Space, Problems in German Aesthetics, 1873–1893*, trans. Harry Francis Mallgrave and Eleftherios Ikonomou (Santa Monica: Getty Center for the History of Art and the Humanities, 1994).

52. Theodor Lipps, "Empathy, Inner Imitation, and Sense-Feelings," trans. Max Schertel and Melvin Rader, in Rader, *Esthetics*, p. 294.

53. Ibid., p. 301.

54. Ibid., pp. 302–3.

55. Alan Robinson, *Poetry, Painting and Ideas, 1885–1914* (London: Macmillan, 1985), p. 68. See Lipps, *Aesthetik: Psychologie des Schonen und der Kunst*, 2 vols. (Hamburg: Verlag von Leopold, 1903–6) I, pp. 91–4.

56. Lipps, *Aesthetik*, I, pp. 106–7; translated by Robinson in *Poetry, Painting and Ideas*, pp. 68–9.

57. Quoted in Gauss, "Empathy," p. 87.

1. *Otvetstvennost'* means both responsibility and answerability. For the most part here, I have chosen to translate the word as answerability, though a strong case can be made for interpreting Bakhtin's earliest usage with the stronger moral connotations of responsibility. Answerability carries the more clear implication of two persons, two consciousnesses, which is important to the themes I develop here.

2. In 1921, Bakhtin had written to Matvei Kagan that he called his essay, "The Subject of Morality and the Subject of Law," *Pamiat'* 4 (1979–81): 263.

3. Bocharov, *Estetika slovesnogo tvorchestva* (Moscow: Iskusstvo, 1979), p. 385.

4. Wilhelm Windleband, *An Introduction to Philosophy*, trans. Joseph McCabe (New York: Henry Holt, 1921), p. 122.

5. Ibid., p. 123.

6. Ibid., p. 124.

7. Caryl Emerson, in a note on Bakhtin's text, *Problems of Dostoevsky's Poetics*, p. 6.

8. I have derived this list from his discussion of the way God/person, self/other, and author/hero relate in specific forms of writing (e.g., autobiography, which describes interaction in terms of self and other, and saints' lives, where interaction is between God and one other person). See Bakhtin, "Author and Hero," pp. 138–87.

9. In exhibition catalog, *Russia, The Land, The People, Russian Painting, 1850–1910* (Washington, D.C.: Smithsonian Institution Traveling Exhibition Service, 1986), p. 52.

10. For a summary of some of the connections of Bakhtin's thought to Bergson, see Michael Holquist, "Introduction," pp. xxxiii–xxxiv.

11. Vadim Liapunov suggests that the phrase "intuitable" means given in intuition and apprehended in perception. See his notes to "Author and Hero," p. 233.

12. Davydov, "U istokov," pp. 178–9.

13. Later, he develops the concept of the chronotope to accent this idea. See Bakhtin "Forms of Time and of the Chronotope in the Novel," *The Dialogic Imagination: Four Essays by M. M. Bakhtin*, ed. Michael Holquist, trans. Caryl Emerson and Michael Holquist (Austin: University of Texas Press, 1981), pp. 84–258.

14. Bakhtin wrote his early texts before he had discovered the word *slovo* – the monologic and dialogic word upon which his writing between 1929 and 1970 was based.

15. Bakhtin, "Author and Hero," p. 110.

16. Emerson, "Problems with Baxtin's Poetics," *Slavic and East European Journal* 32 (Winter 1988): 510.

17. Morson and Emerson, *Rethinking Bakhtin*, p. 284.

18. Emerson, "Baxtin's Poetics," p. 510.

19. Morson and Emerson, *Creation of a Prosaics*, pp. 192–3. Also see Bakhtin, "Author and Hero," pp. 100–1.

20. Although he did not explore them thoroughly, Bakhtin also presented the ideas of *soul-slave* (a soul lacking self-sufficiency); *optical forgery* (a soul without a place of its own); and *mask-face* (not the true face). For more on these ideas, see Morson and Emerson, *Creation of a Prosaics*, Chapter 5.

21. Quoted in Margaret Olin, *Forms of Representation in Alois Riegl's Theory of Art*

(University Park: Pennsylvania State University Press, 1992), p. 140. See Riegl's *Spätrömische Kunstindustrie* (Vienna: Osterr. Staatsdruckerei 1927), pp. 389–90, which was originally published in 1901.

22. Wassily Kandinsky, *Concerning the Spiritual in Art*, trans. M. T. H. Sadler (New York: Dover, 1977), p. 29.

23. Gary Saul Morson, "Prosaics," p. 516. The word "prosaics" was used independently and simultaneously by Morson in his *Hidden in Plain View* (Stanford: Stanford University Press, 1987), and Wlad Godzich and Jeffrey Kittay in *Emergence of Prose: An Essay in Prosaics* (Minneapolis: University of Minnesota Press, 1987). See also Morson and Emerson, *Creation of a Prosaics*, pp. 15–36.

24. Morson, "Prosaics," p. 526.

25. See Chave's *Mark Rothko, Subjects in Abstraction* (New Haven: Yale University Press, 1989).

CHAPTER 4

1. Emerson, "Baxtin's Poetics," p. 510.

2. This is what Tzvetan Todorov has called exotopy in *Mikhail Bakhtin*, passim.

3. Bakhtin described these in "Author and Hero," pp. 138–87.

4. In *Principles of the Philosophy of the Future*, trans. Manfred H. Vogel (Indianapolis: Hackett, 1986), p. 58.

5. Emerson, "Baxtin's Poetics," p. 504.

6. Ibid., p. 505.

7. See, for instance, H. Perry Chapman's *Rembrandt's Self-Portraits, A Study in Seventeenth-Century Identity* (Princeton: Princeton University Press, 1990).

8. See Aline Isdebsky-Pritchard, *The Art of Mikhail Vrubel (1856–1910)* (Ann Arbor: UMI Research Press, 1982), for consideration of Vrubel's many self-portraits.

9. Richard Brilliant, *Portraiture* (Cambridge, MA: Harvard University Press, 1991), p. 112.

10. Ibid., p. 59.

11. Ibid., pp. 14–15.

12. For further discussion of the loophole, see Morson and Emerson, *Creation of a Prosaics*, pp. 67–71, 159–61.

13. For excellent secondary discussions of *Kunstwollen*, see Margaret Iverson, *Alois Riegl: Art History and Theory* (Cambridge, MA: MIT Press, 1993); and Margaret Olin, *Forms of Representation*. Riegl himself articulated the idea in 1901 in *Die spätrömische Kunstindustrie*, which was subsequently reprinted in 1927 and 1973. See Rolf Winkes' translation, *Late Roman Art Industry* (Rome: Giorgio Bretschneider Editore, 1985).

14. Olin, *Forms of Representation*, p. 148.

15. Iverson, *Alois Riegl*, p. 6.

16. Olin, *Forms of Representation*, p. 150.

17. Riegl, *Late Roman Art Industry*, esp. Chapter Five, "The Leading Characteristics of the Late Roman *Kunstwollen*," pp. 223–34.

18. This phrase is Riegl's own definition of the most relevant features of a work of art. Quoted in Iverson, *Alois Riegl*, p. 8.

19. Riegl, *Late Roman Art Industry*, p. 232.

20. Otto Pächt, "Art Historians and Art Critics – 6: Alois Riegl," *Burlington Magazine* 105 (May 1963): 191.

21. Michael Ann Holly, *Panofsky and the Foundations of Art History* (Ithaca, NY: Cornell University Press, 1984), pp. 78–9. Cf. Henri Zerner, "Alois Riegl: Art, Value, and Historicism," *Daedalus* 105 (Winter 1976): 179.

22. Zerner, "Alois Riegl," p. 179.

23. Olin, *Forms of Representation*, p. 156.

24. Emerson, "The Tolstoy Connection in Bakhtin," in *Rethinking Bakhtin*, p. 160. Cf. Bakhtin, "Author and Hero," p. 63.

25. See Katharine Everett Gilbert and Helmut Kuhn, *A History of Esthetics* (Bloomington: Indiana University Press, 1953), pp. 537–43; and Earl of Listowel, *A Critical History of Modern Aesthetics* (London: Allen and Unwin, 1933), pp. 28–9, 64–5. For an interesting account of Groos' articulation of his ideas, see *A History of Psychology in Autobiography* (Worcester, MA: Clark University Press, 1932), pp. 115–52.

26. Cohen, *Asthetik*, pp. 185–6.

27. Ibid., pp. 178, 182–3.

28. For good summaries of this process, see Harold Osborne's entries on expression and expressionism in *The Oxford Companion to Art* (Oxford: Clarendon Press, 1970, reprinted 1986), and in *The Oxford Companion to Twentieth-Century Art* (Oxford: Oxford University Press, 1988).

29. Iverson, *Alois Riegl*, p. 147.

30. Ibid., p. 200.

31. Henri Matisse, "Notes of a Painter," originally published in 1908, but reprinted in Herschel B. Chipp, *Theories of Modern Art, A Source Book by Artists and Critics* (Berkeley: University of California Press, 1971), pp. 131–2.

CHAPTER 5

1. For further discussion of the relative weight Bakhtin accorded finalizability and unfinalizability, see Morson and Emerson, *Creation of a Prosaics*, p. 88 passim.

2. For an interpretation of Bakhtin's ideas on content, material, and form that in many ways parallels my own, see Allan Reid, *Literature as Communication*, pp. 76–91.

3. Donald Judd, *Donald Judd: Complete Writings 1959–1975* (Halifax: Press of the Nova Scotia College of Art and Design; New York: New York University Press, 1975), p. 196.

4. For a brilliant articulation of this process, see Anna C. Chave's, "Minimalism and the Rhetoric of Power," *Arts Magazine* 64 (January 1990): 44–63. Judd's most direct statement about the nature of power in his work is in his important essay, "Specific Objects," *Judd: Complete Writings*, pp. 181–9.

5. Chave, "Minimalism," p. 55.

6. Ernst Gombrich, *In Search of Cultural History* (Oxford: Clarendon Press, 1969), pp. 9–10.

7. Meyer Schapiro, "Style," in *Anthropology Today, An Encyclopedic Inventory*, prepared under the Chairmanship of A. L. Kroeber (Chicago: University of Chicago Press, 1953), p. 293. This essay remains one of the most extensive explorations of the state of research on style. See esp. pp. 292–5.

8. Joy Kasson, *Marble Queens and Captives* (New Haven: Yale University Press, 1990).

9. For an examination of the relationship of their ideas, see Caryl Emerson, "The Outer Word and Inner Speech: Bakhtin, Vygotsky, and the Internalization of

Language," in *Bakhtin, Essays and Dialogues on His Work*, ed. Gary Saul Morson (Chicago: University of Chicago Press, 1986), pp. 21–40.

10. Lev Semenovich Vygotsky, *The Psychology of Art*, intro. A. N. Leontiev, commentary by V. V. Ivanov (Cambridge, MA: MIT Press, 1971), p. 248.

11. Jessica Benjamin, *The Bonds of Love, Psychoanalysis, Feminism, and the Problem of Domination* (New York: Pantheon, 1988), pp. 76–7.

12. For an excellent discussion of these ideas, see the essays by Charlotte Douglas and Rose-Carol Washton Long in *The Spiritual in Art: Abstract Painting 1890–1985* (Los Angeles: Los Angeles County Museum of Art; New York: Abbeville Press, 1986).

13. Hugo Muensterberg, *Principles of Art Education* (New York: Prang, 1905); excerpted in Melvin Rader, ed., *A Modern Book of Aesthetics*, p. 437.

14. Cf. the interpretations of this shift in Clark and Holquist, *Mikhail Bakhtin*, esp. Chapter 14, and Morson and Emerson, *Creation of a Prosaics*, pp. 36–48.

15. For an explication of the meaning of transgredient, especially as it is similar to transcendent, see the notes to Bakhtin's "Author and Hero," p. 233. Whereas in the Kantian tradition it meant "beyond the limits of possible experience" (in Jonas Cohn), here Bakhtin seemed to follow Johannes Volkelt in suggesting that the transgredient lies outside the immediate act of thinking, but presumably within the realm of the possible.

16. For his discussion of this typology, see Bakhtin, "Author and Hero," pp. 138–87.

17. Morson, "Prosaics," p. 520.

18. I must note here the relative valences of these two words. Whereas "finalization" has a cold and businesslike sound, there is an obvious sexual connotation in "consummation." I have chosen here to use whichever translation seems to fit Bakhtin's meaning in context.

19. *Encyclopedia of Philosophy*, Vol. 5, ed. Paul Edwards (New York: Macmillan and The Free Press, 1967), p. 88.

20. Holquist, "Introduction," p. 8.

21. Emerson and Morson, "Penultimate Words," p. 44.

CHAPTER 6

1. For the suggestion that these two images might be connected, I am indebted to W. Sherwin Simmons. I build on his discussion in *Kasimir Malevich's Black Square and the Genesis of Suprematism 1907–1915* (New York: Garland Press, 1981), pp. 234–9. For a very brief consideration of the relationship of "Orthodoxy and the Avant-Garde," see John E. Bowlt's article of that name in *Christianity and the Arts in Russia*, eds. William C. Brumfield and Milos M. Velimirovic (Cambridge: Cambridge University Press, 1991), pp. 145–150.

2. The nature of minimalist art has been the subject of numerous monographs. An especially keen interpretation of the power dynamics in this American movement is developed by Anna C. Chave, "Minimalism," pp. 44–63.

3. Timothy Ware, *The Orthodox Church* (Baltimore: Penguin, 1963), p. 236. The following discussion is based on Ware's description in Chapters 11 and 12.

4. Dawn Ades, "Reviewing Art History," *New Art History*, eds. A. L. Rees and Frances Borzello (Atlantic Highlands, NJ: Humanities Press, 1988), p. 13.

5. Discussed in Leonid Ouspensky and Vladimir Lossky, *The Meaning of Icons*,

trans. G. E. H. Palmer and E. Kadloubovsky (Boston: Boston Book and Art Shop, 1952), pp. 33–4.

6. In Simmons, *Malevich's Black Square*, p. 236. The *Spas* is a double-sided icon, with an image of the crucifixion painted on the other side. In what follows, I do not further discuss the reverse image.

7. Ernst Kitzinger, "The Cult of Images in the Age Before Iconoclasm," *Dumbarton Oaks Papers* 8 (1954): 113.

8. Ibid., p. 143.

9. This understanding of the role of the painter is articulated in George Galavaris, *Icons from the Elvehjem Art Center* (Madison: University of Wisconsin Press, 1973), p. 29.

10. Boris Uspensky, *The Semiotics of the Russian Icon*, ed. Stephen Rudy (Lisse: Peter de Ridder Press, 1976), p. 10. Uspensky is quoting from the preface to a manuscript *podlinnik*, a practical manual on icon painting used in Russia.

11. For a detailed description of how this process evolved, see Robert L. Nichols, "The Icon in Russia's Religious Renaissance," in Brumfield and Velimirovic, eds., *Christianity and the Arts*, pp. 131–44. Cf. Galavaris, *Icons from the Elvehjem Art Center*, p. 29.

12. This interpretation is offered by Father Vladimir Ivanov, in *Russian Icons* (New York: Rizzoli, 1988), p. 20. This book was co-published with the Moscow Patriarchate, and no verifying sources are given for Ivanov's claim.

13. Andre Grabar, *Nerukotvorennie spas lanskogo sobora* [*The Savior Not Made by Human Hands of the Laon Synod*] (Prague: Seminarium Kondakovianum, 1930), pp. 21–9.

14. Described in David Freedberg, *The Power of Images* (Chicago: University of Chicago Press, 1989), pp. 207–9. Perhaps the most complete study of paintings "not made by human hands" is Grabar's, *Nerukotvorennie spas*. Another fascinating recent study is Ewa Kuryluk's *Veronica and Her Cloth, History, Symbolism, and Structure of a "True" Image* (Oxford: Basil Blackwell, 1991). Because it appeared while this book was in press, I could not take account of Hans Belting's *Likeness and Presence, A History of the Image Before the Era of Art*, trans. Edmund Jephcott (Chicago: University of Chicago Press, 1994), esp. Chapter 11, "The 'Holy Face.' "

15. This version of the story is retold in Simmons, *Malevich's Black Square*, pp. 235–6. Edessa was originally in Mesopotamia; it is now in southeastern Turkey. A more complete discussion of the story is given in L. Ouspensky, *Essai sur la Theologie de l'Icone dans l'Eglise orthodoxe* (Paris: Editions de l'Exarchat patriarcal Russe en Europe occidentale, 1960), pp. 60–9.

16. In Konrad Onasch, *Russian Icons* (New York: Phaidon, 1977), pp. 236, 347.

17. The precise description of this period as Rus' or Russian has been the subject of much controversy. On the vagaries of the discussion, see Henryk Paszkiewicz, *The Making of the Russian Nation* (London: Henry Regnery, 1963); and V. O. Kluchevsky, *A History of Russia*, trans. C. J. Hogarth (New York: Russell and Russell, 1960), esp. Vol. 1. More recently, Omeljan Pritsak has written a detailed technical analysis of the linguistics and cultural origins of Rus', *The Origin of Rus'* (Cambridge, MA: Harvard Ukrainian Research Institute, 1981), esp. pp. 1–31. Rus' is the appropriate designation for the earliest Slavic state from the ninth century until the formation of a unified Russian state at the end of the fifteenth century.

18. See the first chapter of Paul Miliukov, *Outlines of Russian Culture, Part I, Re-*

ligion and the Church (New York: A. S. Barnes, 1942), pp. 1–9. This perspective is basically reiterated by other sources: E. E. Golubinskii, *Istoriia russkoi tserkvi* [*A History of the Russian Church*], Vol. 1, Parts 1, 2, and 5 (Moscow: Universitetskaia tipographia, 1901, 1904, 1906); Kluchevsky, *A History of Russia*; B. Rybakov, *Early Centuries of Russian History* (Moscow: Progress, 1965).

19. *The Chronicle of Novgorod, 1016–1471*, trans. Robert Michell and Nevill Forbes (London: Offices of the Society, 1914). The other main source of information on this period is the so-called *Ancient Chronicle*. This text exists in two versions, the Laurentian and the Ipatievski. The Laurentian Version, from 1377, is the oldest Russian script telling of Rus'ian history at large. The Ipatievski Version is from the end of the fourteenth or beginning of the fifteenth century; the main chronicle of events is followed by a detailed narrative.

20. George P. Fedotov, *The Russian Religious Mind* (Cambridge, MA: Harvard University Press, 1946), p. 347.

21. Dimitri Obolensky, "Popular Religion in Medieval Russia," in *The Religious World of Russian Culture*, Vol. 2, *Russia and Orthodoxy: Essays in Honor of Georges Florovsky*, ed. Andrew Blane (The Hague: Mouton, 1975), p. 51.

22. Fedotov, *Russian Religious Mind*, pp. 346–53.

23. Miliukov, *Outlines*, p. 7. Also, the Church in old Russia was responsible for the first written laws of jurisprudence. In marked contrast to a few centuries later, the Church supported a basic legal equality of women and men in marriage, and the wife's right to own separate property. Effects of a consistent moral and legal code were slow to develop.

24. In later texts, Bakhtin presented this as a problem of chronotopes, of differences in the temporal-spatial context of the creator and viewer of an artwork. Cf. "Forms of Time and of the Chronotope in the Novel," *The Dialogic Imagination*, pp. 84–258.

25. Anthony Ugolnik, *The Illuminating Icon* (Grand Rapids, MI: William B. Eerdmans, 1989), p. 112.

26. In I. E. Grabar, *Istoriia russkogo iskusstva*, Tom 2 (Moscow: Izdatel'stvo Akademii Nauk SSSR, 1954), p. 115.

27. Sergei Sergeevich Averinsev, "Zoloto v sisteme simvolov rannevizantiiskoi kul'tury" [Gold in the System of Symbols of Early Byzantine Culture], *Vizantiia, iuzhnye slaviane i drevniaia Rus', zapadnaia Evropa; iskusstvo i kul'tura. Sbornik statei v chest' V. N. Lazareva* [*Byzantium, The southern Slavs and ancient Rus', Western Europe; Art and Culture. A collection of essays in honor of V. N. Lazarev*], ed. V. N. Grashchenkov et al. (Moscow: Nauka, 1973), p. 47.

28. Ouspensky and Lossky, *Meaning of Icons*, p. 70.

29. Grabar, *Nerukotvorennie spas*, pp. 17–18.

30. Ouspensky and Lossky, *Meaning of Icons*, p. 70, identify this name as "THE BEING." A fascinating connection between the *Spas* and *Black Square* that I do not discuss here is suggested in Malevich's 1919 "The Being." He links God as an all powerful, omniscient Being with 'The Being of man', which is in the process of uniting with God. In *The Artist, Infinity, Suprematism, Unpublished Writings 1913–1933*, Vol. 4, trans. Xenia Hoffman, ed. Troels Andersen (Copenhagen: Borgen, 1978), pp. 54–72.

31. In theoretical terms, as Krystyna Pomorska has described it, " 'Form' in art . . . is particular in expressing and conveying a system of values, as follows from the very nature of communication, which is an exchange of meaningful messages. . . . [That is,] 'form' is active in the structure [of an artwork] as a specific

aspect of the 'message.' " In "Mikhail Bakhtin and His Dialogic Universe," *Semiotica* 58 (1–2, 1984): 170.

32. B. A. Uspensky, "The Language of Ancient Painting," *Dispositio* I (1976): 231.

33. Grabar, *Nerukotvorennie spas*, p. 34.

34. Mihail Alpatov, "The Icons of Russia," in Kurt Weitzmann et al., *The Icon* (New York: Alfred A. Knopf, 1982), p. 242.

35. Charlotte Douglas, *Swans of Other Worlds: Kasimir Malevich and the Origins of Abstraction in Russia* (Ann Arbor: University of Michigan Press, 1980), p. 67. The Russian *dukh*, spirit, has a broader meaning than the English equivalent, because it involves an intellectual component that is intimately related to the mystical. Caryl Emerson, personal letter, July 1990.

36. Kasimir Malevich, "Suprematism," in *The Non-Objective World*, trans. Howard Dearstyne (Chicago: Paul Theobald, 1959), p. 74. I focus here on Malevich, but it is notable that he derived many of his earliest ideas about Suprematism in dialogue with co-theorists such as Olga Rozanova.

37. Evgenii Kovtun, ed., "K. S. Malevich, Pisma k M. V. Matiushinu," in *Ezhegodnik rukopisnogo otdela Pushkinskogo doma na 1974* (Leningrad: Izdatel'stvo, 1976), p. 192. Translation mine.

38. Troels Andersen, *Malevich* (Amsterdam: Stedelijk Museum, 1970), p. 28.

39. This is especially clear in several of his early essays, e.g., "The Artist," "I Am the Beginning," and "Kor re rezh" in *Artist, Infinity, Suprematism*, pp. 9–30. Also, see his long essay "God Is Not Cast Down," *Essays on Art*, Vol. 2, trans. Xenia Glowacki-Prus and Arnold McMillin, ed. Troels Andersen (Copenhagen: Borgen, 1968), pp. 188–223. For an analysis of the latter, see Julianne L. Muss, "The Suprematist Obsession: The Essays of Kasimir Malevich," Harvard College honors thesis, 1985.

40. Malevich, "From I/42. Notes," in *Essays*, Vol. 2, p. 148.

41. "Fragments from 'Chapters from an Artist's Autobiography' (1933)," trans. Alan Upchurch, *October* 34 (Fall 1985): 44.

42. Ibid., pp. 38–9.

43. From *Mastera iskusstva ob iskusstve* VII, eds. A. A. Fedorov-Davydov and G. A. Nedoshivin (Moscow, 1970), pp. 231–2. Quoted by Margaret Betz, "The Icon and Russian Modernism," *Artforum* 15 (Summer 1977): 39.

44. Anna Leporskaia, "The Beginnings and the Ends of Figurative Painting – and Suprematism," comp. Antonia Gmurzynska, *Kasimir Malewitsch* (Koln: Galerie Gmurzynska, 1978), p. 65. Leporskaia was one of Malevich's pupils at GINKhUK (the State Institute of Artistic Culture) in Petersburg, and she continued to work with him into the 1930s.

45. The *krasnyi ugol* was the customary east upper-corner location of icons in the Russian home. For a discussion of the exhibition, see Charlotte Douglas, "0–10 Exhibition," in *The Avant-Garde in Russia, 1910–1930, New Perspectives,* eds. Stephanie Barron and Maurice Tuchman (Cambridge, MA: MIT Press, 1980), pp. 34–40.

46. Benois is quoted in Betz, "Icon and Russian Modernism," p. 43.

47. Alexander Benois, "Poslednaia futuristskaia vystavka" *Rech*, P, January 9, 1916. Quoted in *Kasimir Malevich, 1878–1935*, ed. W. A. L. Beeren et al. (Moscow: Ministry of Culture; Amsterdam: Stedelijk Museum, 1988), p. 158.

48. Nakov, *Kazimir Malévich: Ecrits* (Paris: Éditions Gérard Lebovici, 1986), pp. 92, 106. Translation mine.

49. In "From Cubism and Futurism to Suprematism: The New Painterly Real-

ism," in John Bowlt, ed., *Russian Art of the Avant Garde, Theory and Criticism 1902–1934*, (New York: Viking, 1976), p. 133. Although I cannot here discuss it in depth, note must be made of the relationship between Malevich's understanding of intuitive reason and Henri Bergson's creative intuition. For an excellent discussion of differences and similarities, see Douglas, *Swans*, pp. 49–62.

50. Malevich, "To the New Image," *Essays on Art*, Vol. 1, p. 51. For discussion of how the evolution of *Black Square* relates to the work of Malevich's contemporaries working in France (e.g., Leger, Picasso, Duchamp, Kupka, Delaunay) and Italy (e.g., Boccioni, Carra, Marinetti, Balla), see the introductory essay by Andreí Nakov, *Ecrits*, esp. pp. 79–108. Also, a keen semiotic interpretation of *Black Square* is offered in N. Savelieva, "Sur les éléments et les processus de constitution de formes en art," *Cahier Malévitch No. 1, Recueil d'essais sur l'oeuvre et la pensée de K. S. Malévitch* (Lausanne: L'Age d'Homme, 1983), pp. 105–10.

51. Both the Tretiakov Gallery in Moscow and the Russian Museum in St. Petersburg own two black square paintings apiece from the 1920s. The original 1915 *Black Square* is in "extremely vulnerable condition." *Kasimir Malevich 1878–1935*, p. 14. According to Troels Andersen, not all of these were executed by Malevich, though he probably signed them. See *Malevich*, pp. 27, 40.

52. For details on its history and relationship to other similar paintings, see Jean-Claude Marcadé, "K. S. Malevich: From Black Quadrilateral (1913) to White on White (1917)," *Avant-Garde in Russia*, Barron and Tuchman, eds., pp. 20–24; Andersen, *Malevich*, esp. p. 40; and Nakov, *Ecrits,* esp. p. 74.

53. Andersen, *Malevich*, p. 26.

54. Malevich, "Suprematism," *The Non-Objective World*, p. 76.

55. These are described in Andersen, *Malevich*, pp. 27.

56. Ibid.

57. In "Suprematism. 34 Drawings," *Essays on Art*, Vol. 1, p. 125.

58. Malevich, "On the Subjective and Objective in Art or on Art in General," trans. John E. Bowlt, in *Kasimir Malewitsch*, p. 49.

59. In "The Question of Imative Art," *Essays on Art*, Vol. 1, p. 177.

60. In *Artist, Infinity, Suprematism*, Vol. 4, p. 9.

61. Malevich, "The Question of Imative Art," *Essays on Art*, Vol. 1, p. 170.

62. Ibid. This theme of revolutionaries who become anti- or counterrevolutionaries is also a common theme in literature of the early 1920s. For instance, in his essay of 1923, "On Revolution, Entropy and Other Matters," Zamiatin makes just this point that permanent revolution is directly related to creative growth. Trans. by W. Vickery, *Partisan Review* 3–4 (1961): 372–8.

63. Malevich, "A Letter from Malevich to Benois," *Essays on Art*, Vol. 1, p. 45.

64. Malevich, "The Question of Imative Art," *Essays on Art*, Vol. 1, p. 171.

65. Malevich, *Artist, Infinity, Suprematism*, Vol. 4, p. 12.

66. Malevich, *Essays on Art*, Vol. 2, p. 201. In "An Approach to the Writings of Malevich," Jean-Claude Marcadé has examined the sources of the religious ideas in Malevich's writing, linking them to diverse writers such as Berdiaev, Bulgakov, Florensky, and in particular, the literary historian, M. Gershenzon. In *Soviet Union* 5 (Part 2, 1978): 225–40.

67. Malevich, *Essays on Art*, Vol. 2, p. 202.

68. This has certainly not always been the dominant interpretation of Malevich's work. For a full discussion of "que le champ de son oeuvre est le champ même

de la spiritualité," see Martineau, *Malevitch et la Philosophie, La Question de la Peinture abstraite* (Lausanne: L'Age d'Homme, 1977).

69. Olga Rozanova, "The Bases of the New Creation and the Reasons Why It is Misunderstood," in Bowlt, ed., *Russian Art of the Avant-Garde*, p. 109.

70. Malevich, *Non-Objective World*, p. 94.

71. Malevich, *Artist, Infinity, Suprematism*, Vol. 4, pp. 29–30. Other commentators have identified the importance of the face motif as a link to the icon tradition. See W. Sherwin Simmons, *Malevich's Black Square*, and A. C. Birnholz. "On the meaning of Kazimir Malevich's 'White on White,' " *Art International 21* (Number 1, 1977): 9–16f.

72. Quoted in Betz, "Icon and Russian Modernism," p. 42.

CHAPTER 7

1. In *Prophesy Deliverance* (Philadelphia: Westminster Press, 1982), Cornel West develops a persuasive account of the development of the modern period to which I am indebted for the following description. West relies on the work of Ernst Cassirer, Peter Gay, Ernst Troeltsch, Theodor Adorno, and Max Horkheimer. Certainly, it is also arguable that the modern era begins in the Renaissance and in the sixteenth-century reformations.

2. T. J. Clark, *The Painting of Modern Life, Paris in the Art of Manet and His Followers* (Princeton: Princeton University Press, 1984), p. 10.

3. West, *Prophesy Deliverance*, p. 37. West is quoting Yeats.

4. Key texts in the debate are too numerous to be identified here, but Linda Hutcheon has compiled a fine bibliography about postmodernism in *The Politics of Postmodernism* (New York: Routledge, 1990), pp. 169–70.

5. Hutcheon, *Politics*, p. 27.

6. Hal Foster, ed., in "Postmodernism, A Preface," *The Anti-Aesthetic, Essays on Postmodern Culture* (Port Townsend, WA: Bay Press, 1983), and Suzi Gablik, *The Reenchantment of Art* (New York: Thames and Hudson, 1991).

7. In a talk at Harvard University, April 30, 1990.

8. I would note that Jameson's language here, e.g., phrases such as "cultural dominant" or "force field," employs metaphors of violence and aggression. These ideas are further developed in "Postmodernism, or the Cultural Logic of Late Capitalism," *New Left Review* 146 (July/August 1984): 53–92.

9. Andreas Huyssen, *After the Great Divide, Modernism, Mass Culture, Postmodernism* (Bloomington: Indiana University Press, 1986), p. 197. Of the many descriptions of the modernism/postmodernism debate, I find Andreas Huyssen's among the most balanced, and therefore I use his model with modifications. Huyssen shares with most feminist and postmodernist theorists the view that a cultural, social, and economic paradigm shift is underway. His main goal is to redefine postmodernism's critical potential.

10. Ibid.

11. See Kirk Varnedoe and Adam Gopnik, eds., *High and Low, Modern Art and Popular Culture* (New York: Museum of Modern Art, 1990), for many examples of how artists have used graffiti, caricature, comics, advertising, and other aspects of popular culture in their work.

12. These arguments are developed persuasively by Craig Owens, "The Discourse of Others: Feminists and Postmodernism," in Foster, ed., *Anti-Aesthetic*, pp. 57–82. See Ernest Laren's article on Rosler's show at the DIA Foundation in

New York, "Who Owns the Streets," *Art in America* 78 (January 1990): 55–61.

13. See essays in Linda Nicholson, *Feminism/Postmodernsim* (New York: Routledge, 1990), and in Alison Jaggar and Susan Bordo, eds., *Gender/Body/Knowledge, Feminist Reconstructions of Being and Knowing* (New Brunswick: Rutgers University Press, 1989). Felski's statement is in *Beyond Feminist Aesthetics: Feminist Literature and Social Change* (Cambridge, MA: Harvard University Press, 1989), p. 13.

14. Roland Barthes, "The Death of the Author," *Theories of Authorship: A Reader*, ed. John Caughie (London: Routledge and Kegan Paul, 1981), pp. 205–217; and Michel Foucault, "What is an Author?," *The Foucault Reader*, ed. Paul Rabinow (New York: Pantheon, 1984), pp. 101–20.

15. Barthes, "The Death of the Author," pp. 212–13.

16. I must note here that Sherman's recent series, "Sex Pictures," moves into new territory. For the first time since she began working with photography, Sherman has abandoned the practice of using herself as the photographic subject. For a sympathetic reading of her work, see the essays by Rosalind Krauss and Norman Bryson in Rosalind Krauss, *Cindy Sherman, 1975–1993* (New York: Rizzoli, 1993).

17. Nancy Grimes, "Sherrie Levine," *Art News* 86 (November 1987): 191–2.

18. Here I have appropriated Foucault's "author function," and his discussion of literary issues, to describe the artist, visual language, artwork, and so on.

19. Marzorati, "Art in the (Re)Making," *Art News* 85 (May 1986): 97.

20. Siegel, "After Sherrie Levine," *Arts Magazine* 59 (Summer 1985): 143.

21. Marzorati, Art in the (Re)Making, p. 96.

22. Siegel, "After Sherrie Levine," p. 142. Krauss offers a convincing justification for Sherman's "refuge in a stolid muteness" in Krauss, *Cindy Sherman*, p. 207.

23. Marzorati, "Art in the (Re)Making," pp. 96–7.

24. Bryson, "House of Wax," in Krauss, *Cindy Sherman*, p. 218. In fact, he suggests that in the trajectory of her work since the 1970s, one sees a movement from the ideal to the abject.

25. Huyssen, *Great Divide*, p. 213. For a critical discussion of Foucault's claims about the death of the author, see Janet Wolff, *The Social Production of Art* (New York: St. Martin's Press, 1981), pp. 117–36.

26. Huyssen, *Great Divide*, p. 107.

27. For feminist discussions of this set of issues, see Carol Gilligan, *In a Different Voice, Psychology Theory and Women's Development* (Cambridge, MA: Harvard University Press, 1982); Mary Field Belenky et al., *Women's Ways of Knowing, The Development of Self, Voice, and Mind* (New York: Basic Books, 1986); and Elizabeth V. Spelman, *Inessential Woman, Problems of Exclusion in Feminist Thought* (Boston: Beacon Press, 1988).

28. bell hooks, *Feminist Theory from Margin to Center* (Boston: South End Press, 1984), p. 62.

29. Ibid., p. 64.

30. Ibid., p. 65.

31. Ibid., p. 47.

32. In the glossary prepared by Emerson and Holquist, *The Dialogic Imagination*, p. 429. Cf. Bakhtin, *Problems of Dostoevsky's Poetics*, ed. and trans. Caryl Emerson (Minneapolis: University of Minnesota Press, 1984), esp. pp. 81–5, 92–3. For a recent attempt to interpret Bakhtin's work in terms of theories of ideology,

see Michael Gardiner, *The Dialogics of Critique, M. M. Bakhtin and the Critique of Ideology* (New York: Routledge, 1992).

33. Louis Althusser, "Ideology and Ideological State Apparatuses," *Lenin and Philosophy and Other Essays*, trans. Ben Brewster (New York: Monthly Review Press, 1971), p. 174.

34. Iris Marion Young, "The Ideal of Community and the Politics of Difference," in Nicholson, ed., *Feminism/Postmodernism*, p. 304.

35. Ibid., pp. 309–10.

36. Ibid., p. 311.

37. Many theological dictionaries have entries on vocation. Cf. Palazzini, "Vocation," *Dictionary of Moral Theology*, comp. Francesco Cardinal Roberti, ed. Monsignor Pietro Palazzini (Westminster, MD: Newman Press, 1962), pp. 1285–8; Han J. W. Drijers, "Vocation," *Encyclopedia of Religion*, Vol. 15, pp. 294–6, ed. Charles J. Adams et al. (New York: Macmillan, 1987); and Th. Scharmann, "Beruf," *Die Religion in Geschichte und Gegenwart, Handworterbuch für Theologie und Religionswissenschaft*, Ester Band, ed. Hans Frhr. v. Camphausen et al. (Tübingen: J. C. B. Mohr (Paul Siebeck), 1957), cols. 1071–82. The most complete discussion of the history of the term is Karl Holl, "Die Geschichte des Worts Beruf," in his *Gesammelte Aufsatze zur Kirchengeschichte*, Vol. 3 (Tübingen: Verlag von J. C. B. Mohr (Paul Siebeck), 1928), pp. 189–219. This has been translated in a pamphlet, "The History of the Word Vocation (*Beruf*)," by Heber F. Peacock. My discussion here is based largely on Holl's address. Studies of the evolving vocation of the artist are few. For one attempt, see Ernst Kris and Otto Kurz, *Legend, Myth and Magic in the Image of the Artist: A Historical Experiment* (Vienna: Krystall Verlag, 1934; New Haven: Yale University Press, 1979).

38. Holl, "History of the Word Vocation," p. 14, and Max Weber, *The Protestant Ethic and the Spirit of Capitalism* (New York: Charles Scribner's Sons, 1958). Holl also mentions the importance of Berthold of Regensburg, Aquinas, and Tauler in developing the idea of vocation.

WORKS CITED

Ades, Dawn. "Reviewing History." In *The New Art History*. Edited by A. L. Rees and Frances Borzello. Atlantic Highlands, NJ: Humanities Press, 1988.

Althusser, Louis. *Lenin and Philosophy and Other Essays*. Translated by Ben Brewster. New York: Monthly Review Press, 1971.

Andersen, Troels. *Malevich*. Amsterdam: Stedelijk Museum, 1970.

Averinsev, S. S. "Zoloto v sisteme simvolov rannevizantijskoi kul'tury." In *Vizantiia, iuzhnye slaviane i drevniaia Rus'. Zapadnaia Evropa. Iskusstvo i kul'tura. Sbornik statei v chest' V. N. Lazareva*. Edited by V. N. Grashchenkov et al. Moscow: Nauka, 1973.

Bakhtin, Mikhail M. "Art and Answerability." In *Art and Answerability*. Translated by Vadim Liapunov and Kenneth Brostrom. Edited with an introduction by Michael Holquist. Austin: University of Texas Press, 1990.

 "Author and Hero in Aesthetic Activity." In *Art and Answerability*. Translated by Vadim Liapunov and Kenneth Brostrom. Edited with an introduction by Michael Holquist. Austin: University of Texas Press, 1990.

 "Avtor i geroi v esteticheskoi deiatel'nosti" [Author and hero in aesthetic activity]. In *Estetika slovesnogo tvorchestva*. Edited by S. G. Bocharov. Moscow: Iskusstvo, 1979.

 The Dialogic Imagination: Four Essays by M. M. Bakhtin. Edited by Michael Holquist. Translated by Caryl Emerson and Michael Holquist. Austin: University of Texas Press, 1981.

 "Iskusstvo i otvetstvennost'" [Art and answerability]. In *Literaturno-kriticheskie stat'i*. Edited by S. G. Bocharov and V. V. Kozhinov. Moscow: Khudozhestvennaia literatura, 1986.

 "K filosofii postupka" [Toward a philosophy of the act]. In *Filosofiia i sotsiologiia nauki i tekhniki*. Moscow: Nauka, 1986.

 "Pis'ma M. M. Baxtina M. I. Kaganu." *Pamiat': Istoricheskii sbornik* 4 (Paris: YMCA Press, 1981): 249–81.

 "The Problem of Content, Material and Form in Verbal Artistic Creation." In *Art and Answerability*. Translated by Vadim Liapunov and Kenneth Brostrom. Edited with an introduction by Michael Holquist. Austin: University of Texas Press, 1990.

 "Problema soderzhaniia, materiala i formy v slovesnom khudozhestvennom tvorchestve" [The problem of content, material and form in verbal artistic creation]. In *Literaturno-kriticheskie stat'i*. Edited by S. G. Bocharov and V. V. Kozhinov. Moscow: Khudozhestvennaia literatura, 1986.

Problems of Dostoevsky's Poetics. Edited and translated by Caryl Emerson. Minneapolis: University of Minnesota Press, 1984.

Rabelais and His World. Translated by Hélène Iswolsky. Bloomington: Indiana University Press, 1984.

Speech Genres and Other Late Essays. Translated by Vern W. McGee. Edited by Caryl Emerson and Michael Holquist. Austin: University of Texas Press, 1986.

Toward a Philosophy of the Act. Translated by Vadim Liapunov. Edited by Michael Holquist and Vadim Liapunov. Austin: University of Texas, 1993.

Bann, Stephen, and John E. Bowlt, eds. *Russian Formalism, A Collection of Articles and Texts in Translation*. Edinburgh: Scottish Academic Press, 1973.

Barron, Stephanie, and Maurice Tuchman, eds. *The Avant-Garde in Russia, 1910–1930, New Perspectives*. Cambridge, MA: MIT Press, 1980.

Barthes, Roland. "The Death of the Author." In *Theories of Authorship: A Reader*. Edited by John Caughie. London: Routledge and Kegan Paul, 1981.

Image/Music/Text. London: Fontana, 1977.

Bauer, Dale M., and S. Jaret McKinstry, eds. *Feminism, Bakhtin, and the Dialogic*. Albany: State University of New York Press, 1991.

Belenky, Mary Field, et al. *Women's Ways of Knowing, The Development of Self, Voice and Mind*. New York: Basic Books, 1986.

Benjamin, Jessica. *The Bonds of Love, Psychoanalysis, Feminism, and the Problem of Domination*. New York: Pantheon, 1988.

Berdiaev, Nikolai. *Dream and Reality, An Essay in Autobiography*. Translated by Katharine Lampert. New York: Macmillan, 1951.

The Meaning of the Creative Act. Translated by Donald A. Lowrie. New York: Harper and Brothers, 1955.

Bethea, David M. *The Shape of Apocalypse in Modern Russian Fiction*. Princeton: Princeton University Press, 1989.

Betz, Margaret. "The Icon and Russian Modernism." *Artforum* 15 (Summer 1977): 38–45.

Bibler, V. C. *Mikhail Mikhailovich Bakhtin ili poetika kul'tury*. Moscow: Izdatel'stvo "Progress," 1991.

Billington, James H. *The Icon and the Axe, An Interpretive History of Russian Culture*. New York: Random House, 1966; Vintage Books, 1970.

Birnholz, A. C. "On the Meaning of Kazimir Malevich's 'White on White.' " *Art International* 21 (Number 1, 1977): 9–16f.

Bowlt, John E. "Russian Art in the Nineteen Twenties." *Soviet Studies* 4 (1971): 575–94.

Bowlt, John E., ed. and trans. *Russian Art of the Avant-Garde, Theory and Criticism 1902–1934*, rev. ed. New York: Thames and Hudson, 1988.

Brilliant, Richard. *Portraiture*. Cambridge, MA: Harvard University Press, 1991.

Brumfield, William C., and Milos M. Velimirovic, eds. *Christianity and the Arts in Russia*. Cambridge: Cambridge University Press, 1991.

Bryer, Anthony, and Judith Herrin, eds. *Iconoclasm: Papers Given at the Ninth Spring Symposium of Byzantine Studies*. Birmingham: Centre for Byzantine Studies, 1977.

Bulgakov, Sergei. *The Orthodox Church*. Translated by Lydia Kesich. Crestwood, NY: St. Vladimir's Seminary Press, 1988.

Burchett, Bessie Rebecca. *Janus in Roman Life and Cult*. Menasha, WI: George Banta, 1918.

WORKS CITED Burger, Christa. "The Disappearance of Art: The Postmodernism Debate in the U.S." *Telos* 68 (Summer 1986): 93–106.

Burgin, Victor. *The End of Art Theory, Criticism and Postmodernity.* Atlantic Highlands, NJ: Humanities Press, 1986.

Carroll, David. "The Alterity of Discourse: Form, History and the Question of the Political in M. M. Bakhtin." *Diacritics* 13 (Summer 1983): 65–83.

Chapman, H. Perry. *Rembrandt's Self-Portraits, A Study in Seventeenth-Century Identity.* Princeton: Princeton University Press, 1990.

Chave, Anna C. *Mark Rothko, Subjects in Abstraction.* New Haven: Yale University Press, 1989.

 "Minimalism and the Rhetoric of Power." *Arts Magazine* 64 (January 1990): 44–63.

Chipp, Herschel B. *Theories of Modern Art, A Source Book by Artists and Critics.* Berkeley: University of California Press, 1971.

The Chronicle of Novgorod, 1016–1471. Translated by Robert Michell and Nevill Forbes. London: Offices of the Society, 1914.

Clark, Katerina, and Michael Holquist. "A Continuing Dialogue." *Slavic and East European Journal* 30 (Spring 1986): 96–102.

 Mikhail Bakhtin. Cambridge, MA: Harvard University Press, 1984.

Clark, T. J. *The Painting of Modern Life, Paris in the Art of Manet and His Followers.* Princeton: Princeton University Press, 1984.

Cohen, Hermann. *Aesthetik des reinen Gefühls.* Berlin: Bruno Cassirer, 1912.

 Der Begriff der Religion im System der Philosophie. Giessen: Verlag von Alfred Toepelmann, 1915.

 Ethik des reinen Willens. Berlin: Bruno Cassirer, 1907.

 Religion of Reason out of the Sources of Judaism. Translated by Simon Kaplan. New York: Frederick Ungar, 1972.

Curtis, James M. "Mikhail Bakhtin, Nietzsche, and Russian Pre-Revolutionary Thought." In *Nietzsche in Russia.* Edited by Bernice Glatzer Rosenthal. Princeton: Princeton University Press, 1986.

Davydov, Iurii N. "U istokov sotsial'noi filosofii M. M. Bakhtina." *Sotsiologicheskie issledovaniia* 2 (1986): 170–81.

Dietrich, Wendell S. *Cohen and Troeltsch: Ethical Monotheistic Religion and Theory of Culture.* Atlanta: Scholars Press, 1986.

Douglas, Charlotte. "The New Russian Art and Italian Futurism." *Art Journal* 34 (Spring 1975): 229–39.

 "Suprematism: The Sensible Dimension." *Russian Review* 34 (July 1975): 266–81.

 Swans of Other Worlds: Kazimir Malevich and the Origins of Abstraction in Russia. Ann Arbor: University of Michigan Press, 1980.

Drijers, Han J. W. "Vocation." *Encyclopedia of Religion,* 16 volumes. Editor in chief, Mircea Eliade. In Vol. 15, pp. 294–6. Edited by Charles J. Adams et al. New York: Macmillan, 1987.

Egan, Rose Frances. *The Genesis of the Theory of "Art for Art's Sake" in Germany and England.* Folcroft, PA: Folcroft Press, 1921.

Emerson, Caryl. "Bakhtin and Intergeneric Shift: The Case of Boris Godunov." *Studies in Twentieth Century Literature* 9 (Fall 1984): 145–67.

 "Bakhtin as Counter-Revolutionary." Paper presented at Boston University, November 9, 1989.

"Problems with Baxtin's Poetics." *Slavic and East European Journal* 32 (Winter 1988): 503–525.

"Review of Mikhail Bakhtin: The Dialogical Principle." *Comparative Literature* 38 (Fall 1986): 370–2.

"Russian Orthodoxy and the Early Bakhtin." *Religion and Literature* 22 (Summer–Autumn 1990): 109–31.

Emerson, Caryl, and Gary Saul Morson. "Penultimate Words." In *The Current in Criticism, Essays on the Present and Future of Literary Theory*. Edited by Clayton Koelb and Virgil Lokke. West Lafayette, IN: Purdue University Press, 1987.

Eremeev, A. F., et al. *Estetika M. M. Bakhtina i sovremennost'*. Saransk, 1989.

Erlich, Victor. *Russian Formalism, History-Doctrine*, 3d ed. New Haven: Yale University Press, 1981.

Fedotov, George P. *The Russian Religious Mind*. Cambridge, MA: Harvard University Press, 1946.

Felski, Rita. *Beyond Feminist Aesthetics: Feminist Literature and Social Change*. Cambridge, MA: Harvard University Press, 1989.

Feuerbach, Ludwig. *Principles of the Philosophy of the Future*. Translated by Manfred H. Vogel. Introduction by Thomas E. Wartenberg. Indianapolis: Hackett, 1986.

Foster, Hal, ed. *The Anti-Aesthetic. Essays on Postmodern Culture*. Port Townsend, WA: Bay Press, 1983.

Dia Art Foundation Discussions in Contemporary Culture, Number One. Seattle: Bay Press, 1987.

Foucault, Michel. *Language, Counter-memory, Practice. Selected Essays and Interviews*. Edited by Donald F. Bouchard. Translated by Donald A. Bouchard and Sherry Simon. Ithaca, NY: Cornell University Press, 1977.

Power/Knowledge: Selected Interviews and Other Writings, 1972–1977. Edited by Colin Gordon. Translated by Colin Gordon, Leo Marshall, John Mepham, and Kate Soper. New York: Pantheon Books, 1980.

Freedberg, David. *The Power of Images*. Chicago: University of Chicago Press, 1989.

Gablik, Suzi. *The Reenchantment of Art*. New York: Thames and Hudson, 1991.

Gadamer, Hans-Georg. "The Hermeneutics of Suspicion." In *Hermeneutics, Questions and Prospects*. Edited by Gary Shapiro and Alan Sica. Amherst, MA: University of Massachusetts Press, 1984.

Galavaris, George. *The Icon in the Life of the Church*. Leiden: Brill, 1981.

Icons from the Elvehjem Art Center. Madison: University of Wisconsin Press, 1973.

Gardiner, Michael. *The Dialogics of Critique, M. M. Bakhtin and the Critique of Ideology*. New York: Routledge, 1992.

Gauss, Charles Edward. "Empathy." In *Dictionary of the History of Ideas: Studies in Selected Pivotal Ideas*. Edited by Philip P. Weiner. New York: Charles Scribner's Sons, 1973.

Gay, Peter. *The Enlightenment: An Interpretation*. New York: Alfred A. Knopf, 1966.

Gilbert, Katharine Everett, and Helmut Kuhn. *A History of Esthetics*. Bloomington: Indiana University Press, 1953.

Gilligan, Carol. *In a Different Voice, Psychology Theory and Women's Development*. Cambridge, MA: Harvard University Press, 1982.

Godzich, Wlad, and Jeffrey Kittay. *Emergence of Prose, An Essay in Prosaics*. Minneapolis: University of Minnesota Press, 1987.

WORKS CITED Golubinskii, E. E. *Istoriia russkoi tserkvi*, Vol. 1. Moscow: Universitetskaia tipogra-
phia, 1901, 1904, 1906.

Gombrich, Ernst. *In Search of Cultural History.* Oxford: Clarendon Press, 1969.

Grabar, Andre. *Nerukotvorennie spas lanskogo sobora.* [*The Savior Not Made by Human
Hands of the Laon Synod.*] Prague: Seminarium Kondakovianum, 1930.

Grabar, I. E. *Istoriia russkogo iskusstva.* Tom 2. Moscow: Izdatel'stvo Akademii
Nauk SSSR, 1954.

Valentin Aleksandrovich Serov, Zhizn' i tvorchestvo, 1865–1911. Moscow: Uzda-
tel'stvo Iskusstvo, 1965.

Gray, Camilla. *The Russian Experiment in Art 1863–1922.* Revised by Maria Bur-
leigh-Motley. London: Thames and Hudson, 1962.

Grimes, Nancy. "Sherrie Levine." *Art News* 86 (November 1987): 191–2.

Groos, Karl. *A History of Psychology in Autobiography.* Worcester, MA: Clark Uni-
versity Press, 1932.

Groys, B. "Problema avtorstva u Bakhtina i russkaia filosofskaia traditsiia." *Russian
Literature* 26 (1989): 113–30.

Guyau, Jean Marie. *The Problems of Contemporary Aesthetics, Book I.* Translated by
Helen L. Mathews. Los Angeles: DeVorss, 1947.

Hamilton, George Heard. *Painting and Sculpture in Europe 1880–1940.* New York:
Penguin, 1986.

Hassan, Ihab. *The Postmodern Turn, Essays in Postmodern Theory and Culture.* Co-
lumbus: Ohio State University Press, 1987.

Hauser, Arnold. *Sociology of Art.* Translated by Kenneth J. Northcott. Chicago:
University of Chicago Press, 1982.

Hegel, Georg Wilhelm Friedrich. *Lectures on the Philosophy of Religion, One Volume
Edition, The Lectures of 1827.* Edited by Peter C. Hodgson. Berkeley: Uni-
versity of California Press, 1988.

Henderson, Linda Dalrymple. *The Fourth Dimension and Non-Euclidean Geometry
in Modern Art.* Princeton: Princeton University Press, 1983.

Hirschkop, Ken. "The Domestication of M. M. Bakhtin." *Essays in Poetics* 11
(Spring 1986): 76–87.

Hirschkop, Ken, and David Shepherd, eds. *Bakhtin and Cultural Theory.* Man-
chester: Manchester University Press, 1989.

Holl, Karl. "Die Geschichte des Worts Beruf." *Gesammelte Aufsatze zur Kirchen-
geschichte.* In Vol. 3, pp. 189–219. Tübingen: Verlag von J. C. B. Mohr (Paul
Siebeck), 1928. Translated by Heber F. Peacock as pamphlet, *The History of
the Word Vocation* (*Beruf*). Cambridge, MA: Andover-Harvard Library, Har-
vard Divinity School.

Holly, Michael Ann. *Panofsky and the Foundations of Art History.* Ithaca, NY: Cor-
nell University Press, 1984.

Holquist, James M., and Katerina Clark. "The Influence of Kant in the Early
Work of M. M. Bakhtin." In *Literary Theory and Criticism, Festschrift Presented
to René Wellek in Honor of his Eightieth Birthday, Part I: Theory.* Edited by
Joseph P. Strelka. Bern: Peter Lang, 1984.

Holquist, Michael. "Answering as Authoring: Mikhail Bakhtin's Trans-Linguis-
tics." In *Bakhtin, Essays and Dialogues on His Work.* Edited by Gary Saul
Morson. Chicago: University of Chicago Press, 1986.

Dialogism, Bakhtin and his World. New York: Routledge, 1990.

"Introduction." *Studies in Twentieth Century Literature* 9 (Fall 1984): 7–12.

hooks, bell. *Feminist Theory from Margin to Center.* Boston: South End Press, 1984.

Hutcheon, Linda. *The Politics of Postmodernism.* New York: Routledge, 1990.

Huyssen, Andreas. *After the Great Divide, Modernism, Mass Culture, Postmodernism.* Bloomington: Indiana University Press, 1986.

Isdebsky-Pritchard, Aline. *The Art of Mikhail Vrubel (1856–1910).* Ann Arbor, MI: UMI Research Press, 1982.

Isupov, K. G., et al. *Bakhtinskii sbornik.* Moscow, 1990.

Ivanov, Father Vladimir. *Russian Icons.* New York: Rizzoli, 1988.

Iverson, Margaret. *Alois Riegl, Art History and Theory.* Cambridge, MA: MIT Press, 1993.

Jameson, Fredric. "Postmodernism, or the Cultural Logic of Late Capitalism." *New Left Review* 146 (July/August 1984): 53–92.

John of Damascus. *Apologies Against Those Who Attack Divine Images.* Translated by David Anderson. Crestwood, NY: St. Vladimir's Seminary Press, 1980.

"The Orthodox Faith." In *Saint John of Damascus, Writings.* Translated by Frederic H. Chase, Jr. New York: Fathers of the Church, 1958.

Judd, Donald. *Donald Judd, Complete Writings 1959–1972.* Halifax: Press of the Nova Scotia College of Art and Design; New York: New York University Press, 1975.

Kandinsky, Wassily. *Kandinsky, Complete Writings on Art,* 2 vols. Edited by Kenneth C. Lindsay and Peter Vergo. Boston: G. K. Hall, 1982.

Concerning the Spiritual in Art. Translated by M. T. H. Sadler. New York: Dover, 1977.

Kant, Immanuel. *Critique of Judgment.* Translated by Werner S. Pluhar. Indianapolis: Hackett, 1987.

Kaplan, E. Ann, ed. *Postmodernism and Its Discontents: Theories, Practices.* London: Verso Press, 1988.

Kasson, Joy. *Marble Queens and Captives.* New Haven: Yale University Press, 1990.

Kelly, Catriona, Michael Makin, and David Shepherd. *Discontinuous Discourses in Modern Russian Literature.* London: Macmillan, 1989.

Khardzhiev, Nikolai, ed. *K istorii russkogo avantgarda.* Stockholm: Almqvist and Wiksell, 1976.

Kinser, Samuel. "Chronotopes and Catastrophes: The Cultural History of Mikhail Bakhtin." *Journal of Modern History* 56 (June 1984): 301–10.

Kitzinger, Ernst. "The Cult of Images in the Age Before Iconoclasm." *Dumbarton Oaks Papers* 8 (1954): 83–150.

Kluchevsky, V. O. *A History of Russia.* Translated by C. J. Hogarth. New York: Russell and Russell, 1960.

Kondakov, Nikolai. *Ikonografiia Gospoda Boga i Spasa nashego Iusa Khrista. Litsevoi ikonopisnyi podlinnik,* Tom I. St. Petersburg: A. Vil'borg, 1905.

The Russian Icon. Translated by Ellis H. Minns. Oxford: Clarendon Press, 1927.

Kovtun, Evgenii, ed. "K. S. Malevich, Pisma k M. V. Matiushinu." In *Ezhegodnik rukopisnogo otdela Pushkinskogo doma na 1974.* Leningrad: Izdatel'stvo, 1976.

Kozhinov, B. "Konspektii leksii M. M. Baxtina." *Prometei* 12 (1980): 257–68.

Krauss, Rosalind E. *Cindy Sherman, 1975–1993.* New York: Rizzoli, 1993.

Kris, Ernst, and Otto Kurz. *Legend, Myth, and Magic in the Image of the Artist: A Historical Experiment.* New Haven: Yale University Press, 1979; reprint edition, Vienna: Krystall Verlag, 1934.

Kuryluk, Ewa. *Veronica and Her Cloth, History, Symbolism, and Structure of a "True" Image.* Oxford: Basil Blackwell, 1991.

Laren, Ernest, "Who Owns the Streets." *Art in America* 78 (January 1990): 55–61.

Lessing, Gotthold. *Laocoon: An Essay upon the Limits of Poetry and Painting*. Translated by Ellen Frothingham. New York: Noonday Press, 1957.

Lipps, Theodor. *Aesthetik: Psychologie des Schonen und der Kunst*, 2 vols. Hamburg and Leipzig: Verlag von Leopold, 1903–6.

——— "Empathy, Inner Imitation, and Sense-Feelings." Translated by Max Schertel and Melvin Rader. In *A Modern Book of Esthetics*. Edited by Melvin Rader. New York: Holt, Rinehart and Winston, 1966.

Listowel, William Francis Hare, Earl of. *A Critical History of Modern Aesthetics*. London: Allen and Unwin, 1993.

Lodder, Christina. *Russian Constructivism*. New Haven: Yale University Press, 1983.

Lossky, N. O. *History of Russian Philosophy*. New York: International Universities Press, 1955.

Lotman, Iurii. *The Structure of the Artistic Text*. Translated by Ronald Vroon. Ann Arbor: University of Michigan Press, 1977.

Maguire, Henry. *Art and Eloquence in Byzantium*. Princeton: Princeton University Press, 1981.

Malevich, K. S. *The Artist, Infinity, Suprematism, Unpublished Writings 1913–1933*. Vol. 4 of *Essays on Art*. Translated by Xenia Hoffman. Edited by Troels Andersen. Copenhagen: Borgens Forlag, 1978.

——— *Essays on Art 1915–1928*, Vol. 1. Translated by Xenia Glowacki-Prus and Arnold McMillin. Edited by Troels Andersen. Copenhagen: Borgen, 1968.

——— *Essays on Art 1928–1933*, Vol. 2. Translated by Xenia Glowacki-Prus and Arnold McMillin. Edited by Troels Andersen. Copenhagen: Borgen, 1968.

——— "Fragments from 'Chapters from an Artist's Autobiography' (1933)." Translated by Alan Upchurch. *October* 34 (Fall 1985): 25–44.

——— *The Non-Objective World*. Translated by Howard Dearstyne. Chicago: Paul Theobald, 1959.

——— *The World as Non-Objectivity, Unpublished Writings 1922–25*. Vol. 3 of *Essays on Art*. Translated by Xenia Hoffman and Edmund T. Little. Edited by Troels Andersen. Copenhagen: Borgens Forlag, 1976.

Malevitch. Exhibition catalog. Musée National d'Art Moderne. Paris: Centre Georges Pompidou, 1978.

Kasimir Malevich, 1878–1935. Exhibition catalog. Edited by W. A. L. Beeren et al. Amsterdam: Stedelijk Museum; Moscow: Ministry of Culture, 1988.

Kasimir Malewitsch. Exhibition catalog. Koln: Galerie Gmurzynska, 1978.

Marcadé, Jean-Claude. "An Approach to the Writings of Malevich." *Soviet Union* 5 (Part 2, 1978): 225–40.

Martineau, Emmanuel. *Malevitch et la Philosophie, La Question de la Peinture abstraite*. Lausanne: L'Age d'Homme, 1977.

Marzorati, Gerald. "Art in the (Re) Making." *Art News* 85 (May 1986): 90–9.

Medvedev. P. M. *The Formal Method in Literary Scholarship*. Translated by Albert J. Wehrle. Cambridge, MA: Harvard University Press, 1985.

Miles, Margaret R. "Theological Education in a Religiously Diverse World." *Theological Education* 23 (Supplement 1987): 34–52.

Miliukov, Paul. *Outlines of Russian Culture, Part I, Religion and the Church*. New York: A. S. Barnes, 1942.

Morson, Gary Saul. *Hidden in Plain View*. Stanford: Stanford University Press, 1987.

"Prosaics: An Approach to the Humanities." *The American Scholar* (Autumn 1988): 515–28.

Morson, Gary Saul, ed. *Bakhtin, Essays and Dialogues on His Work.* Chicago: University of Chicago Press, 1986.

Morson, Gary Saul, and Caryl Emerson. *Mikhail Bakhtin: Creation of a Prosaics.* Stanford: Stanford University Press, 1990.

Morson, Gary Saul, and Caryl Emerson, eds. *Rethinking Bakhtin, Extensions and Challenges.* Evanston, IL: Northwestern University Press, 1989.

Mowat, C. L., ed. *New Cambridge Modern History, Vol. XII, The Shifting Balance of World Forces, 1898–1945.* Cambridge: Cambridge University Press, 1968.

Muensterberg, Hugo. *Principles of Art Education.* New York: Prang, 1905.

Nakov, Andréi. *Kazimir Malévich: Ecrits.* Paris: Editions Gérard Lebovici, 1986.

Nicholson, Linda J., ed. *Feminism/Postmodernism.* New York: Routledge, 1990.

Obolensky, Dimitri. "Popular Religion in Medieval Russia." In *The Religious World of Russian Culture*, Vol. 2, pp. 43–54. *Russia and Orthodoxy: Essays in Honor of Georges Florovsky.* Edited by Andrew Blane. The Hague: Mouton, 1975.

Olin, Margaret. *Forms of Representation in Alois Riegl's Theory of Art.* University Park: Pennsylvania State University Press, 1992.

Onasch, Konrad. *Gross-Nowgorod, Aufstieg und Niedergang einer russischen Stadtrepublik.* Vienna: Verlag Anton Schroll, 1969.

Kunst und Liturgie der Osfkirche in Stichworten unter Berücksichtigung der altern Kirche. Vienna: Verlag Hermann Böhlaus Nachf., 1981.

Russian Icons. New York: Phaidon, 1977.

Osborne, Harold. *The Oxford Companion to Art.* Oxford: Clarendon Press, 1970.

The Oxford Companion to Twentieth-century Art. Oxford: Oxford University Press, 1988.

Ouspensky, Leonid, and Vladimir Lossky. *The Meaning of Icons.* Translated by G. E. H. Palmer and E. Kadloubovsky. Boston: Boston Book and Art Shop, 1952.

Ouspensky, Leonide. *Essai sur la Theologie de l'Icon dans l'Eglise orthodoxe.* Paris: Editions de l'Exarchat Patriarcal Russe en Europe occidentale, 1960.

Ouspensky, Petr. *Tertium Organum, A Key to the Enigmas of the World,* 2nd ed. Translated by Nicholas Bessaraboff and Claude Bragdon. New York: Alfred A. Knopf, 1922.

Pächt, Otto. "Art Historians and Art Critics – VI: Alois Riegl." *Burlington Magazine* 105 (May 1963): 188–93.

Palazzini, Monsignor Pietro. "Vocation." *Dictionary of Moral Theology.* Compiled under the direction of Francesco Cardinal Roberti. Edited by Monsignor Pietro Palazzini. Westminster, MD: Newman Press, 1962.

Paszkiewicz, Henryk. *The Making of the Russian Nation.* London: Henry Regnery, 1963.

Patterson, David. *Literature and Spirit, Essays on Bakhtin and his Contemporaries.* Lexington: University Press of Kentucky, 1988.

Perlina, Nina. "Bakhtin and Buber: Problems of Dialogic Imagination." *Studies in Twentieth Century Literature* 9 (Fall 1984): 13–28.

Peterson, Ronald E. *The Russian Symbolists, An Anthology of Critical and Theoretical Writings.* Ann Arbor, MI: Ardis, 1986.

Pomorska, Krystyna. "Mikhail Bakhtin and His Dialogic Universe." *Semiotica* 58 (1–2, 1984): 169–74.

Povelikhina, Alla. "Matiushin's Spatial System." In *Die Kunstismen in Russland/ The Isms of Art in Russia 1907–1930*. Köln: Galerie Gmurzynska, 1977.

Pritsak, Omeljan. *The Origin of Rus'*. Cambridge, MA: Harvard Ukrainian Research Institute, 1981.

Rabinow, Paul, ed. *The Foucault Reader*. New York: Pantheon, 1984.

Rader, Melvin, ed. *A Modern Book of Esthetics: An Anthology*. New York: Henry Holt, 1966.

Reid, Allan. *Literature as Communication and Cognition in Bakhtin and Lotman*. New York: Garland, 1990.

Rice, Tamara Talbot. *Russian Icons*. London: Spring Books, 1963.

Ricoeur, Paul. *Hermeneutics and the Human Sciences, Essays on Language, Action, and Interpretation*. Edited and translated by John B. Thompson. Cambridge: Cambridge University Press, 1981.

Riegl, Alois. *Die spätrömische Kunstindustrie nach den Funden in Osterreich-Ungarn*. Vienna: Osterr. Staatsdruckerei, 1927.

Late Roman Art Industry. Translated by Rolf Winkes. Rome: Giorgio Bretschneider Editore, 1985.

Roberts, Mathew. "Neither a Formalist Nor a Marxist Be: Notes on the Early Ethical-Aesthetic Writing of Mixail Baxtin." Master's thesis, Cornell University, Ithaca, NY, 1989.

Robinson, Alan. *Poetry, Painting and Ideas 1885–1914*. London: Macmillan, 1985.

Rus'kina, E. C., ed. *M. M. Bakhtin: Problemi nauchnogo naslediya*. Saransk: Izdatel'stvo Mordovskogo universiteta, 1992.

Rybakov, B. *Early Centuries of Russian History*. Translated by John Weir. Moscow: Progress, 1965.

Savelieva, N. "Sur les éléments et les processus de constitution de formes en art." *Cahier Malévitch No. 1, Recueil d'essais sur l'oeuvre et la pensée de K. S. Malévitch*. Lausanne: L'Age d'Homme, 1983.

Schapiro, Meyer. "Style." In *Anthropology Today, An Encyclopedic Inventory*. Prepared under the Chairmanship of A. L. Kroeber, pp. 287–312. Chicago: University of Chicago Press, 1953.

Scharmann, Th. "Beruf." *Die Religion in Geschichte und Gegenwart, Handworterbuch für Theologie und Religionswissenschaft*. Ester Band. Edited by Hans Frhr. v. Camphausen et al. Cols. 1071–82. Tübingen: J. C. B. Mohr (Paul Siebeck), 1957.

Seeskin, Kenneth. *Jewish Philosophy in a Secular Age*. Albany: State University of New York Press, 1990.

Shklovsky, Victor. "Art as Technique." In *Russian Formalist Criticism: Four Essays*. Translated and with an introduction by Lee T. Lemon and Marion J. Reis. Omaha: University of Nebraska Press, 1965.

Shukman, Ann, ed. *The Semiotics of Russian Culture*. Ann Arbor: University of Michigan Press, 1984.

Siegel, Jeanne. "After Sherrie Levine." *Arts Magazine* 59 (Summer 1985): 141–4.

Simmons, W. Sherwin. *Kasimir Malevich's Black Square and the Genesis of Suprematism 1907–1915*. New York: Garland, 1981.

Singer, Irving. "The Aesthetics of 'Art for Art's Sake'." *Journal of Aesthetics and Art Criticism* 12 (March 1954): 343–59.

Smirnova, E. S. *Zhivopis' velikogo Novgoroda: seredina XIII–nachalo XV veka*. Moscow: Nauka, 1976.

Solovyov, Vladimir. *A Solovyov Anthology*, reprint ed. Arranged by S. L. Frank. Translated by Natalie Duddington. Westport, CT: Greenwood Press, 1974.

Spelman, Elizabeth V. *Inessential Woman, Problems of Exclusion in Feminist Thought.* Boston: Beacon Press, 1988.

The Spiritual in Art: Abstract Painting 1890–1985. New York: Abbeville Press; Los Angeles: Los Angeles County Museum of Art, 1986.

Stewart, David A. *Preface to Empathy.* New York: Philosophical Library, 1956.

Striedter, Jurij. *Literary Structure, Evolution and Value, Russian Formalism and Czech Structuralism Reconsidered.* Cambridge, MA: Harvard University Press, 1989.

Titunik, I. R. "The Baxtin Problem: Concerning Katerina Clark's and Michael Holquist's *Mikhail Bakhtin.*" *Slavic and East European Journal* 30 (Spring 1986): 91–5.

Todorov, Tzvetan. *Mikhail Bakhtin, The Dialogical Principle.* Translated by Wlad Godzich. Minneapolis: University of Minnesota Press, 1984.

Ugolnik, Anthony. *The Illuminating Icon.* Grand Rapids, MI: William B. Eerdmans, 1989.

Uspensky, Boris A. "The Language of Ancient Painting." *Dispositio* 1 (1976): 219–46.

The Semiotics of the Russian Icon. Edited by Stephen Rudy. Lisse: Peter de Ridder Press, 1976.

Uspensky, Boris, and Iurii Lotman. "New Aspects in the Study of Early Russian Culture." In *The Semiotics of Russian Culture.* Edited by Ann Shukman. Ann Arbor: University of Michigan Press, 1984.

Varnedoe, Kirk, and Adam Gopnik, eds. *High and Low, Modern Art and Popular Culture.* New York: Museum of Modern Art, 1990.

Vico, Giambattista. *The New Science of Giambattista Vico.* Translated by Thomas Goddard Bergin and Max Harold Fisch. Ithaca, NY: Cornell University Press, 1968.

Vischer, Robert. *Uber das optische Formgefühl: Ein Beitrag zur Aesthetik.* Leipzig: Hermann Credner, 1873.

Vischer, Robert, et al. *Empathy, Form, and Space, Problems in German Aesthetics, 1873–1893.* Translated by Harry Francis Mallgrave and Eleftherios Ikonomou. Santa Monica: Getty Center for the History of Art and the Humanities, 1994.

Voloshinov, V. N. *Freudianism, A Critical Sketch.* Translated by I. R. Titunik. Edited in collaboration with Neal H. Bruss. Bloomington: Indiana University Press, 1987.

Marxism and the Philosophy of Language. Translated by L. Matejka and I. R. Titunik. Cambridge, MA: Harvard University Press, 1986.

Vygotsky, Lev Semenovich. *The Psychology of Art.* Cambridge, MA: MIT Press, 1971.

Ware, Timothy. *The Orthodox Church.* Baltimore: Penguin, 1963.

Weber, Max. *The Protestant Ethic and the Spirit of Capitalism.* New York: Charles Scribner's Sons, 1958.

Weitzmann, Kurt, et al. *The Icon.* New York: Alfred A. Knopf, 1982.

West, Cornel. *Prophesy Deliverance.* Philadelphia: Westminster Press, 1982.

Williams, Raymond. *Keywords, A Vocabulary of Culture and Society.* New York: Oxford University Press, 1983.

Windelband, Wilhelm. *A History of Philosophy.* Translated by James H. Tufts. New York: Macmillan, 1935.

WORKS CITED

An Introduction to Philosophy. Translated by Joseph McCabe. New York: Henry Holt, 1921.

Wolff, Janet. *The Social Production of Art.* New York: St. Martin's Press, 1981.

Zamiatin, Evgenii. "On Revolution, Entropy and Other Matters." Translated by W. Vickery. *Partisan Review* 3–4 (1961): 372–8.

Zerner, Henri. "Alois Riegl: Art, Value, and Historicism." *Daedalus* 105 (Winter 1976): 177–88.

INDEX